MW00589208

Beautiful Bacteria

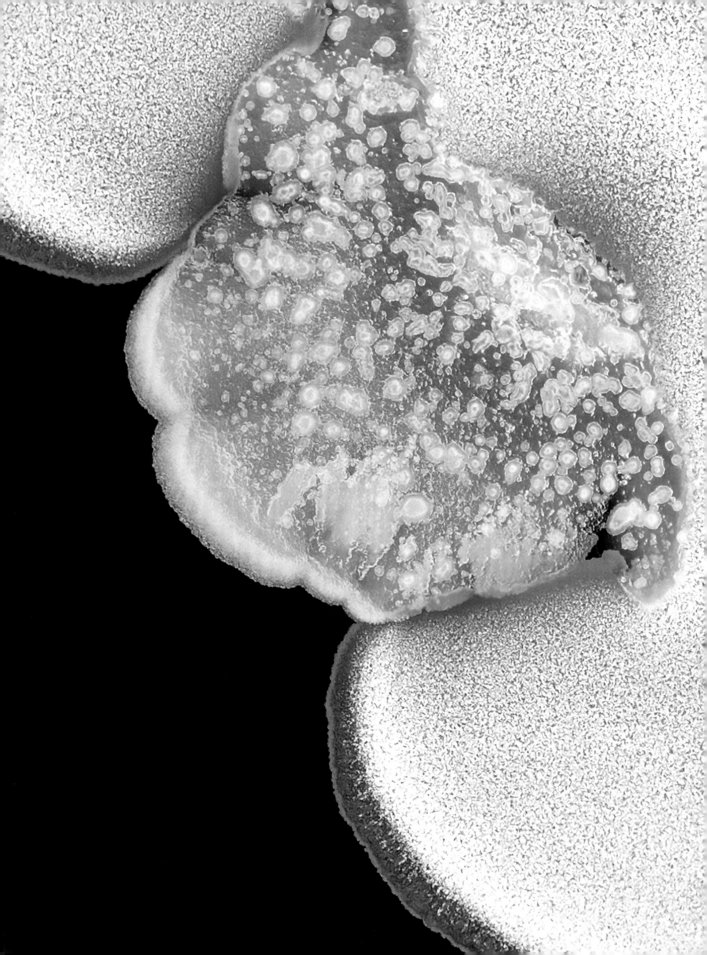

Beautiful Bacteria

ENCOUNTERS IN THE MICROUNIVERSE

Tal Danino

FOREWORD BY VIK MUNIZ
AFTERWORD BY JEFF HASTY, PHD

07 FOREWORD

11 INTRODUCTION

177 AFTERWORD

178 FURTHER READING

179 CREDITS

180 ACKNOWLEDGMENTS

181 ABOUT THE AUTHORS

1

CH. 1 THE ORIGINS OF LIFE
OUR MICROBIAL ANCESTORS 17

CH. 2 WONDERFUL TO BEHOLD
IDENTIFYING BACTERIA 27

CH. 3 GROWTH AND
EMERGENCE *SINGLE CELLS*
TO COMPLEX COLONIES 41

2

CH. 4 FIRST ENCOUNTER
BEFORE BIRTH 61

CH. 5 INTREPID EXPLORERS
ON OUR SKIN 69

CH. 6 MAKING THEMSELVES
AT HOME *IN OUR GUT* 85

3

CH. 7 ABUNDANT GUESTS
IN OUR HOMES 105

CH. 8 COMPETITION AND
COEXISTENCE
WITHIN OUR COMMUNITIES 117

CH. 9 MICROBIAL MAPS
ON OUR EARTH 133

4

CH. 10 HARNESSING CHAOS
BACTERIAL DESIGN 153

CH. 11 REWIRING BIOLOGY
PROGRAMMING MICROBES 169

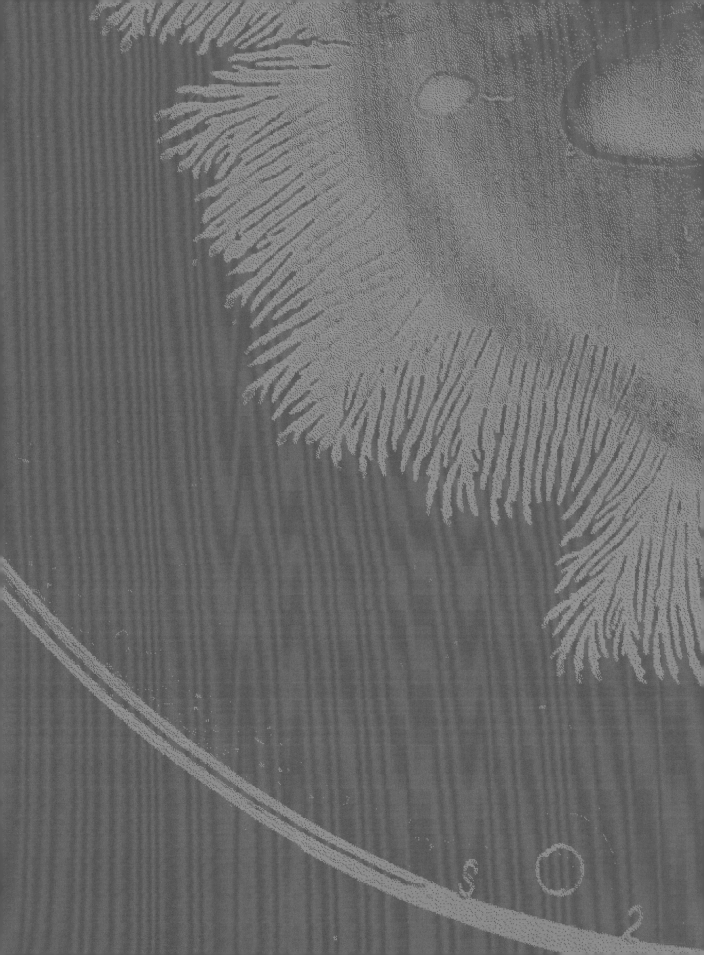

FOREWORD

VIK MUNIZ

Pulchritudo splendor veritatis.

Both science and art are organized ways of observing and understanding the world around us. While science is generally concerned with finding truths that lie beyond the reach of our senses, art deals with how sensorial stimuli connects with complex internal emotional and cognitive processes. We do hear about the beauty of certain scientific theories or the elegance of mathematical solutions but the role of aesthetics in scientific thought has always been either neglected or reduced to matters such as simplicity and symmetry. In fact, it is fair to say that both artistic and scientific practices share little or nothing in terms of objectives—although aesthetic bewilderment is a common ground that engenders a great deal of artistic and scientific ideas. I personally have a hard time differentiating the working processes of artists and scientists. Both are empirical practices within some kind of historical background. Both start with observation and rely on one's being able to communicate the thing observed. Lastly, having enjoyed the company of scientists in many collaborations throughout my thirty years of artistic practice, I noticed that our minds are generally tickled by the same sort of stimuli. So why is it that aesthetics has been so vehemently shunned in scientific discourse for so long?

We hear stories of how Jean Painlevé's pioneering underwater films were snubbed by academia for being too beautiful and entertaining. I do feel that every time beauty invades the experiment, it renders the experiment implausible. From Harold Edgerton's time-slicing images to Berenice Abbott's pictures of bubbles, every effort to extract scientific splendor from the world of numbers, equations, and immaterial experiments results in exposing the huge gap between what is known and the means of transmitting the beauty inherent in every beautiful idea.

I met Tal Danino during a residency at MIT Media Lab a little over a decade ago, just as I had been obsessing over Lynn

Margulis and Dorion Sagan's *Microcosmos*. And so my brain was already infested with ideas about the mighty bacteria when I first saw Tal's beautiful experiments with quorum sensing, for which he programed bacteria to glow rhythmically once they reached a critical mass. When I say those are beautiful, I am speaking as an artist because I immediately thought of an electronic soundtrack for the videos that would morph the serious experiment into some microscopic Coldplay concert. The famous physicist Richard Feynman recounted a two-day encounter with artist Robert Irwin sponsored by the Los Angeles County Museum when, after a great effort discussing back and forth, the Nobel Prize winner finally understood what the artist was saying to him and he thought it was interesting and wonderful. With Tal, it was quite different. From the onset, there was nothing to be described or explained as Tal set the process as a treasure hunt. Only after we agreed on the beauty of a certain colorful pattern on a petri dish would he reveal that it was in fact a species of the genus *Paenibacillus*, or even salmonella. Tal showed me the beauty of cancer cells, extending not only my comprehension of what we are really made of as complex organisms, but also my understanding of beauty as something acquirable with knowledge and experience.

A hunter once told me that the hardest part of hunting a deer is carrying it back to the car. A scientific mind may dwell in exclusive areas of knowledge, discovering universes unimaginable even to the wildest creative individual; however, the work of making these discoveries transcends the forest of erudition. It becomes a language that can not only be transmitted for practical purposes but also enjoyed for its immanent aesthetic properties. It is a product of generosity, empathy, and resolve.

Beautiful Bacteria is a seductive guide to the world of our most ubiquitous co-existing life forms. Employing an eclectic variety of visual languages, it illustrates both the theme and the author's fascination for it. Tal is an amazing scientist who also has a genuine interest in how ideas get transmitted. Perhaps his conviviality with the bacteria has taught him that when it comes to culture—any culture—dissemination is just as important as production and conservation. The ever-talented bacterium never asked for a champion; it needs no help from humans to exist and its prowess more than speaks for itself. *Beautiful Bacteria* is a book that allows humans to connect to and learn from something that has been everywhere since the dawn of life—but has remained unnoticed largely because it was never seen as a form of beauty.

Paenibacillus bacteria collected and isolated from sand from Venice Beach, California. A drop of bacteria was spotted at the bottom of a petri dish, where it grew to form a complex colony over several days, which was then stained with dyes.

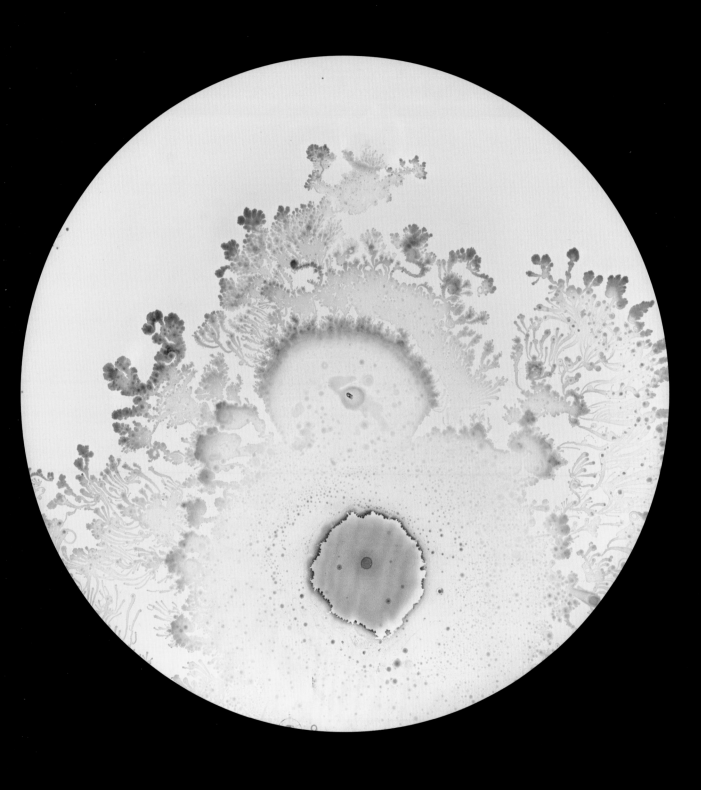

PAENIBACILLUS LAUTUS

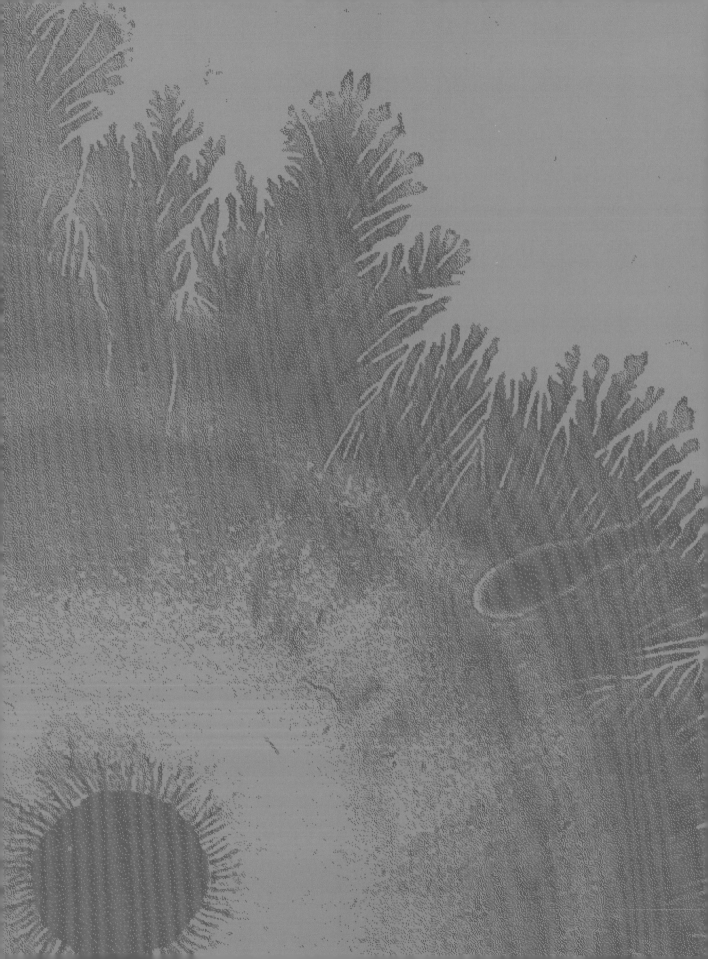

INTRODUCTION

The invisible microbial world is experiencing a kind of renaissance. Microbes are no longer viewed primarily as agents of disease; instead these microorganisms, from bacteria and viruses to fungi, archaea, and protists, have become a source of fascination for many. Their impact has become part of public and private discourse, whether as the influence of our microbiomes on health, the role of environmental microbes in climate change and planetary health, or the potential of biotechnology.

Inspired by the wonders of bacteria, I think about how we can bioengineer microbes for beneficial purposes. I am one of many fellow bacteria enthusiasts in the Synthetic Biological Systems Laboratory (often referred to as the "Danino lab")—an amazing group of diverse individuals coming from science, engineering, design, and art backgrounds, driven to repurpose bacteria's evolutionary inventions for different aims.

Synthetic biologists like us view microbes as tiny programmable machines that can be deployed through the body to survey, sense, and treat diseases. Exploiting the diverse niches bacteria occupy on and throughout the body, we can replace them with bespoke-designed microbes to enhance human health. This manipulation extends to other ecosystems and applications involving bacteria.

This book features bacteria within a petri dish. I have long been fascinated with how such a simple platform can demonstrate the incredible diversity and complexity of microbes. Within a dish, from single cells governed by simple communication rules, bacterial communities emerge, forming snowflake-like patterns. By cultivating bacteria from the human body and environmental samples, we at the Danino lab shape these living organisms into aesthetic forms to leverage them as a medium to communicate their history, their intricate lifestyles, the impact they have on the world, and how they can be repurposed for good.

After all, humans still often perceive microbes, such as molds or other decaying bacteria, in a negative light. Our evolutionary instincts have conditioned us to avoid them. However, our evolution is also intertwined with an innate appreciation for aesthetic forms in nature, such as the vibrant colors of flowers and fruits that have promoted color vision in the animal kingdom. Throughout history, humans have selectively bred animals and plants to appeal to our sense of beauty—so why not microbes? Why can't beautiful bacteria not only serve to communicate scientific principles but inspire new and creative directions in scientific research as well?

Through their collaboration with us at the lab, bacteria form visible communities, resembling natural processes such as snowflakes, swarms of fish and birds, or repeating patterns on plant leaves. The growth and symmetrical forms of bacteria are then pleasing to the eye, from their attractive patterns to their captivating colors. We exert control over bacteria by providing them with specific environmental conditions, or manipulate their genetics for precision—yet they often deviate from our plans, introducing chaos and becoming active participants in the creation of artworks themselves. Although the resulting images look effortlessly composed, creating them takes time and work, such as coloring the plates manually, rather than digitally, with scientific and artistic dyes.

Within the pages of this book, each enlarged petri dish resembles a microcosmic universe. In looking at an image, it's hard to tell if it is something one might find at the bottom of the ocean or instead a false-color image of a faraway galaxy. This scale-invariant quality of the dishes is something that allows imaginations to extrapolate from the world of bacteria to broader implications of life in the universe. In viewing living bacteria, we are able to read stories about these microbes and our shared environments—and ultimately come closer to understanding more about life itself.

Isolated bacterial species collected from soil, sand, and leaves; grown on a gel medium in petri dishes; and stained with dyes.

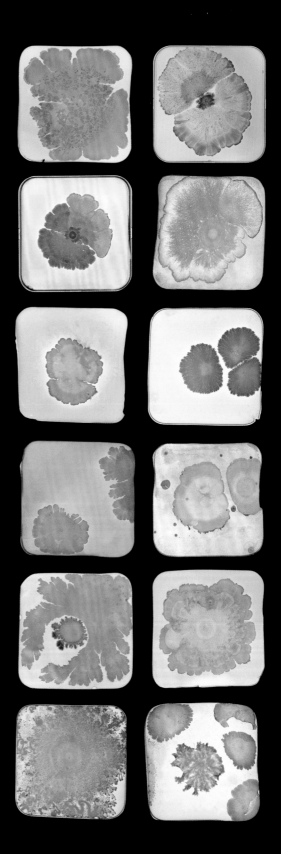

Multiple colonies
of *Escherichia coli*
(E. coli) cultivated
in a petri dish. This
dish was stained
with dyes and pre-
served by drying it.

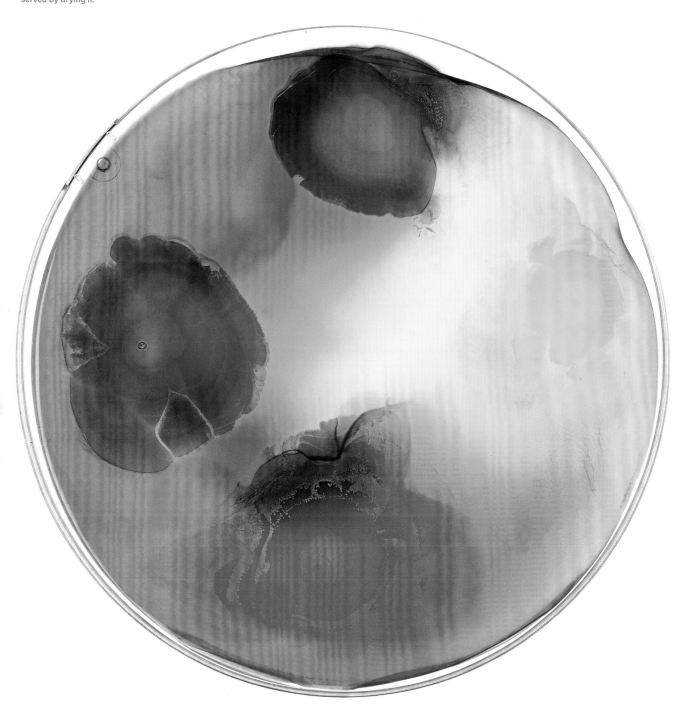

ESCHERICHIA COLI

WHERE THE TELESCOPE
ENDS, THE MICROSCOPE BEGINS.
WHICH OF THE TWO
HAS THE GRANDER VIEW?

Victor Hugo, *Les Misérables* (1862)

PART
1

THE
MICROUNIVERSE

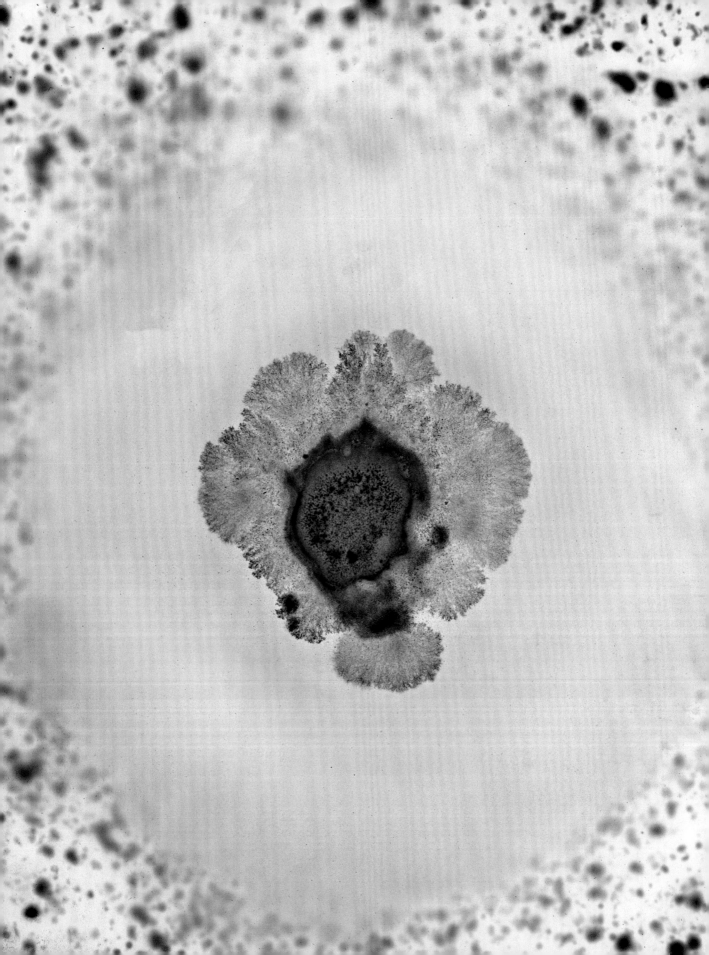

CH. 1 *THE ORIGINS OF LIFE*
OUR MICROBIAL ANCESTORS

Soil bacteria grown in a petri dish (detail). The first microbial species emerged about 3.6 billion years ago in deep-sea vents, about 1 billion years after the earth formed.

Life on our planet began in the deep sea—close to volcanic vents that marked where the earth's tectonic plates move apart and far from sunlight and oxygen. Rich in minerals and organic compounds, these vents spewed heat and nutrients that fueled a genesis on a molecular level. The transformation of nonliving molecules into living organisms was a change of epic proportions at a microscopic scale. This transition was not a single event but a gradual progression of increasing complexity, supporting the formation of a habitable planet and conditions for the subsequent evolution of single cells to increasingly complex life-forms.

The origin of life has been fascinating to me since early childhood, and like many others, it was in the form of an obsession with dinosaurs. I would memorize as many species as I possibly could and draw scenes of the ancient worlds they lived in. Paleontology was one of my first exposures to science and the excitement of discovery. When I was growing up, I heard about discoveries of new fossils and dinosaur species on the news all the time—but I didn't know what bacteria were.

This could be due to the fact that—in contrast to dinosaurs—individual bacteria cells are invisible to the naked eye and have left very few traces of their existence. Their remains create nothing like the spectacular fossils generated by dinosaurs that are not just visible and tangible but enormous, with a wow factor that naturally engages people. In fact, my current work (and this chapter) was inspired in part by the amazing recruitment tool inherent in the field of paleontology: big fossils that can be reassembled into spectacles to be seen by people in museums and spark enthusiasm. Yet, when one considers the far earlier origins of life and beginnings of bacteria—billions of years ago, compared to dinosaurs' closer to 250 million years ago—those first origins become even more fascinating.

Bacteria have evolved to become part of each and every one of our cells. Research dates the formation of the earth to about 4.6 billion years ago—and about 1 billion years later, microbes began their reign. The first microbial species that developed in deep-sea vents are thought to be relatives of bacteria called archaea (meaning "ancient"). Perhaps another 1 billion years after that, communities of cyanobacteria (bacteria that use light as an energy source), grew on land and left the earliest fossils by imprinting sedimentary stone. Then, in the subsequent 1 to 2 billion years, over several minuscule but monumental steps, unicellular life made a transition to multicellularity, with single cells becoming part of a larger organism.

As cells evolved over time, they grew larger and developed specialized and localized functions within them. For example, they evolved a nucleus to protect the cell's genetic material (DNA), and a Golgi apparatus, which helps modify, sort, and package proteins within and outside the cell. Perhaps one of the most dramatic steps in evolution was an event where one of these larger cells engulfed a smaller microbe. The first such merger event is thought to be when an archaea, unable to grow in oxygen-rich conditions, engulfed an aerobic bacterium, which preferred oxygen.

Endosymbiotic relationships, in which one cell lives inside another, are prevalent throughout nature. These relationships are often mutualistic, benefiting both the host cell and the internalized cell. In the aforementioned merger event, the host cell gained the ability to grow in oxygen-rich conditions, while the internalized cell gained protection. Over the course of evolution, these kinds of mutualistic relationships could become even more entwined. Together, the merged "cell" benefits from the combined attributes, allowing it to grow and adapt. In fact, the internalized cell (called an endosymbiont) may transfer some of its essential survival genes to the host cell, losing its ability to grow on its own and relying completely on the host. These so-called organelles perform vital functions; for example, mitochondria generate energy in oxygenated conditions within microscopic yeast and all human cells, and chloroplasts, which come from engulfed cyanobacteria, enable photosynthesis in plants. Chloroplasts in plants are another example, which come from engulfed cyanobacteria and enable photosynthesis. Several lines of evidence support these theories. Notably, mitochondria have their own DNA, of similar size and structure to bacteria. They also replicate on their own, have their own ribosomes, share similar membranes with certain species of bacteria, and transport proteins to them. Today, the theory of endosymbiosis is widely accepted, with these merger events thought to occur as far back as 1 to 2 billion years.

Within this chapter's pages are photographs of bacteria that evoke the imprints and traces left by the ancient microbial world. Various species of bacteria were grown on agar and photographed, and their images printed on handmade *washi* paper. By using species such as *Bacillus subtilis*, *B. mycoides*, *Proteus mirabilis*, and strains of the genus *Paenibacillus*, which are

(opposite)
Strains of *Bacillus* bacteria isolated from soil. The complex growth patterns reveal the dynamic interplay between these organisms.

collected from the soil, a habitat where fossils are found, we touch upon the organic connection and lineage of living things—for example, the origins of life through bacteria as ancient microbial ancestors, which then evolved into more complex cells containing endosymbiotic bacteria, and subsequently into more complex life-forms such as dinosaurs and humans, which each in turn harbor microbial communities.

The ongoing mostly mutualistic relationships with humans and other animals on the planet permeate nearly every aspect of our lives, ranging from our homes and the environment to even within our own bodies. Microbes are not only all around us but inside each and every one of our cells—and a part of our collective human story. Their presence reminds us of the interconnectedness of life-forms and the continuing evolution of life on earth, as well as the influence that microbes have on shaping the world around us. Searching for where life began leads to discoveries that upend our very notion of who our ancestors were, and how they relate to us today.

(following spreads)
P. mirabilis, *B. subtilis*, *B. pseudomycoides*, and *Paenibacillus* strains isolated from soil. This chapter's images, photographs printed on handmade *washi* paper and framed with hardwood, were created to evoke how life on earth evolved and is interconnected.

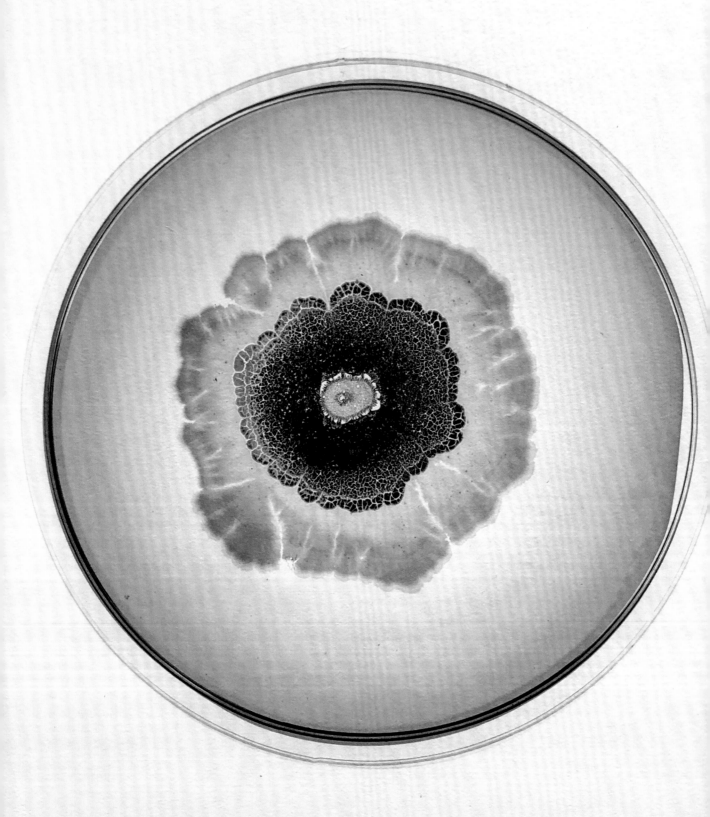

PROTEUS MIRABILIS

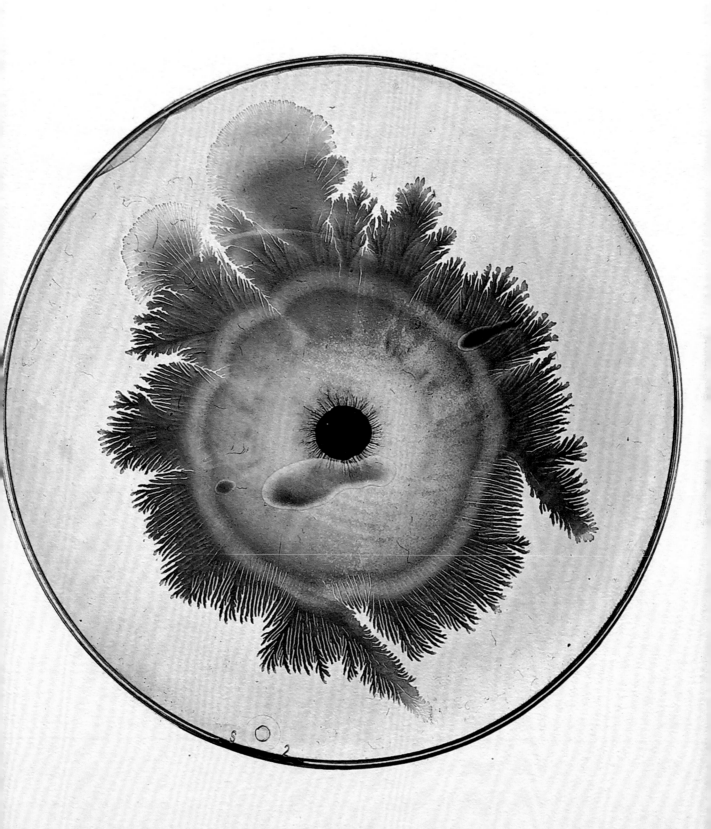

PAENIBACILLUS DENDRITIFORMIS

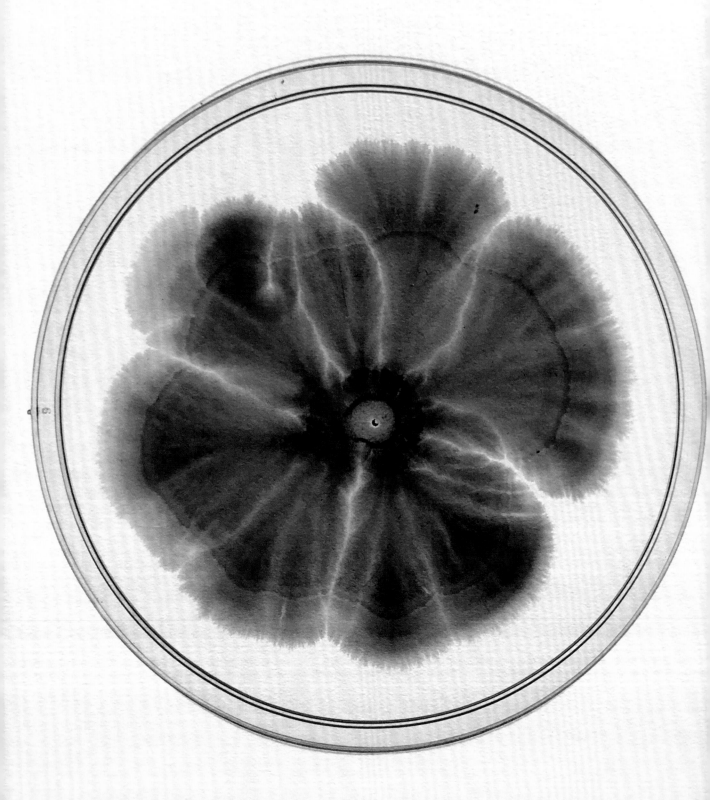

BACILLUS SUBTILIS

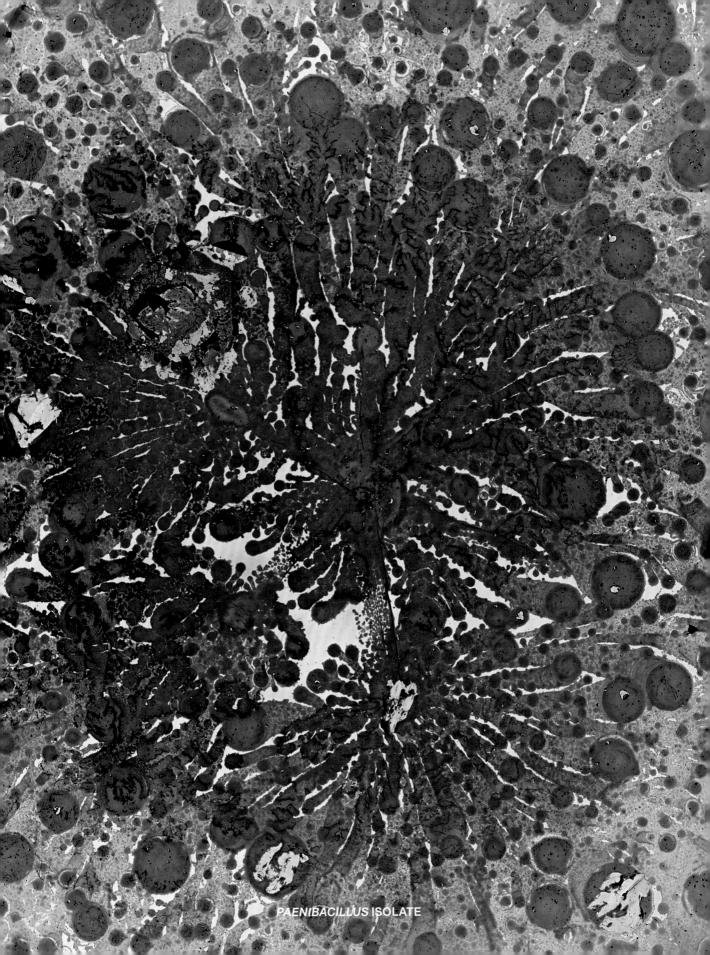
PAENIBACILLUS ISOLATE

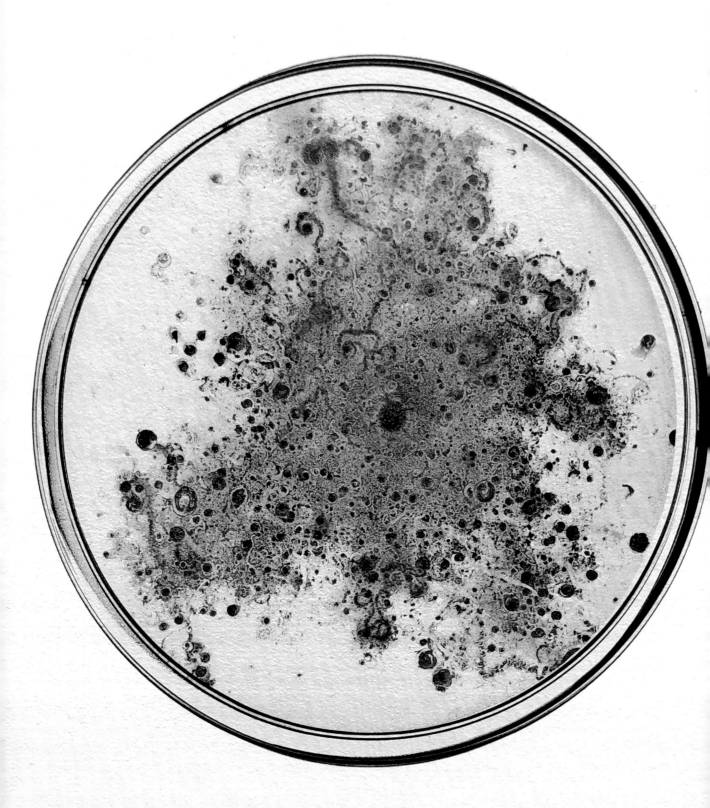

PAENIBACILLUS ISOLATE

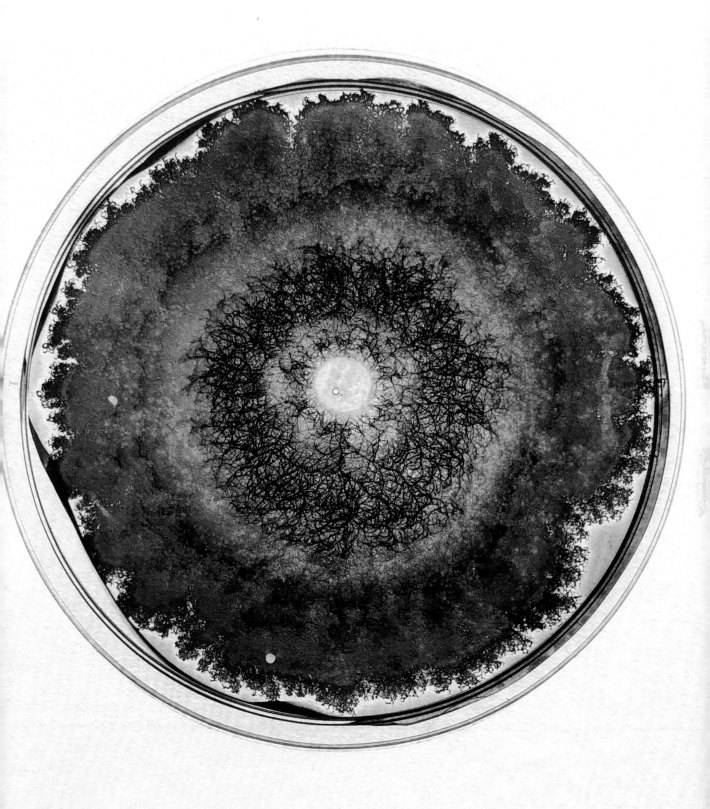

BACILLUS PSEUDOMYCOIDES

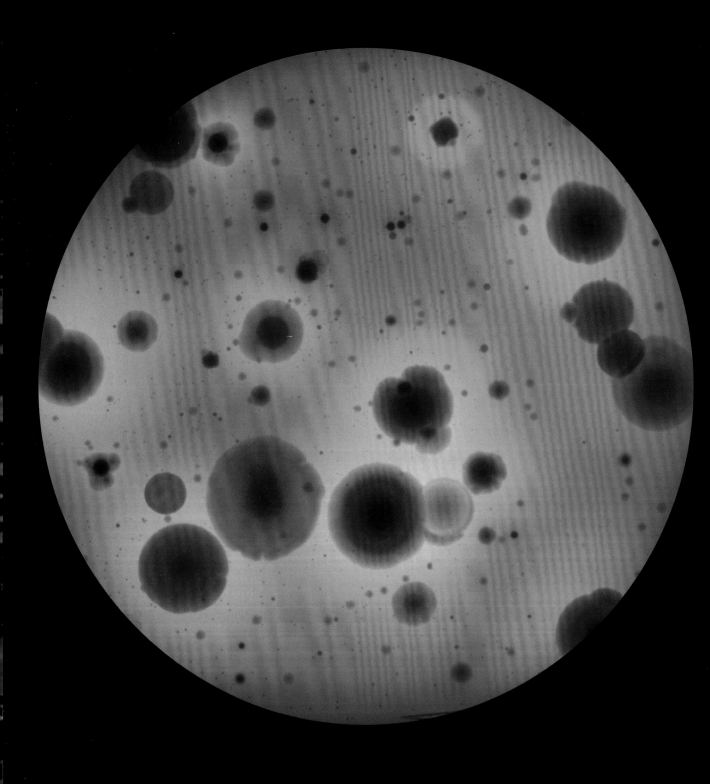

CH. 2

WONDERFUL TO BEHOLD
IDENTIFYING BACTERIA

Bacteria from drain water, grown on blood agar to help isolate fastidious organisms. The colonies' colors, morphologies, and sizes hint at the identification of about ten different species seen here.

In the seventeenth century, Robert Hooke noted: "I examined water in which I had steeped the pepper I formerly mentioned; and as if I had been looking upon a Sea, I saw infinite of small living Creatures swimming and playing up and down in it, a thing indeed very wonderful to behold." For centuries, the name behind these now-famous lines in one of the most important books in the history of science was forgotten. Today, Hooke and his *Micrographia* are recognized as pivotal to the study of the "minute world." A scientist and microscopy enthusiast, as well as a trained painter, Hooke is now often called "London's Leonardo," after the Renaissance polymath Leonardo da Vinci, who exemplified the interconnectedness of art and science.

Hooke took advantage of the then-new technology of microscopes, which enabled scientists to delve even deeper into the hidden world of tiny structures and organisms. He used a compound microscope consisting of two lenses that gathered light and magnified the image, and that had a focusing mechanism.

In 1665, furthering his meticulous observations of insects, plants, and other objects he had viewed under the microscope, Hooke published *Micrographia: or some physiological descriptions of minute bodies made by magnifying glasses with observations and inquiries thereupon*, which captured his detailed engravings. With the first published depiction of a microorganism—the microfungus *Mucor*, which we know well as "bread mold"—*Micrographia* became a sensation and spurred microscopic investigations by scientists and hobbyists throughout the world. This work was even said to inspire Antonie van Leeuwenhoek, a draper in Delft, whose scientific career was likely started by the use of a magnifying glass to inspect the quality of cloth. Leeuwenhoek developed unique, self-designed microscopes of superior quality (capable of 250x magnification, compared to 25x, common at the time), and later he became the first person to observe and describe what he called "animalcules" ("little animals")—or bacteria, which typically are only about one to two micrometers, or millionths of a meter, in diameter.

From these curious, passionate, and intellectually rigorous scientific explorers came the tools of microscopy and the practice of growing or "culturing" bacteria, leading to the field of microbiology—the study of the growth, behaviors, and characteristics of bacteria, algae, fungi, and other microbial organisms. Today, with instruments capable of more than one-millionfold magnification, microscopy assists with the identification of bacteria by revealing their shapes and lifestyles. Bacterial cells can be spherical (cocci), rod (bacilli), or other forms including helical, curved, and appendaged. How they grow and bundle together provides more information. Cocci can exist individually or in pairs (diplococci), strips (streptococci), or even clusters (staphylococci); this naming is quite useful when discussing bacterial species. For example, the naming of *Streptococcus pyogenes*, which causes strep throat, indicates that these bacteria live as strips of little spheres. (The latter part of the name indicates a descriptor, in this case, pus-forming.) Similarly, *Staphylococcus epidermidis* (which

is ubiquitous on the skin) is seen as clusters of spheres, and *Bacillus subtilis* (which is common in the soil) appears as rod-shaped cells. Each individual bacterium can also have "flagella," taillike structures outside its cell membrane that help it move up to forty microns—about ten times its body length—in one second (the equivalent of a human swimming the length of a swimming pool in that same amount of time). The flagella also indicate a species: some tails spread around the entire cell; others have a tail as a single strand or clustered on one side. These molecular motors help propel these tiny cells through their microuniverse, observed by anyone with a simple microscope.

Individual bacterial cells are small and transparent, making it difficult to visualize their intricate structures in detail. Therefore, scientists often "stain," or color, bacterial components for more reliable identification. In fact, Leeuwenhoek is credited with first using saffron to provide contrast and allow him to more clearly observe the more minute structures of cells. Since his time, scientists have developed procedures that utilize the way bacteria interact with dye molecules, from dyes taken up by only certain types of bacteria to those bounded by specific types of molecules (such as the supramolecular flagella) within microbes. One of the best-known examples is the Gram stain, which can help scientists differentiate between "gram-negative" bacteria such as *Escherichia coli* (better known as *E. coli*) and "gram-positive" bacteria such as *Bacillus* species (many probiotics).

Isolating, or differentiating, bacteria from a mixed population is critical to the process of identification. A key advance was the development of the petri dish by Julius Petri in 1887, a researcher in Robert Koch's lab. (Koch developed germ theory, connecting specific microbes to specific

(opposite, top) A single colony of *Pseudomonas aeruginosa*, a common pathogenic bacterium, on a cetrimide agar plate. An antimicrobial molecule on the agar inhibits the growth of other bacteria.

(opposite, bottom) *Escherichia coli* bacteria grown on Hektoen Enteric (HE) agar. This agar's indicators and selective agents allow for the identification of specific enteric pathogens, which affect the intestines.

diseases, and discovered the bacteria that cause tuberculosis, cholera, and anthrax.) While microbiologists were struggling for years to keep environmental bacteria out of their cultures, Petri developed a dish with an overlapping lid, making it difficult for contaminants to get in but allowing oxygen to get through. Furthermore, bacteria in dishes could be grown upside down, further reducing risk of contamination, as well as preventing water condensation.

Most of the petri dishes used for the cultures featured in this book are a standard 10 centimeters (4 inches) in diameter. Some in Chapter 8 are square, and a few of those are larger (30 centimeters, or 12 inches, in width). The basic components of a petri dish include a warm liquid containing agar, a jellylike substance that comes from seaweed and certain species of red algae. Nutrients, typically consisting of peptides, vitamins, salts, and minerals, are added to this mixture and dissolved to allow for growth of bacteria. It is then sterilized by heating it to high temperatures to kill any germs, originally through a process developed by Louis Pasteur (called pasteurization); more recently, autoclaves are used to achieve higher temperatures to kill any resilient spores. The sterile mixture is then cooled and poured into the dish to solidify.

At the Danino lab, we commonly use Lysogeny broth (LB), a rich nutrient medium that has a yellowish tint and is used to grow bacteria like *E. coli*. The mixture of these nutrients and agar is cooled to room temperature and forms a solid gel surface for bacteria to grow on. However, many species of bacteria, particularly those that grow in the body, prefer other nutrients. Alternative nutrients for these so-called fastidious (or "picky") organisms include blood agar, which contains a fraction of

sheep's or cow's blood and has a striking red appearance; what is known as chocolate agar, a blood agar that has been heated to release extra nutrients for bacteria, and has a brownish hue; and potato agar, prepared by boiling and mashing potatoes and adding dextrose and agar, which is used for cultivation of fungi and some bacteria. Other species can grow naturally only in low-oxygen conditions (such as in the colon), requiring not just specific adjustments but also incubation of petri dishes in low-oxygen environments in the lab. Further still, many bacteria are not culturable, preferring not to grow in petri dishes at all.

To isolate specific bacteria, a sample is diluted in a petri dish by a process called "streaking." A sterile wand or swab is touched to the sample (such as water collected from the environment, or a part of the human body) and spread onto part of the gel in the bacterial dish. Then a fresh wand or swab is touched to the initial sample on the dish and "streaked" across another part of the dish. The process is repeated, each step serving to dilute the original sample until fewer bacteria are present in each "streak," allowing for a single species of bacteria to replicate, essentially cloning itself into

a colony. This colony can then be picked easily and grown in a broth of nutrients for further study.

Some agars provide nutrients for only certain species to grow, so they can be used to isolate and identify specific bacteria. For example, cetrimide agar selects for species of *Pseudomonas*. Others include HiCrome, De Man, Rogosa and Sharpe (MRS), and Hektoen Enteric (HE) agar, as well as dozens more. To help identify or determine viability, microbial dyes can be added to petri dishes; by turning color or fluorescing, they measure bacterial metabolic processes. Other dyes are activated in the presence of specific metabolic enzymes, signaling to researchers, with a multitude of displays of colors, fluorescence, or luminosity, the ability of an enzyme to metabolize lactose, for example. Dyes and additives are used to stain the agar as well—such as the aforementioned blood agar, and black agar, which contains activated charcoal, providing a high-contrast background that can be used to enhance detection of slow or small colony-forming microbes.

Lastly, the morphology of colonies in and of itself provides clues to identifying bacteria. Colonies are typically circular, meaning they grow out radially and symmetrically. But due to their interactions (explained in detail in Chapter 3), they can also be irregular or asymmetrical; filamentous or sparse, growing and spreading out more than a dense colony. From the profile view, these same colonies can have raised elevations that are flat, convex,

(opposite, top)
An *Enterococcus* colony grows radially from the center of a Hektoen Enteric (HE) agar plate.

(opposite, bottom)
A single colony of *Bacillus subtilis* isolated from soil and grown on black agar. Here, the growth medium enhances the contrast of colony features.

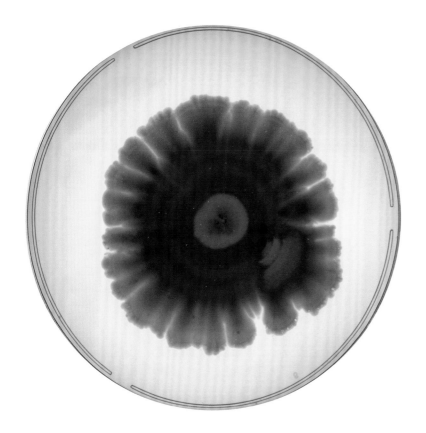

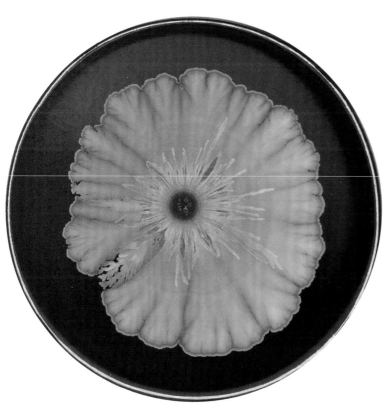

or marked by bumps or craters. They can reflect light differently, appearing glistening, opaque, transparent, or pigmented, with variations along the colony surface or margin as they grow outward. Descriptive as these colony morphologies are, it can still be challenging to identify species of bacteria, based on morphology alone. Thus, modern approaches to identification often rely on DNA sequencing. A colony can be identified based on variations in a slowly evolving gene that almost all bacteria have (16S rRNA). By sequencing this gene and comparing it to collected sequences in a reference database, we can obtain at least an approximate identification. Often the isolates we collect have no known match, but a closely related strain or species in the same family can be identified. For more thorough identification, the entire genome of a bacterium can be sequenced.

The process of characterizing bacterial species has been an ongoing journey of scientific exploration and interdisciplinary breakthroughs spanning centuries. And art has played an important role too—the drawings of Robert Hooke in *Micrographia* were key to sparking scientists' imaginations across many fields. Albert Einstein reflected on this intersection of art and science throughout his lifetime and acknowledged how great achievements in science often start from intuitive knowledge—which is often associated with the arts. As he said, "The greatest scientists are always artists as well."

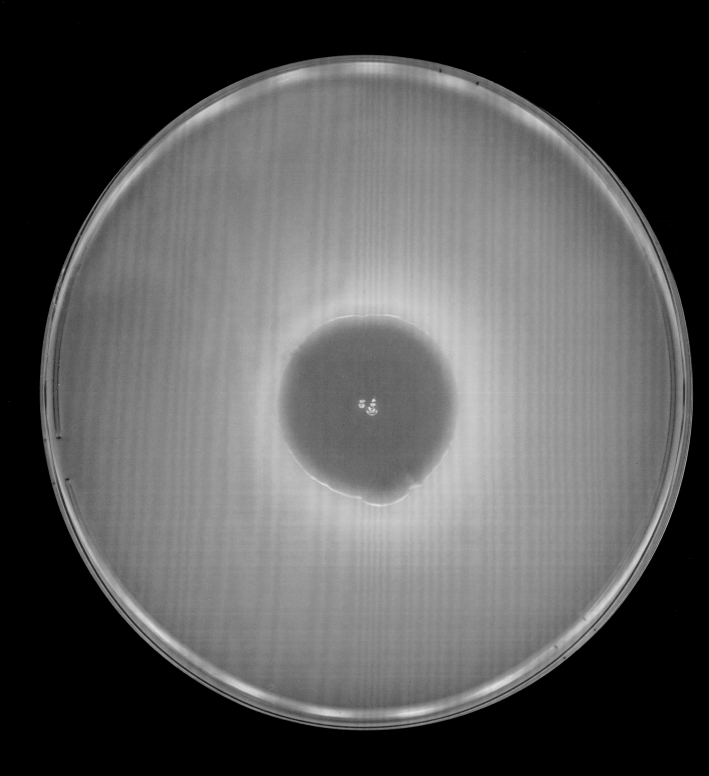

ENTEROCOCCUS ON HEKTOEN ENTERIC (HE) AGAR

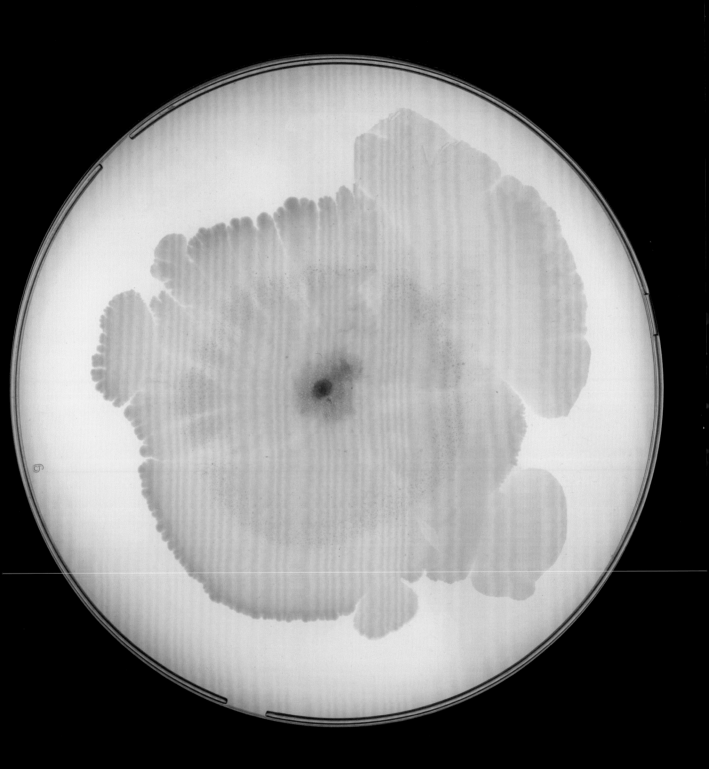

PSEUDOMONAS AERUGINOSA ON HEKTOEN ENTERIC (HE) AGAR

A close-up of a single colony. HiCrome agar's substrates react with specific enzymes produced by certain bacteria, which then form colored colonies.

BACILLUS SUBTILIS ON HICROME AGAR

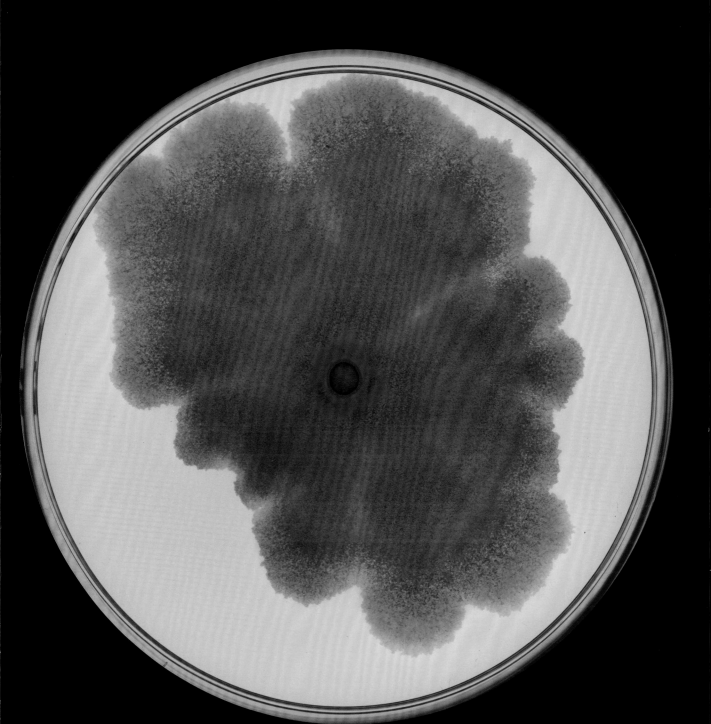

This species commonly grows in the soil. Here it produced distinct swarming morphologies, with the cells moving together as a group.

(top to bottom, left to right) **Pond water; Mumbai water; plant isolate; drain water; Mumbai water; garden soil**

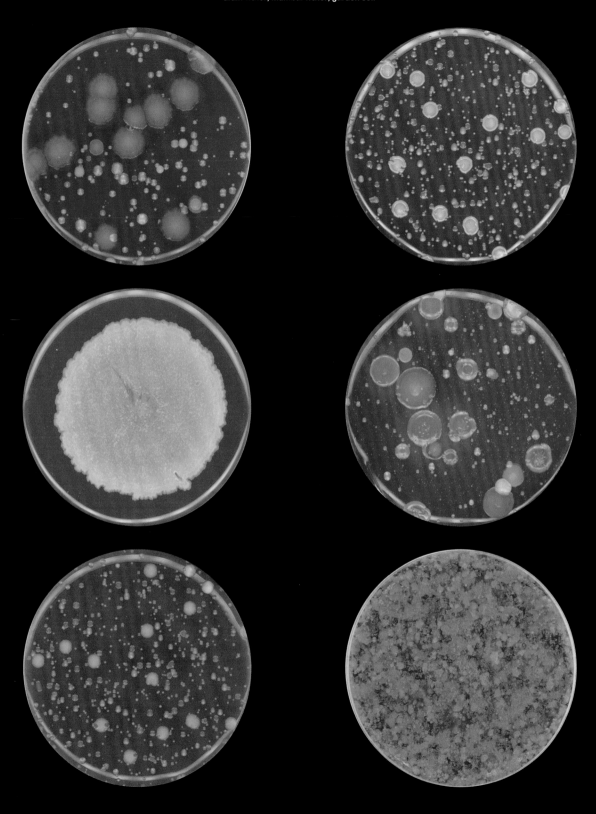

BACTERIA ON BLOOD AGAR

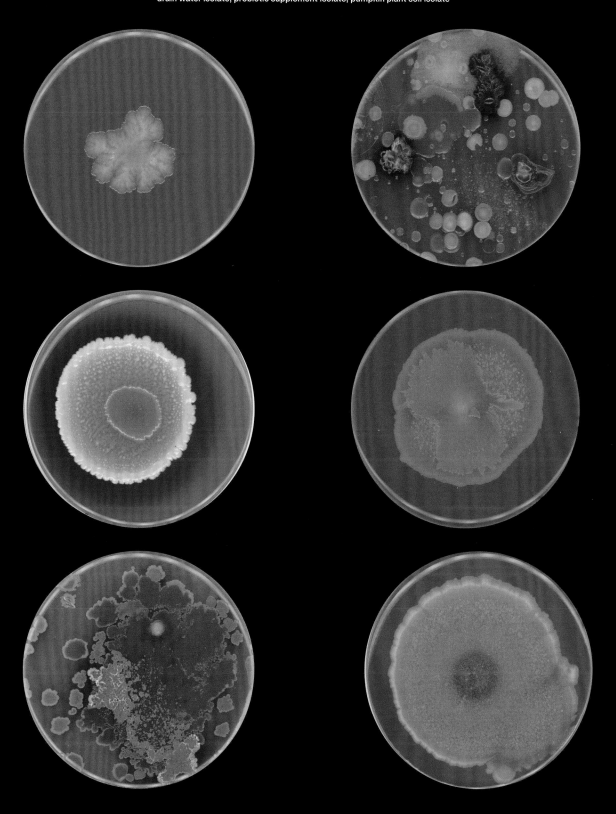

(top to bottom, left to right) ***E. coli***; Venice Beach, California, sand; drain water isolate; drain water isolate; probiotic supplement isolate; pumpkin plant soil isolate

BACTERIA ON CHOCOLATE AGAR

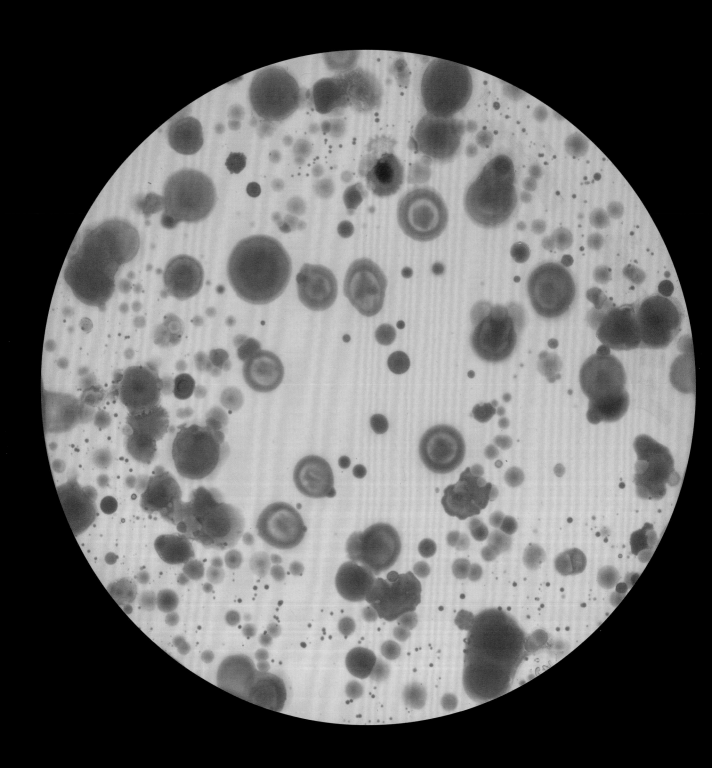

DRAIN WATER ON POTATO DEXTROSE AGAR

39

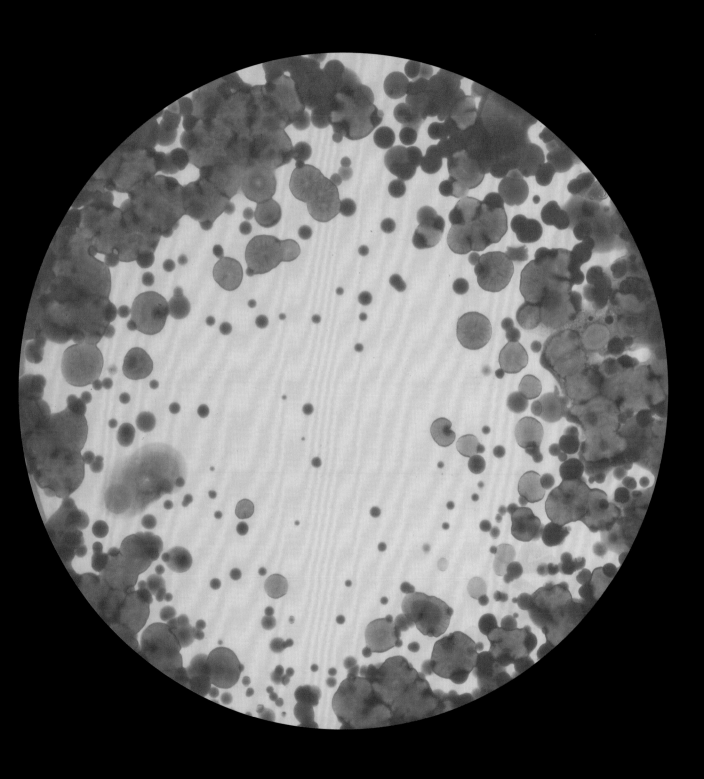

WATER FROM RAJASTHAN, INDIA, ON POTATO DEXTROSE AGAR

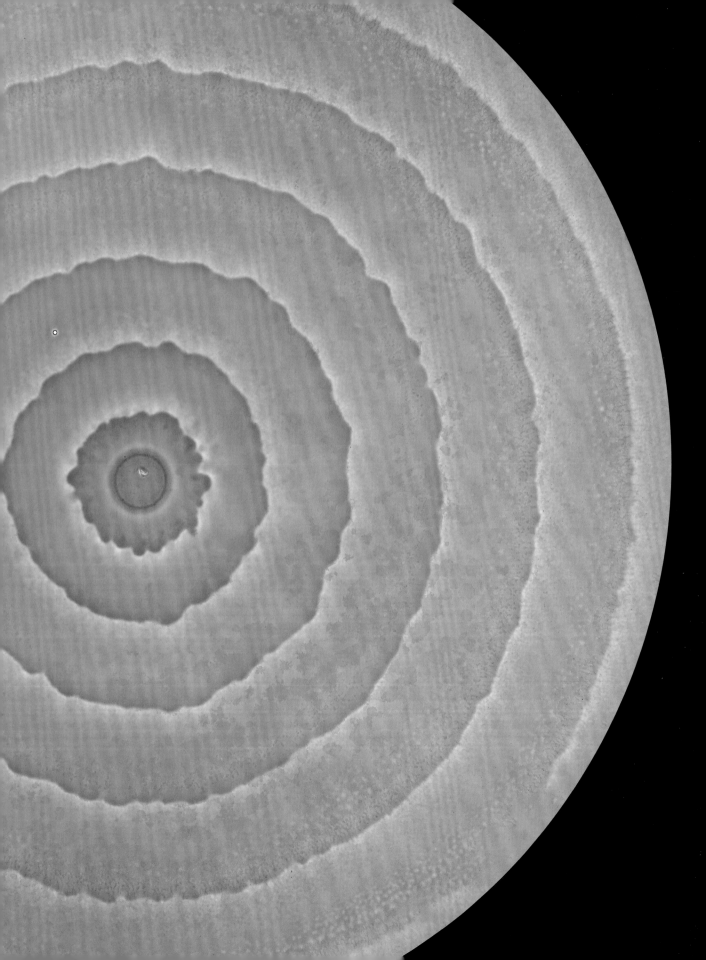

CH. 3 *GROWTH AND EMERGENCE*
SINGLE CELLS
TO COMPLEX COLONIES

Proteus mirabilis grown at 30°C (80°F) for twenty-four hours on solid agar. From the center of the petri dish, cyclical rounds of swarming and resting create the colony's "bull's-eye" pattern.

How does one bacterium not even one-quadrillionth of our size have such an outsize impact on the world and our bodies? Bacteria act not just as single entities but as a community to coordinate certain behaviors—such as their amazing growth patterns seen in petri dishes. While composed of only a single, seemingly simple cell, an individual bacterium is incredibly sophisticated. It actively senses and responds to its surroundings, metabolizes nutrients, reproduces, and moves through its environments. But bacteria are not solely individual entities; they also can act together, communicating and coordinating with one another, leading to the emergence of highly intricate behaviors that are far more complex than any single bacterial cell can perform.

Each bacterial cell consists of a few key components. The cell contains a milieu of molecules and cellular structures necessary for metabolism, growth, and replication. The cell membrane acts as a barrier and regulates the passage of substances in and out. On this membrane, many bacteria possess flagella, or long stringlike appendages that whirl around and propel cells forward. Some species also have pili and fimbriae—hairlike structures extending from the surface that help them attach to surfaces or other bacteria.

Bacteria use their flagella, tails that they spin around, for two types of motion: "runs" and "tumbles." During a "run" phase, bacteria move in a relatively straight path driven by their flagella, useful for exploring the environment and moving toward nutrients, which they may sense due to a gradient in concentration. In the "tumble" phase, they randomly spin around like a carousel, which helps them orient and figure out which direction to go. Together, these two motions optimize their response to their surroundings, and for many bacteria these happen in seconds—meaning this microbial movement can be visualized in real time with simple microscopes (much as Leeuwenhoek observed centuries ago; see Chapter 2).

While run-and-tumble motility is most efficient in liquid environments, certain bacteria can move on a solid or gel-like surface, such as in a petri dish, by another

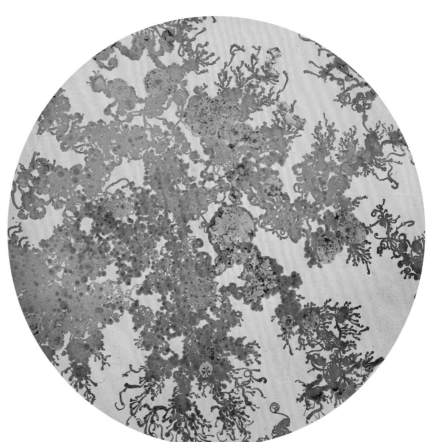

type of motion called "swarming." Swarming motility can be defined as a rapid multicellular migration across a surface that involves flagella—meaning that cells bundle together and move as a group over a surface, perhaps even with a twitching, gliding, or sliding motion.

One feat of swarming is done by a species of bacteria called *Proteus mirabilis*. *P. mirabilis* is named for the Greek god Proteus, who had the ability to foretell the future. In Homer's *Odyssey*, Proteus was highly sought-after, and he changed forms to avoid capture. As early as 1885, "Proteus" was used to describe bacteria that changed shape, shifting from short rods typical of bacteria to long, multinucleated cells with thousands of flagella that they use to coordinate movement. *P. mirabilis* is found widely in soil and water, and also in human gastrointestinal tracts. *P. mirabilis* is a leading agent of many diseases, most notably the cause of almost half of catheter-associated urinary tract infections (CAUTIs).

One of the reasons why *P. mirabilis* is unique is that it forms a bull's-eye pattern when grown in a petri dish. This is related to its ability to swarm across the surface via sequential rounds of normal rod-shaped cells differentiating into "swarmer cells." Swarmer cells are much longer than normal cells; they produce high levels of flagella, intercellularly communicate, and begin to secrete a surfactant to make the agar more slippery for rapid movement. These individual cells then align into "rafts" by bundling their flagella together to quickly move across a surface. After this

migration, which could take a few hours or a few days, cells return to their normal state, reduce motion, and grow into denser colonies. The ring patterns are generated by the cyclical, synchronous repetition of this process from an initial bacterial colony.

A form of chemical communication called quorum sensing regulates many swarming and coordinated behaviors in bacteria. Understanding bacterial communication originally came through observations of the Hawaiian bobtail squid, a nocturnal animal that lives in the shallow waters in the Pacific Ocean. When this squid emerges at night to feed, moonlight can cast its shadow on the ocean floor, which predators can easily track. In response, the squid has developed specific organs to harbor bioluminescent *Vibrio fischeri* bacteria. In exchange for feeding and housing them, the bacteria produce luminescent glowing substrates that produce light. The light is useful because it matches the moonlight, obscuring the squid's shadow from below. Because of this symbiosis with microbes, the

squid is able to add an additional layer of "camouflage" and efficiently defend against predators.

Many other species form intricate patterns on growth mediums in petri dishes as well, such as *Pseudomonas aeruginosa* and other soil bacteria, which can be coaxed into different forms under certain conditions. *P. aeruginosa* exhibits large, unique tentacles (also known as dendrites or tendrils) spreading uniformly across the surface. During the process of spreading, it is believed that individual dendrites undergo expansion and repulsion from one another, driven by the interplay of two secreted molecules. Other bacteria, such as soil-dwelling *Paenibacillus*, form "fractal-like" patterns in petri dishes. Specifically, two pattern-forming species, *Paenibacillus dendritiformis* and *Paenibacillus vortex*, make spiraling vortices composed of localized groups of cells traveling in a common circular path. In the case of *P. vortex*, the combination of swarming and their naturally curved cell shape may be responsible for the distinctive vortex pattern. In some forms of *P. dendritiformis*, colonies can exhibit "chirality," meaning they will spiral in only one direction, either clockwise or counterclockwise, which may be a result of the underlying turning mechanism of bacterial flagella.

To create this chapter's images in the Danino lab, we placed a drop of bacteria at the center of a petri dish (sometimes you can see where it was touched to the dish). A single drop can contain about a million bacteria, which begin to rapidly divide into so-called daughter cells. Most bacterial species that we use double into two daughters every twenty to thirty minutes at 37°C (98.6°F). This initial spot often grows and gets denser, and then some

bacteria begin to move outward, swarming or spreading by growth. The swarming patterns depend on the particular species, as well as the temperature, humidity, and density of the gel surface.

Swarming abounds in the macrouniverse as well, from ant and honeybee colonies to fish schools and bird flocks. The common thread is the collective behavior of a group of entities—a decentralized yet organized prime directive that enables communities to coordinate for survival. These can be expressed in visual displays that have an otherworldly beauty, from starlings' murmurations to *P. aeruginosa*'s delicate tendrils, their patterns evoking snowflake formation or animal coat patterns described by elegantly simple mathematical equations (most famously, by Alan Turing). In the case of living microbial cells, though individually identical genetically, a single cell contains the instructions to produce complex interactions that lead to the emergence of "intelligent" behavior, or at least behaviors not readily expected from observing a single cell. Together, these phenomena demonstrate the capacity of microbes to transcend individuality and manifest collective intelligence in their pursuits.

(opposite)
Paenibacillus lautus isolated from California beach sand and grown under pattern-forming conditions, then stained with food coloring.

(following spread) Time-lapse photography of *Proteus mirabilis* growth in a petri dish. From an initial spot, the microbes synchronously swarm outward and pause, repeating this sequence to create a bull's-eye pattern.

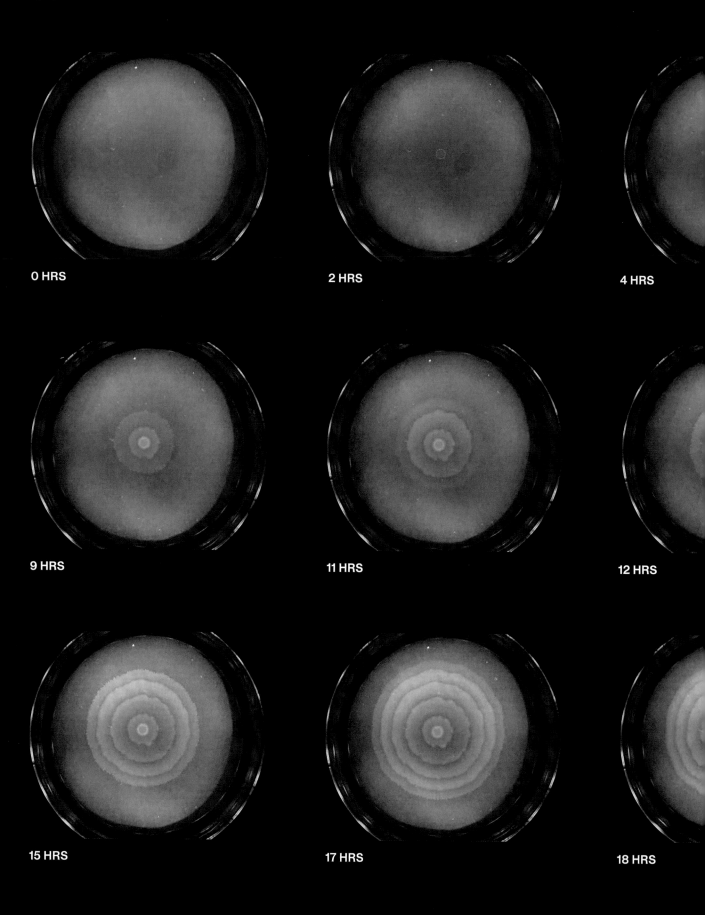

0 HRS

2 HRS

4 HRS

9 HRS

11 HRS

12 HRS

15 HRS

17 HRS

18 HRS

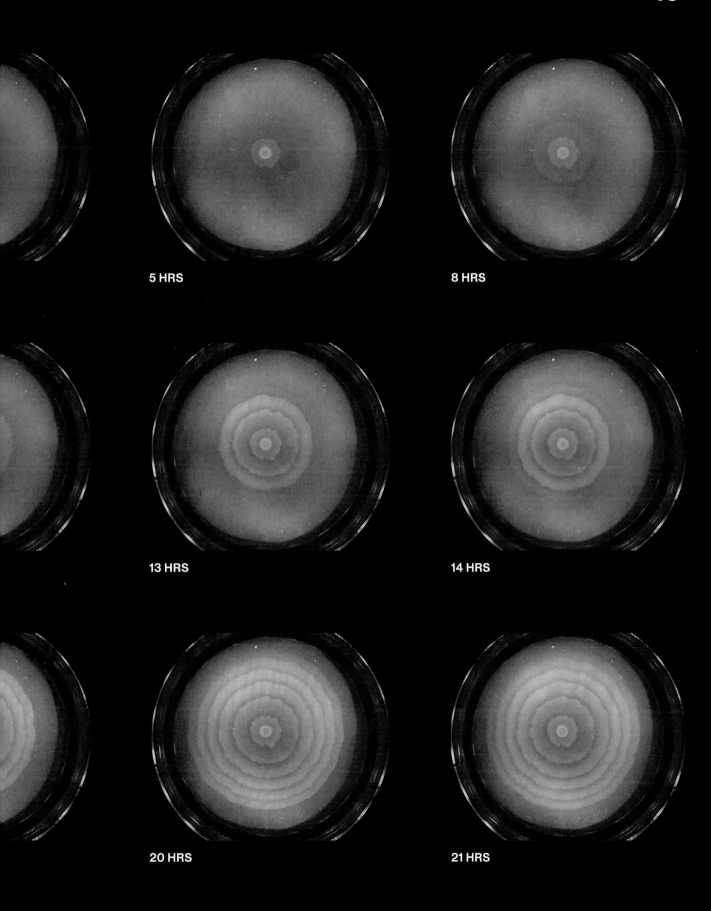

5 HRS

8 HRS

13 HRS

14 HRS

20 HRS

21 HRS

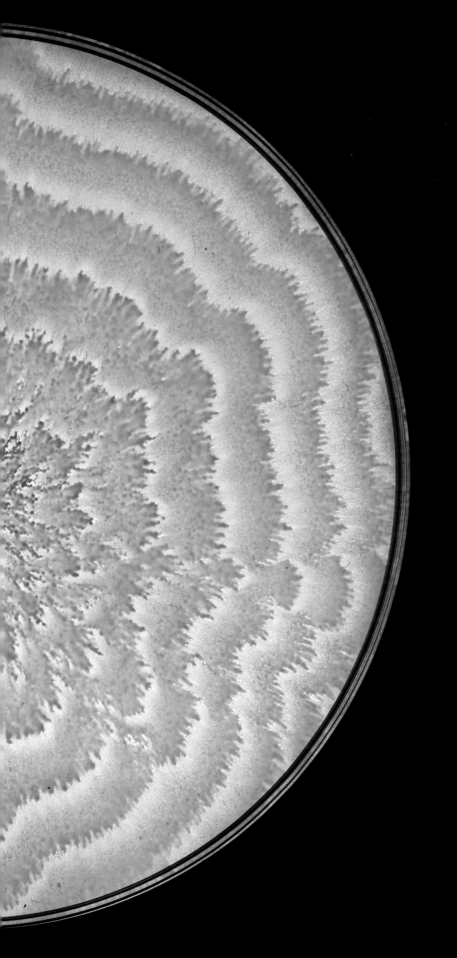

Proteus mirabilis
engineered to produce
extra proteins that
inhibit swarming,
which makes its ring
patterns "spikier."

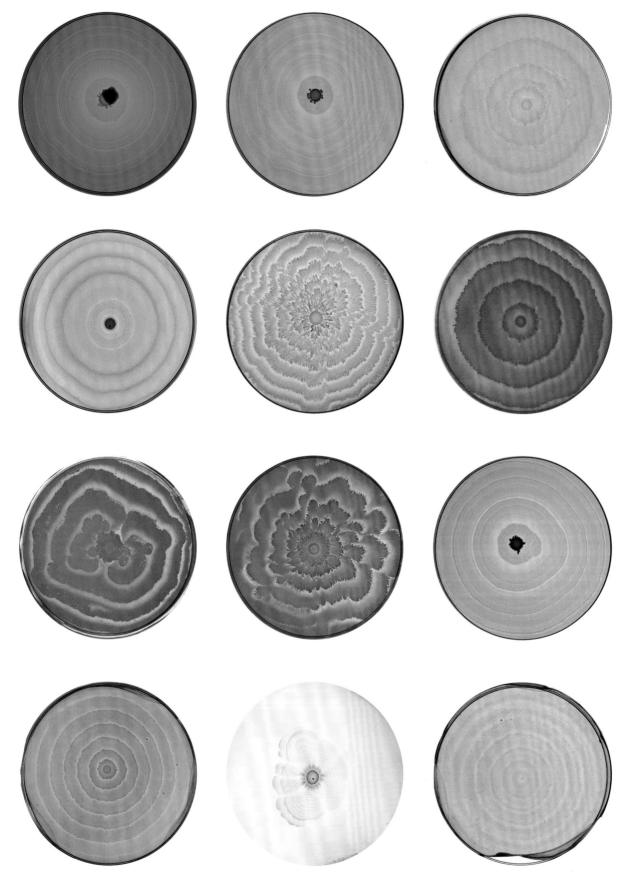

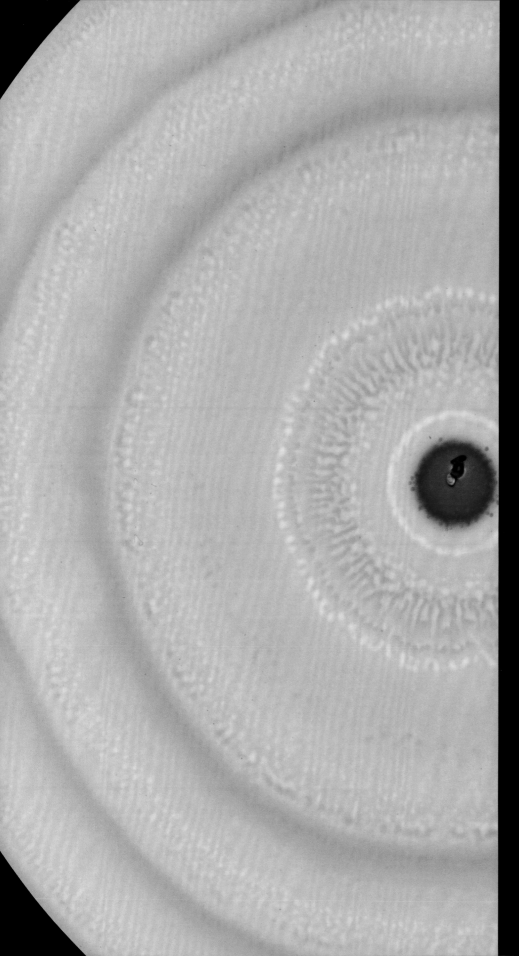

Proteus mirabilis swarming's clock-like timing and consistency of ring formation suggest application as a recording system, similar to the way a growing tree records information in the rings in its trunk. *P. mirabilis* can be engineered to sense various stimuli such as copper, which is a water contaminant, and change its swarming process. The end result, stained for visualization, is a system that can visibly "write" information about levels of a contaminant onto a petri dish.

(this spread and following spread) Collection of *Proteus mirabilis* strains grown in petri dishes and dyed with various colors. Each strain has been engineered to produce additional proteins that influence the type of pattern produced.

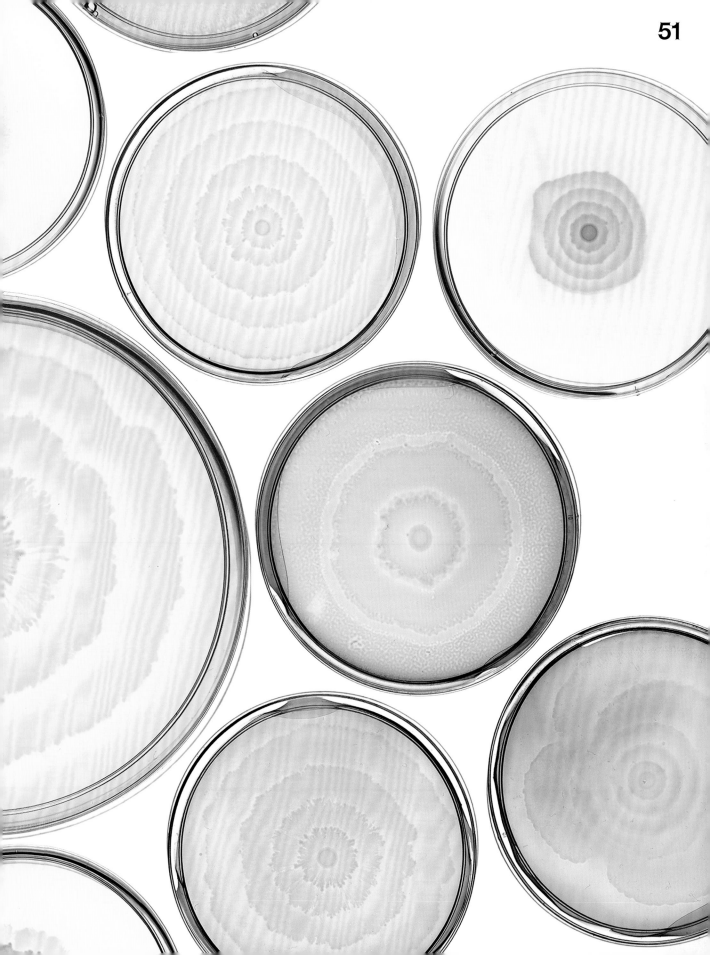

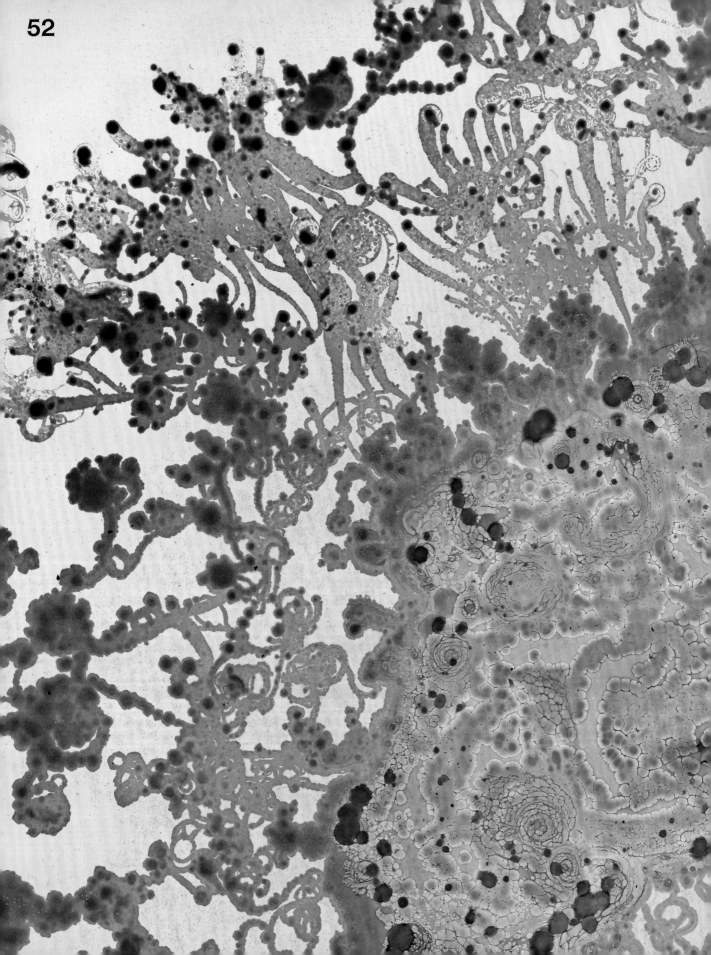

Two different isolates of *Paenibacillus* bacteria from California beach sand. As these species swarm, they form localized clusters in "fractal-like" patterns.

PAENIBACILLUS

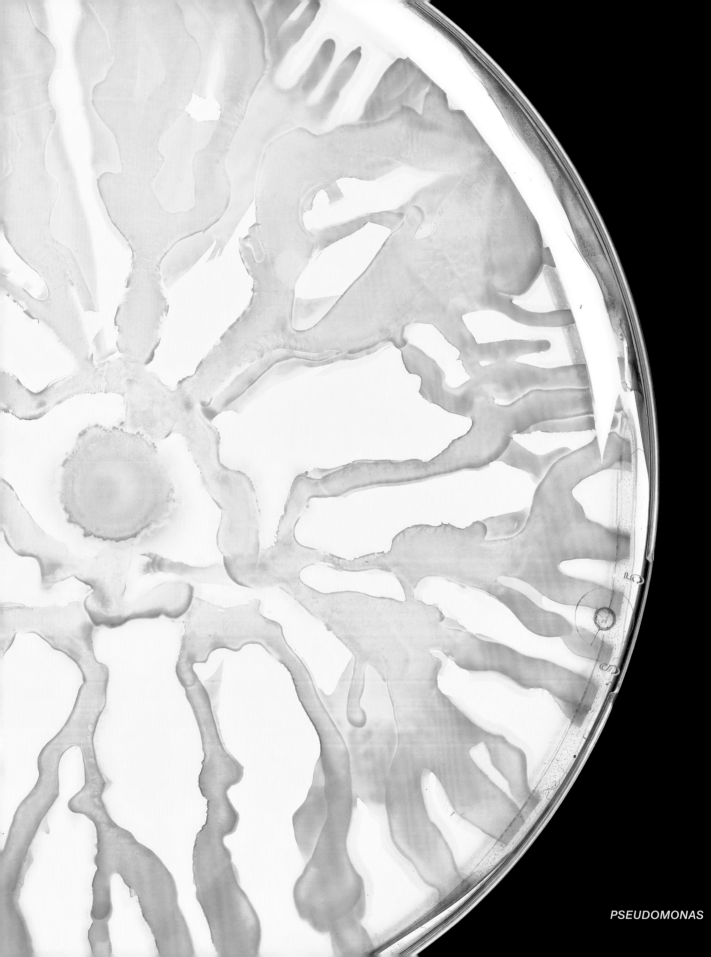

PSEUDOMONAS

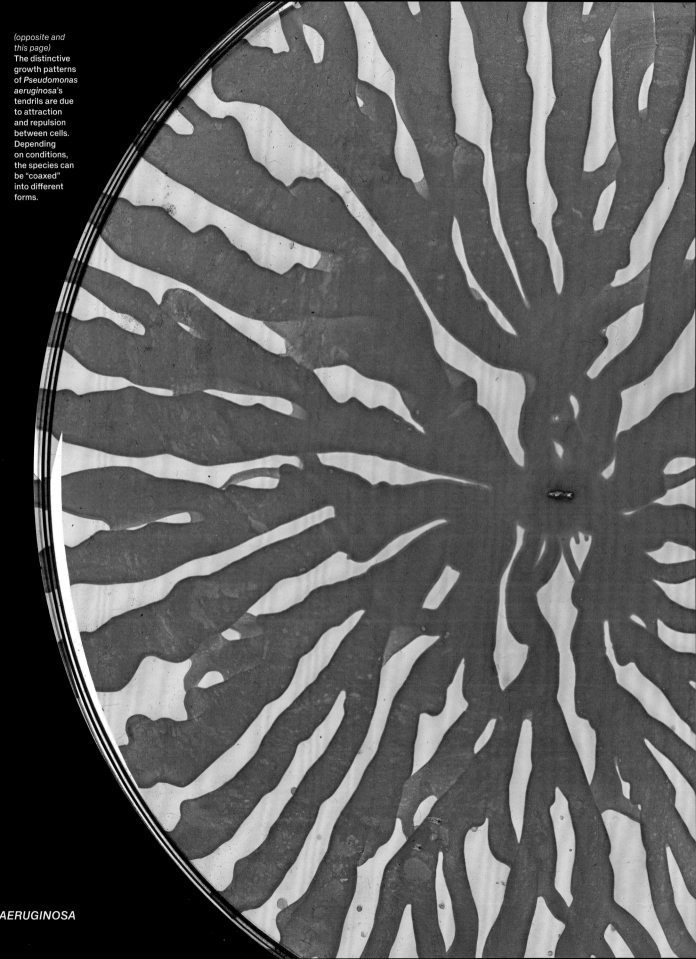

(opposite and this page) The distinctive growth patterns of *Pseudomonas aeruginosa*'s tendrils are due to attraction and repulsion between cells. Depending on conditions, the species can be "coaxed" into different forms.

AERUGINOSA

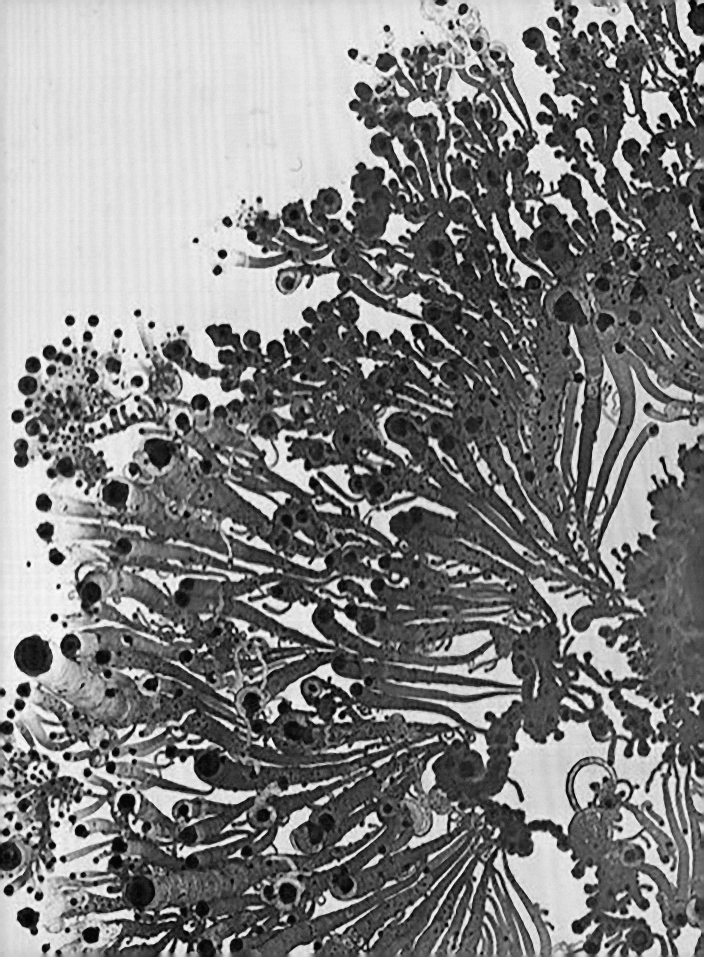

Isolated from sand and grown in a petri dish, *Paenibacillus lautus* forms complex colony structures.

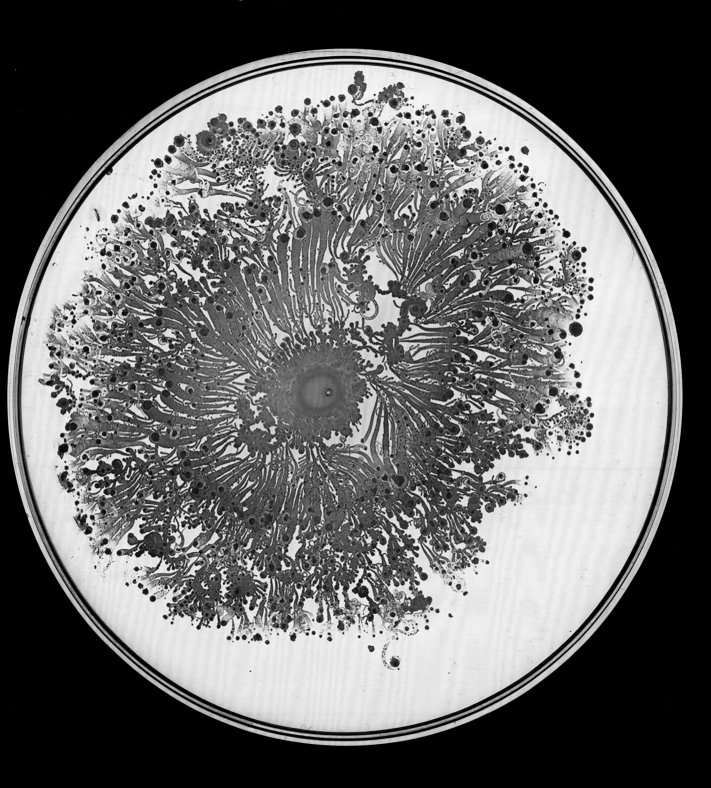

PAENIBACILLUS LAUTUS

EACH LIVING CREATURE
MUST BE LOOKED AT AS A MICROCOSM—
A LITTLE UNIVERSE, FORMED OF A
HOST OF SELF-PROPAGATING
ORGANISMS, INCONCEIVABLY MINUTE
AND AS NUMEROUS AS THE STARS
IN HEAVEN.

Charles Darwin, *The Variation of Animals and Plants
under Domestication* (1868)

PART

2

BACTERIA
WITHIN US

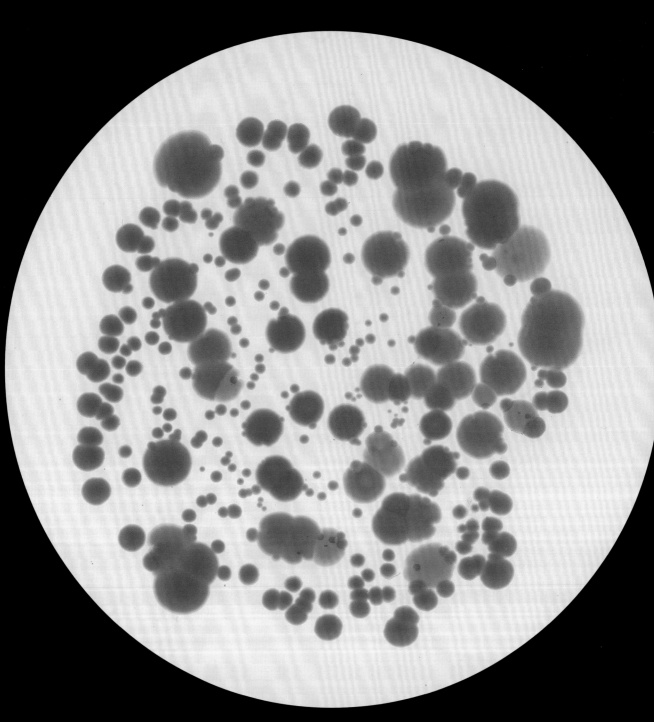

CH. 4 *FIRST ENCOUNTER* BEFORE BIRTH

A sample grown from breast milk, after three days. The varieties of colors and shapes portray a number of bacterial species found in skin, milk, and environmental microbiomes.

There are trillions of bacteria in and on our body—far more than there are stars in the galaxy. The majority of the microorganisms on our bodies are bacteria (more than 99 percent), yet, fortunately for our own survival, most microbes that the human body encounters do not generally cause disease. Our bodies provide rich environments for these microbiota, whose collective genes compose the diverse microbiomes such as those in our gut and on our skin. We carry these teeming bacterial communities throughout our lives, and we encounter their effects even before we meet our parents.

When are we first exposed to microbes? This very question has been debated in scientific circles. In 1900, French pediatrician Henry Tissier and others declared babies in the womb to be sterile, or free from bacteria—which is a logical conclusion given their assertion, based on research at the time, that otherwise a fetus would not be able to survive bacterial attacks. More recently, some researchers point to studies showing the presence of bacteria (as measured by DNA, and sometimes culturing of microbes) in the placenta, amniotic fluid, and meconium (early stool from a fetus)—findings that others say are inconclusive. However, increasing evidence suggests that there is a first encounter in the womb with something *produced* by microbes.

In the course of their growth cycle, the bacteria in the mother's gut chew up sugar molecules and in turn create waste molecules, called metabolites. These are tiny enough to cross from the mother's gut into the bloodstream to reach the fetus. These molecules influence how a growing fetus and its immune system develop. For example, acetate molecules produced by a mother's microbiota have been shown to "imprint" the fetal immune system, which shapes and enhances immune responses later in life (in this case, the generation of regulatory T cells in adults, which can protect against asthma).

Our first major exposure to bacteria is during birth. As a baby is born, the body is exposed directly to bacteria through the immediate environment, either by

Vaginal samples grown in oxygen or aerobic *(top)*, and no-oxygen or anaerobic *(bottom)*, conditions. These portray the distinct anaerobes common in a mother's vaginal microbiota.

microorganisms in the mother's vaginal canal or, in the case of a C-section, by common skin and environmental microbes. The skin and gut of vaginally delivered infants are often initially enriched by the *Lactobacillus* species present in the mother's vaginal microbiota. *Lactobacillus* is a genus of rod-shaped bacteria that make lactic acid through fermentation. They are commonly found in the human gastrointestinal tract and are known for their beneficial effects on gut health and digestion. (They are also widely used in the production of fermented foods as well as probiotic supplements.) In contrast, the skin and gut of babies delivered by C-section have more common skin and environmental microbes such as *Staphylococcus*, *Streptococcus*, or *Propionibacterium*. These genera include species that are generally part of the normal human microbiota, though under certain conditions they can also cause a range of infections. Whether *Lactobacillus* or *Staphylococcus*, these microbes are the pioneers, seeking out nutrients, establishing colonies, and creating generations of microbial strains that grow ever more diverse as the child grows, comes into contact with other microbes, and develops an immune system.

Pioneering species of microbes are adaptable, often able to grow in either low- or high-oxygen conditions (called facultative anaerobes). They deplete the oxygen and set the stage for bacterial species that are intolerant of oxygen (called obligate anaerobes), in a type of "microbial succession." When bacteria are grown in petri dishes, they are exposed to oxygen, which thereby already, in a sense, preselects the kinds of bacteria that are seen. (Growing them in low- or no-oxygen conditions is also possible but more technically challenging; examples of a vaginal sample grown in high or low oxygen are shown at left). These pioneers initiate the baby's microbiome over the first few weeks of life and open the door for

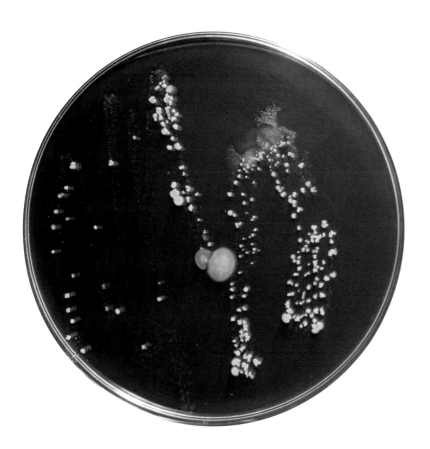

A sample from a mother's nipple shows bacteria such as *Staphylococcus epidermidis*, part of the normal human microbiota.

a more diverse bacteria population, which takes residence in specific parts of the body.

The most dramatic transition occurs shortly after birth, when the infant's gut biome completely changes. In part, it is in what the baby eats. With direct breast-feeding, microbes such as *Staphylococcus*, *Streptococcus*, *Lactobacillus*, and *Bifidobacterium* are transferred from the skin of the mother or through the milk, which floods the baby's gut with microbes. Breast milk has an incredible microbial diversity, with more than two hundred strains of bacteria. These are instrumental in creating an intestinal environment that may be helpful in reducing pathogenic exposures.

Sampling a newborn's diaper reveals early colonizers, species of *Bifidobacterium* that are the dominant bacteria present in an infant's gut during the first few months of life. These species are well adapted to the infant gut and compete against other, possibly more dangerous microbes, serving not only to protect the infant from pathogens but also to help break down the complex sugars in the mother's milk. *Bifidobacterium infantis* in particular is a uniquely evolved species that rapidly grows when fed human milk oligosaccharides (HMOs), or chains of up to several simple sugars, present in breast milk and some infant formulas. However, its presence in the human gut is short-lived, as it dies out when a baby stops feeding from a source that contains HMOs.

Once a baby starts eating solid foods, the gut microbiome dramatically changes again, and it becomes a more stable community. By the end of the first year of life, the *Bifidobacterium* species that were dominant give way to a mixture of *Clostridium*, *Bacteroides*, and *Bifidobacterium*. The phylum *Firmicutes* (controversially renamed *Bacillota* in 2021) grows more abundant, while the numbers of *Bifidobacterium* wane, converging toward the average adult healthy microbiome typically dominated by *Bacteroidetes* (also renamed in 2021, as *Bacteroidota*) and *Firmicutes* by

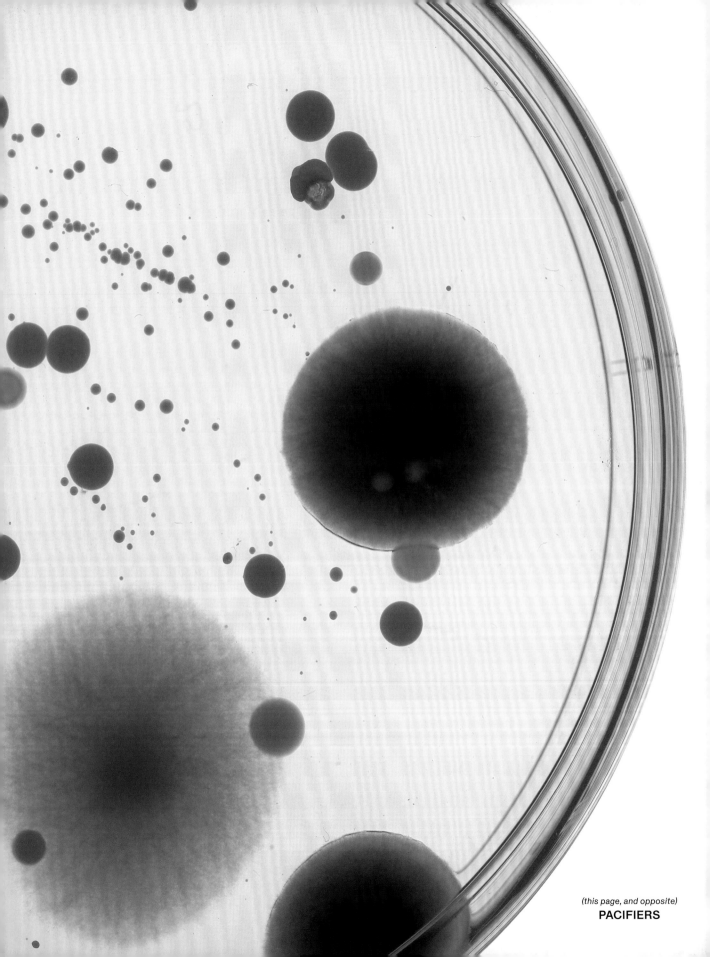

Parenting habits are a natural source of microbes for newborns. For example, the practice of sucking on a baby's pacifier to clean it has been associated with a distinct oral microbiota in the infant. In a study of 184 families, children whose parents cleaned their pacifier by sucking it were less likely to have asthma, eczema, and sensitization at eighteen months of age than children whose parents did not, perhaps supporting the idea that equipping infants with our own microbes can be beneficial.

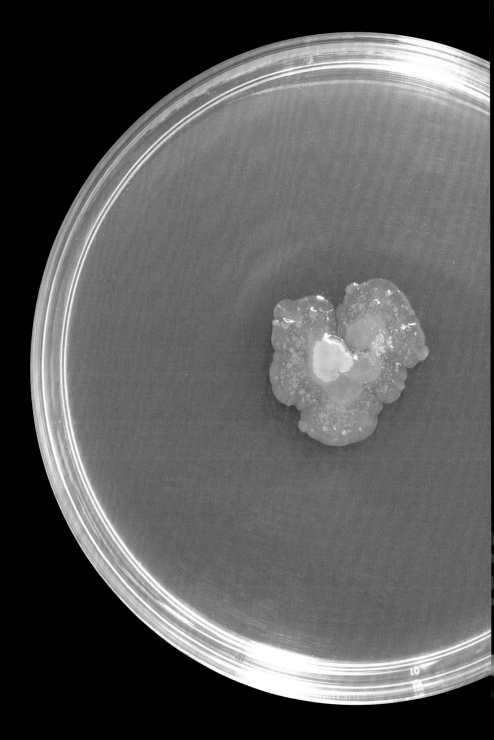

(opposite) Bacteria from a baby's pacifier, collected and spread across a petri dish. The various species grew isolated from one another.
(this page) Here, the baby's pacifier was pressed against the gel surface, and a mixture of multiple species grew close together.

the time the child is three to six years old. Both of these phyla are obligate anaerobes, meaning they can be detected only by growing them in petri dishes with very low or no oxygen.

These initial encounters with microbes are pivotal in shaping our lives as superorganisms. As we undergo significant transitions in diet and behaviors through the first year of life, so too does our microbiome gradually mature into a stable community that sustains us throughout our life span. This intricate interplay between the body and microbes lays the foundation for overall well-being as well as serving as a constant companion throughout our journey through life.

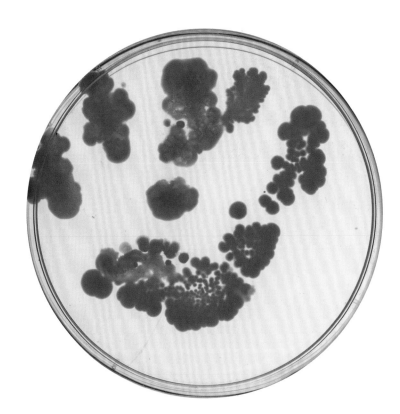

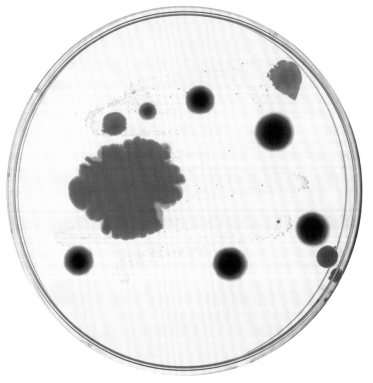

(top) Bacteria collected from a baby's hand retains the shape of the handprint pressed against a petri dish.

(bottom) Bacteria collected from a baby's mouth and spread with a swab across a petri dish.

A sample of one bacterial colony isolated from a baby's hand, which then patterned beautifully.

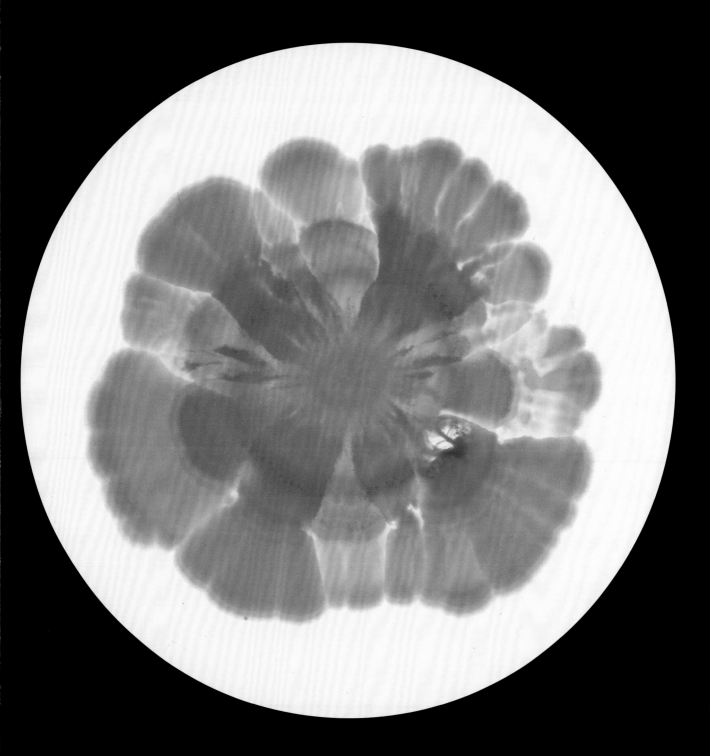

BABY HAND

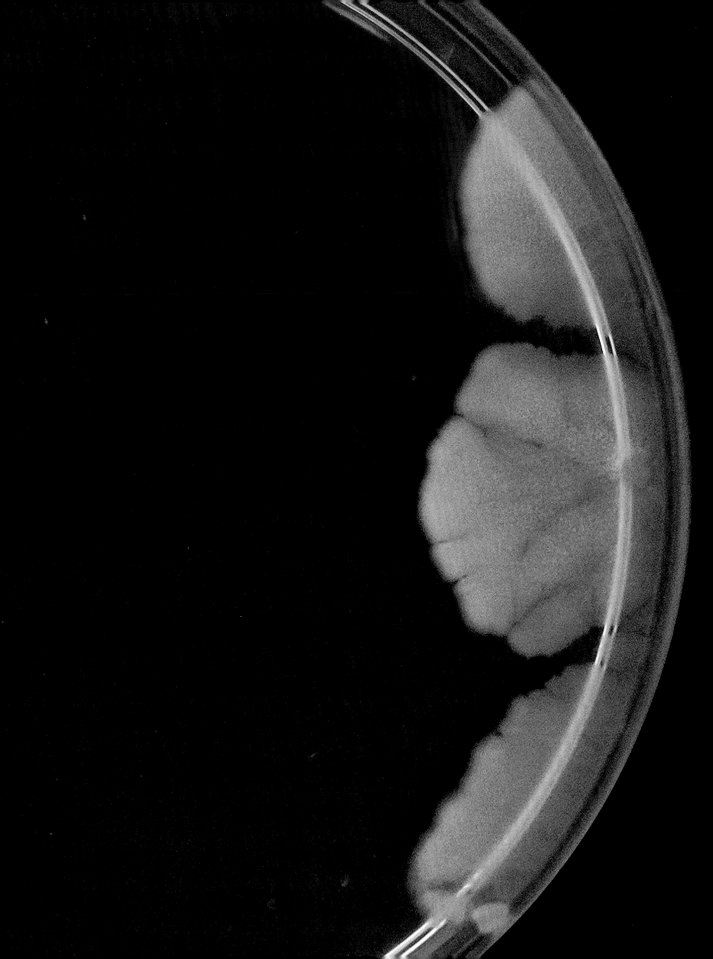

CH. 5 *INTREPID EXPLORERS* ON OUR SKIN

Bacteria from a scalp microbiome sample, growing from its initial "spot" on the side of this petri dish. The skin is packed with microorganisms that have evolved to thrive in its desertlike environment.

Like an invisible shell of protective armor, the microbes on our skin form the outermost layer of our bodies. The microbes in our gut get more attention, but the ones on our skin are just as important to our health, and they live in a much less microbe-friendly environment. This is because the skin, the largest organ of the human body, is essentially a desert. With low moisture and sparse nutrients, this acidic environment is also full of adversarial microbes that are constantly on the attack, with the potential to cause inflammation, penetrate the skin to cause infection, and battle the flora of the skin. Yet the skin is densely packed with bacteria, their numbers second only to the multitudes that reside in our gut (approximately 0.1 trillion bacteria on our skin, compared to the 50 trillion in our gut). The skin microbiota's function is broad and critical—breaking down natural products, training the immune system, and protecting against invading pathogens. And in terms of diversity, some skin sites such as the index finger, the back of the knee, and the sole of the foot can contain a higher microbial diversity than the gut. Thus, as in a flourishing desert ecosystem, specific bacteria have adapted to use what is available, thriving to numbers as high as 10 million for each thumb-print-sized patch of our skin.

The skin microbiome evolves rapidly compared to other microbiomes. At birth, an infant's skin microbiota contains an abundance of *Lactobacillus* species from the mother's vaginal microbiome (or, as noted in the previous chapter, more skin and environmental species if the baby was delivered via C-section). Yet, in just four to five weeks, the bacterial community on the infant's skin has similar features to an adult's skin microbiota. Already in that short span of time, predominant genera over the entire body appear, like *Staphylococcus* and *Corynebacterium*, while other species appear in only specific sites of the body.

In sequencing healthy adults, researchers have found that the composition of microbes is primarily dependent on the physiology of the skin site, rather than certain microbes being associated with specific organs.

For example, the four regions that represent the microenvironments of the skin include the sebaceous regions that are oily (otherwise known as lipid-rich), such as on the forehead; dry regions such as those on the forearm; moist regions such as those in the bends of the elbows and knees; and spaces between the toes. Generally, sebaceous sites are dominated by species of *Propionibacterium*, which can thrive in the lipid-rich environment, whereas *Staphylococcus* and *Corynebacterium* species prefer moist areas such the bend of the elbows and knees.

Unlike the intestines, where a rich abundance of nutrients is found, the skin lacks such nourishment, and so the bacteria that reside on the skin have adapted to thrive on molecules such as proteins and lipids rather than typical sugars, utilizing other resources in sweat or in fat produced by glands under the skin. *Propionibacterium acnes*—from which "acne" is derived—is one such species of bacteria. It lives on the skin and is the most abundant bacterial species in healthy adults. However, *P. acnes*, which is ordinarily beneficial to its hosts by regulating acidity, breaking down natural oils, and modulating the immune

system, can become problematic under certain conditions. For example, the more fat secretion from glands, the worse the acne can be. Another species often found on healthy skin is *Staphylococcus aureus*, which has evolved ingenious ways to survive this relatively harsh environment, such as being able to tolerate the high salt content of sweat and utilize the urea present in sweat as a nitrogen source needed to make essential molecules such as proteins or DNA. They foster further colonization both by producing molecules on their surface that can adhere to the skin and by secreting enzymes that liberate nutrients. As with *P. acnes*, *Staphylococcus* can become problematic: in higher proportions, it is associated with conditions such as eczema.

The skin also supports fungal communities, known as the skin "mycobiome." In contrast to bacterial communities, fungal composition is generally more similar across body sites. For example, fungi of the genus *Malassezia* predominate at core body and arm sites, whereas foot sites are colonized by a more diverse combination of *Malassezia* species as well as other fungi such as species of *Aspergillus* (the same genus as fungi that make the beverage sake or colonize warm, damp bathrooms). *Malassezia* is the most common fungus of the skin—a type of lipophilic (fat-loving) yeast that thrives in areas of the skin with high oil production, such as the scalp, face, chest, and back. Many fungal species are able to grow in petri dishes and thus are commonly observed in the samples on these pages. They are able to spread rapidly, building threadlike structures known as hyphae to shoot upward above the flat plane of a petri dish, which is usually dominated by bacteria. Fascinating to observe in their own way, mycobiota are generally far less abundant than the communities of bacteria they grow among, and more research is needed to catalog and understand their roles.

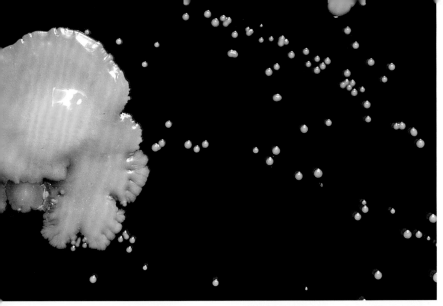

Each skin site's physiology determines its microbial composition, as in these close-ups of bacterial samples, from an adult female's scalp (*top*) and foot (*bottom*); and an adult male's foot (*middle*).

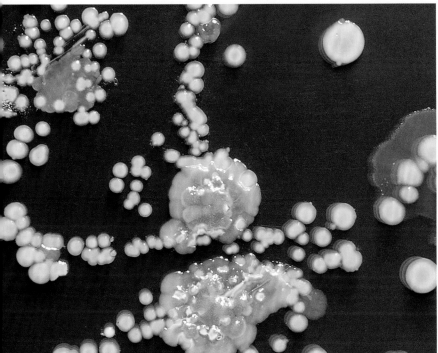

What does our own skin microbial biogeography look like? In the Danino lab, we sampled—through a sterile swab or directly imprinted onto the gel in a petri dish—body sites including the head (scalp/hair), ear, nose, armpits, belly button, fingers, and toes of an adult male and female, and the results display distinct and shared communities. The nose shows more abundant bacterial colonies and a few larger, dark fungi. The hands and feet show a high abundance of bacterial colonies such as *Staphylococcus epidermidis* as well as a couple of spreading fungal colonies.

It is true that an individual's daily activities and habits are dominant contributors to the microbes found on the skin, and even that a microbiota's composition varies drastically over the course of the day and among individuals. However, studies suggest that specific body habitats have a greater influence on what lives in the skin's desertlike landscape. Bacteria in these small oases seem undeterred by daily fluctuations and seasonal changes, an individual's personal habits or lifestyle. Resilient and opportunistic, these bacteria find ways to thrive in the interconnected, diverse landscape of the body, and they contribute to the shared habitats created by our human communities.

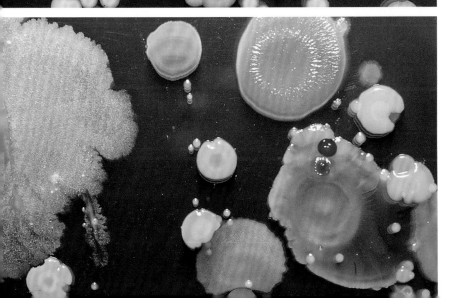

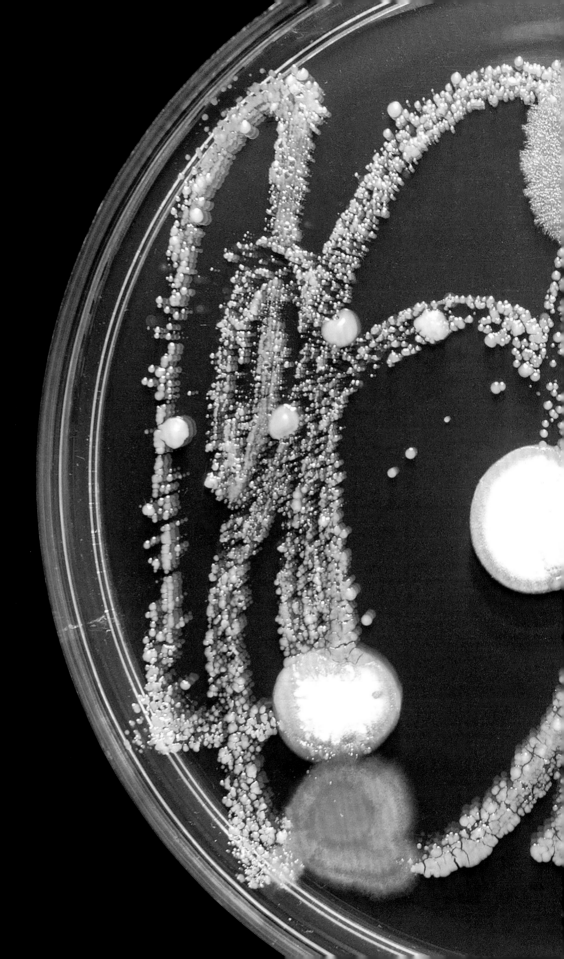

Bacteria sampled from an adult female's nose. This site's microbial community is generally complex, with many bacterial species. At the center here is a white mold.

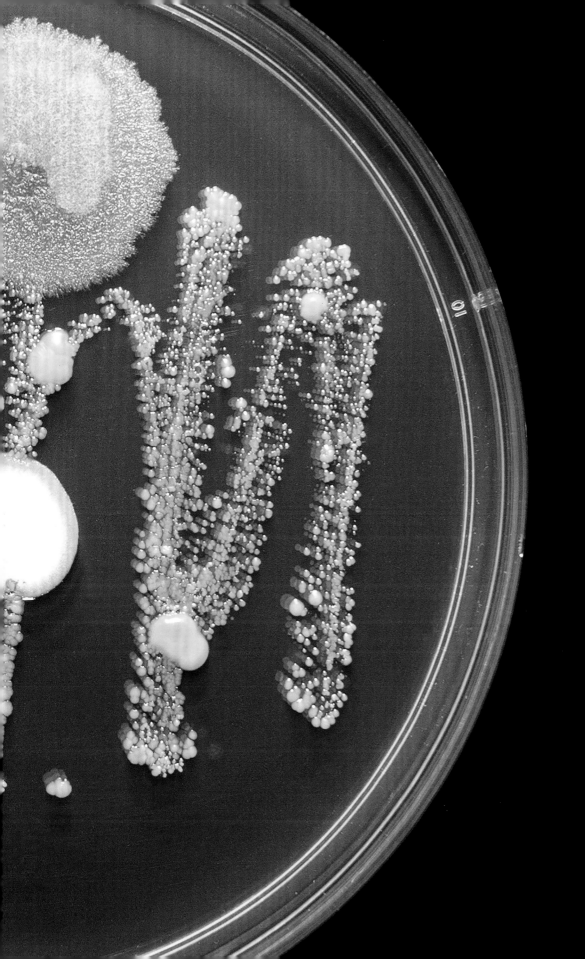

The microenvironments of the skin support a diverse population of microorganisms, from bacteria to the skin's "mycobiome," or fungal community.

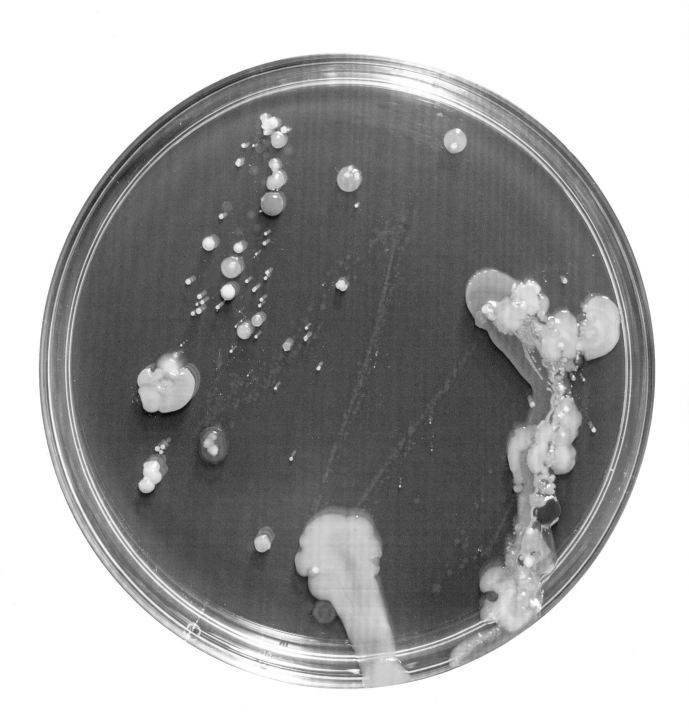

FEMALE ARMPIT

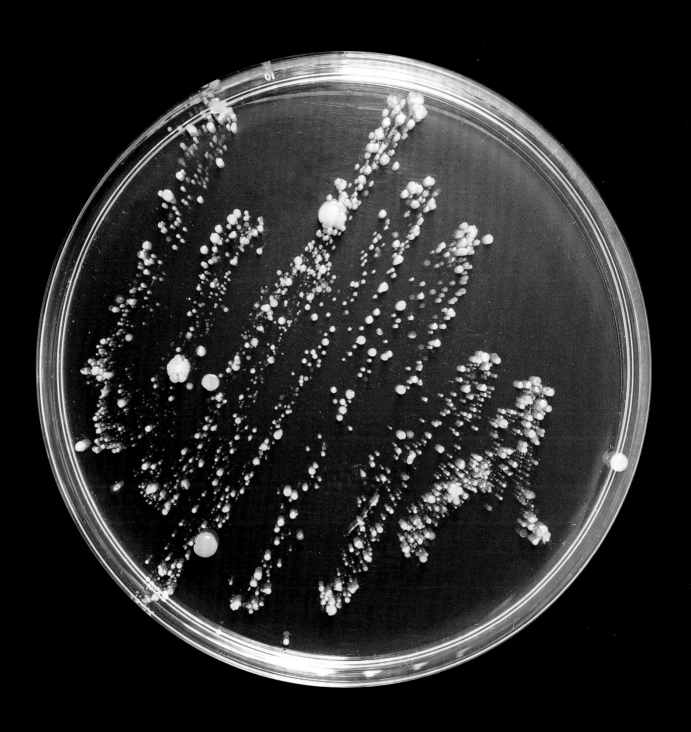

FEMALE BELLY BUTTON

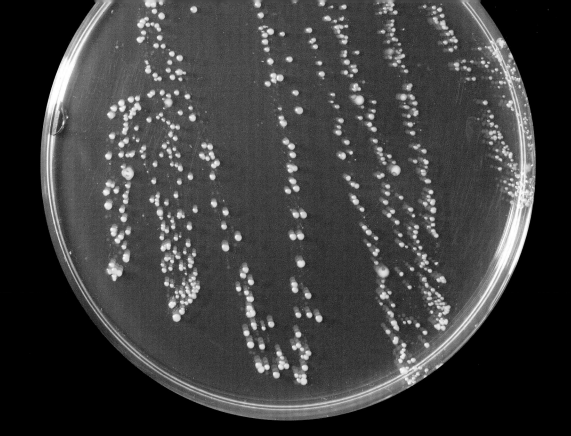

MALE GROIN

MALE FOOT

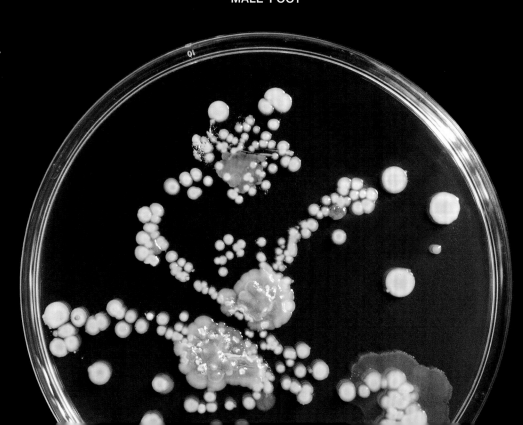

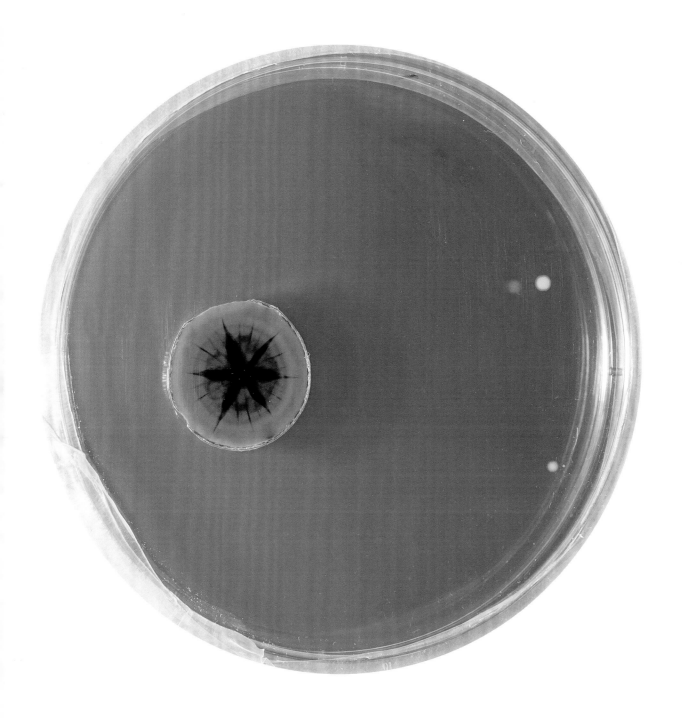

FEMALE EAR, WITH FUNGI

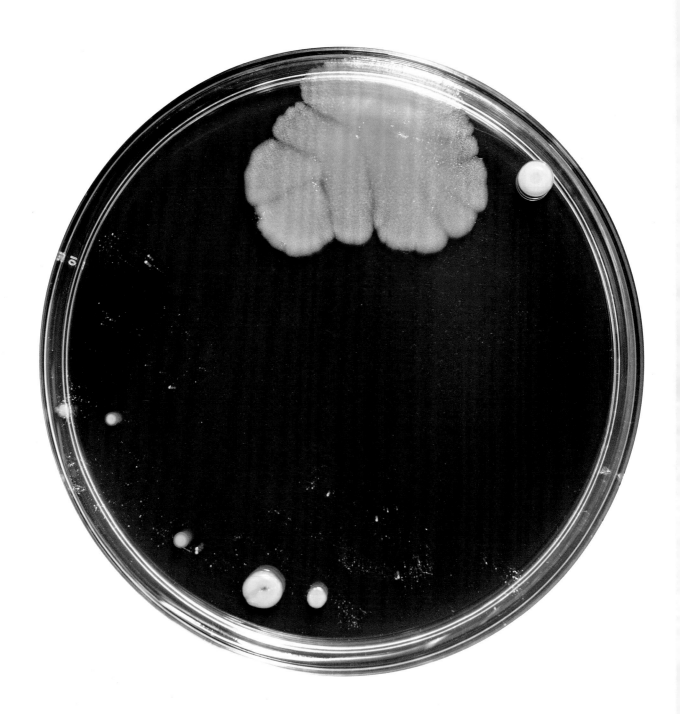

MALE BELLY BUTTON

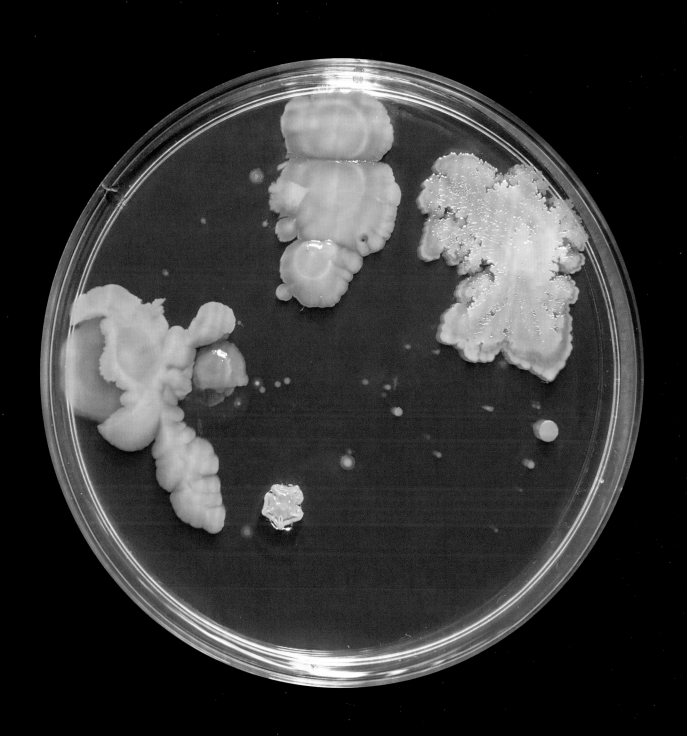

FEMALE HAND

A sample collected from a toddler's hand. The colors, textures, and shapes demonstrate diverse species present.
A *Bacillus* species at left grows filamentously across the petri dish.

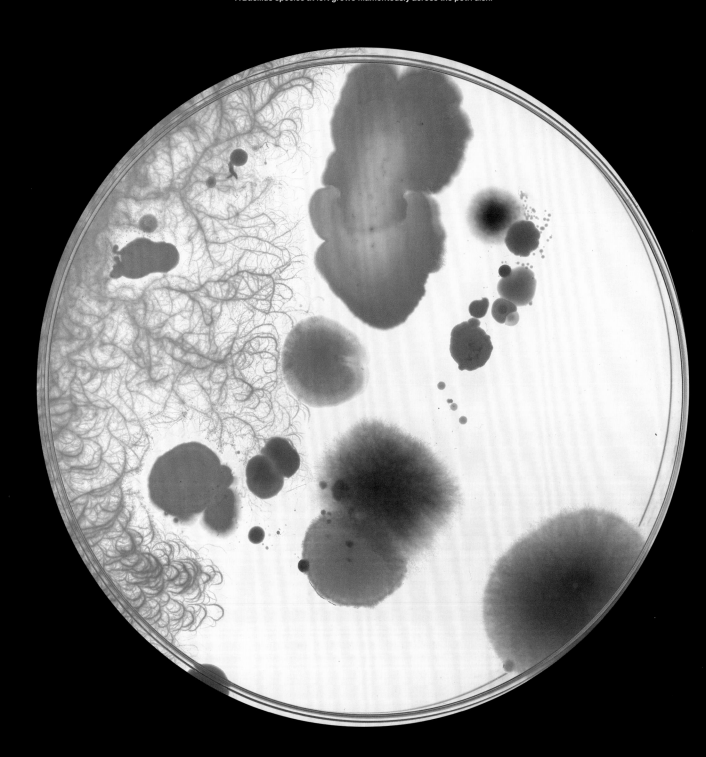

TODDLER SKIN

A sample from a toddler's finger that had touched her tongue. Spread across the petri dish are many skin-based species, shown as small colonies, and other species that grow larger.

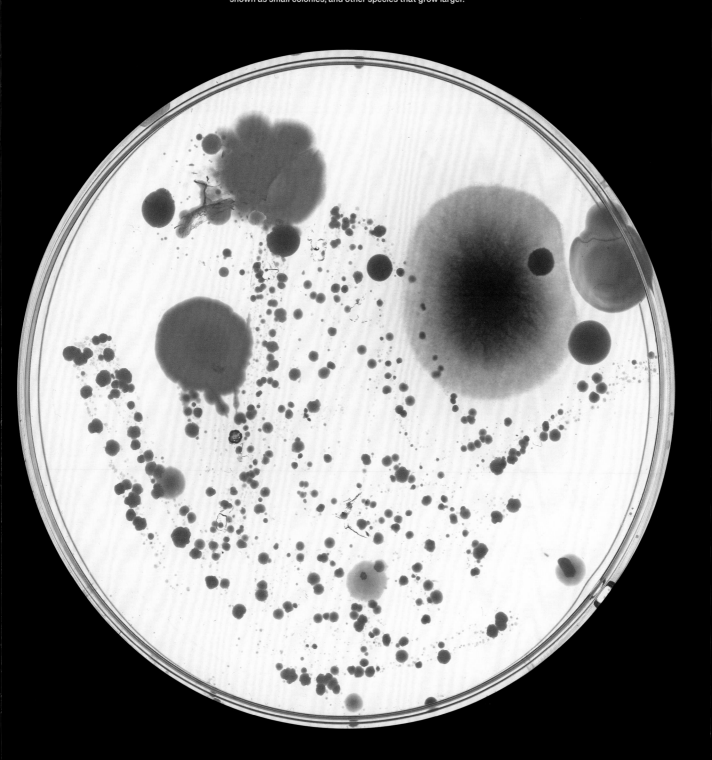

TODDLER FINGER

A toddler's toes stamped into a petri dish at the center.
These bacteria were grown under humid conditions that enabled rapid spreading.

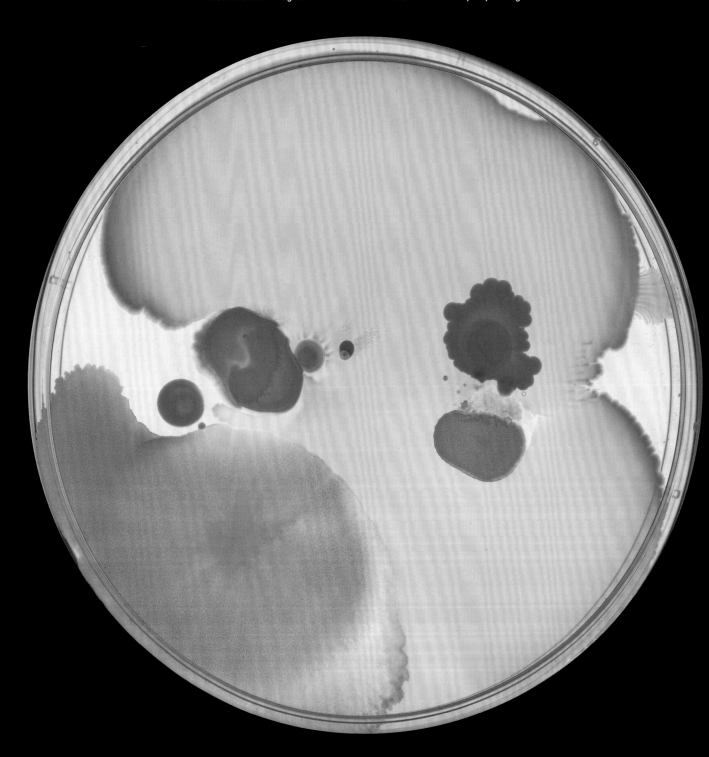

TODDLER TOES ON LB AGAR

A toddler's hand pressed against a petri dish.
The various shapes indicate a diverse microbial community.

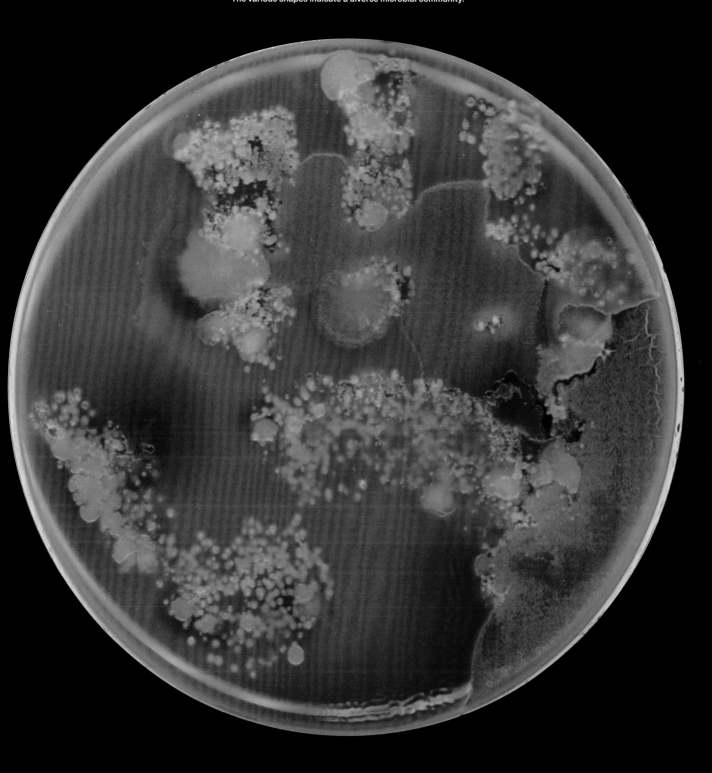

TODDLER HAND ON CHOCOLATE AGAR

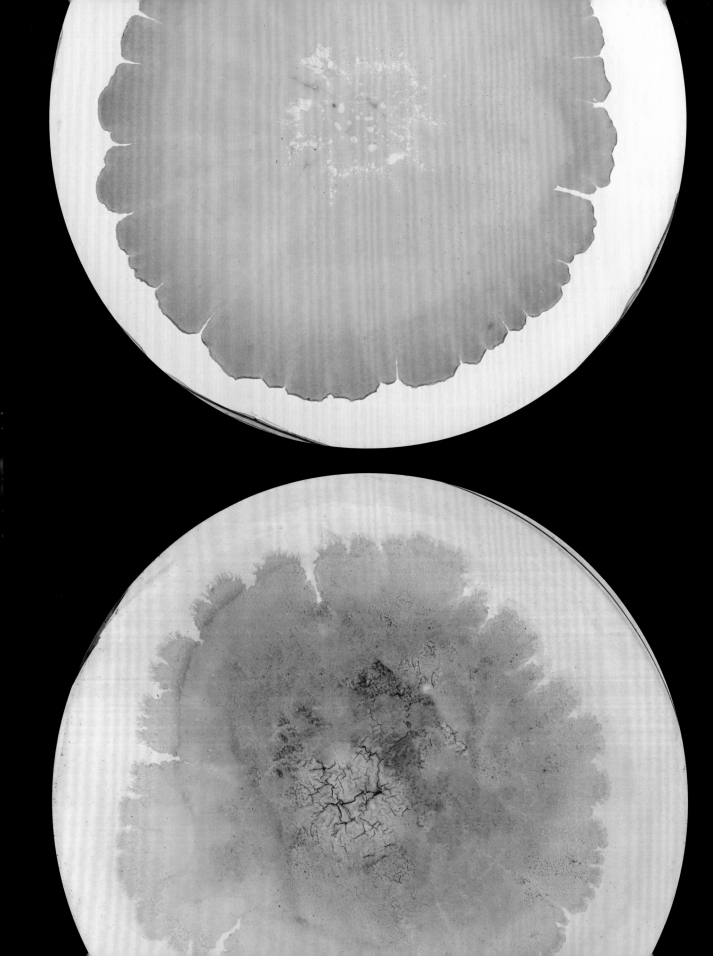

CH. 6 *MAKING THEMSELVES AT HOME* IN OUR GUT

Two bacterial isolates from probiotics grow from a spot at the center of the petri dish. Probiotics are microbes taken to maintain or improve health in the gut or other microbial niches.

In comparison to the sparse, desertlike environment of the skin, the gut is a bustling metropolis of microorganisms. Its residents are predominantly bacteria, whose orchestrated interactions throughout the entire body influence our health.

The gut microbiome is the most well-known and studied of all microbiomes, and it harbors the body's largest bacterial communities, holding more than 99 percent of bacteria in the body—a hundredfold more than on the skin. The gut encompasses the entire gastrointestinal tract, which starts at the mouth and extends through the esophagus, stomach, small intestine, and large intestine, or colon. As the central part of the digestive system, the gut plays an important role in nutrient absorption, immune function, and waste elimination. Aiding this work are trillions of microbes living all along this long road with most, over 99 percent, living in the colon.

The mouth is the entry point and connection of the gut to the outside world, acting as a sort of bacteria way station for transit deeper into the body. Since the mouth is in contact with the skin and environment, it shares similar microbes with them, but it has unique conditions of its own. For example, oxygen-rich areas, such as the front of the tongue, are colonized by aerobic bacteria (which can grow in oxygen). In contrast, anaerobic bacteria dominate in oxygen-deprived regions, such as dental plaque and periodontal pockets. Saliva helps maintain a slightly acidic pH, favoring the growth of acid-tolerant and acid-producing bacteria, such as those from the *Streptococcus* genera.

The oral cavity also has a mycobiome, with some fungal *Candida* species known to colonize this site on the first day of life. Little is known about the development of the oral mycobiome over time, but it contains less diversity than the skin or gut. While small compared to the colon, the microbial population in the oral cavity is highly diverse and fairly large in number (estimates vary between 10 billion and 1 trillion bacteria).

Deeper into the gastrointestinal tract are the esophagus and stomach, with relatively few bacterial inhabitants, a scant 1 trillion. The stomach's high acidity and thick mucosal barrier keep most bacterial species at bay, but some pathogenic strains can infect this

region. Most notorious is *Helicobacter pylori*, a helical-shaped species that can grow in the stomach's mucus layer; *H. pylori* infection can lead to ulcers, chronic gastritis, and even, under certain conditions, stomach cancer. In the early 1980s, the prevailing belief among doctors was that stress and lifestyle were the primary causes of stomach ulcers. However, Dr. Barry Marshall, an Australian physician, challenged this conventional knowledge—and to prove his theory, he ingested a mixture containing this bacteria to infect himself. Within a few days, he had symptoms of gastritis and ulcers, demonstrating the direct causal link, and eventually winning the Nobel Prize for his work on *H. pylori*.

Even deeper in the gut, from the small intestine to the large intestine, conditions of moisture, acidity, and nutrients become ever more perfect for microbes to survive and thrive. The numbers of these minute residents begin to ramp up, with the large intestine alone teeming with around 50 trillion microbes. In turn, these microbes perform essential tasks: they ferment undigested carbohydrates, metabolize nutrients, help modulate the immune system, and synthesize vitamins. For example, gut bacteria break down consumed complex carbohydrates through fermentation, producing metabolic by-products that serve as an energy source and keep cells in

the colon healthy. Certain strains of *Clostridium* and *Bacteroides* bacteria increase the abundance of regulatory T cells, which play a crucial role in homeostasis and suppress excessive immune activation and inflammation. These immune cells help prevent immune responses against harmless antigens or helpful bacteria, preventing allergies and autoimmune disorders. Lastly, certain species of *Escherichia* and others are known to synthesize vitamin K. They convert precursors from the diet into biologically active forms of the vitamin that are critical for host functions such as blood clotting and bone health.

Gut microbiota continue to change as adults mature, with diet being a major determinant of their composition, even more so in many ways than a person's genes. Some foods, particularly vegetables and fibrous foods, are considered "prebiotic," meaning they can have a beneficial effect on our gut due to balancing "probiotics," which contain live microorganisms that can confer a health benefit. Microbes break down the raw form of food molecules in fermented foods, prohibiting the growth of other bacteria and molds and creating distinctive tastes in olives, cheeses, yogurts, and salamis, as well as coffee, beer, wine, and much more.

As foods ferment, certain types of microorganisms thrive while others decline, a "microbial succession" that changes the microbial community and contributes to the unique flavors and preservation of fermented foods, such as kimchi. Some studies have shown two of kimchi's ingredients, cabbage and garlic, provide the required microbes, particularly lactic acid bacteria (LAB). A high concentration of salt and low temperatures combine to inhibit bacterial growth, except for LAB species (typically from the genera *Leuconostoc*, *Lactobacillus*, and *Weissella*), which break down vegetables to produce lactic acid and create an acidic environment, as well as producing antibacterial molecules that prevent the growth of other bacterial species. After reaching their peak levels of nearly a trillion bacteria per milliliter over several weeks, subsequent microbes such as *Saccharomyces* (a yeast) can grow from the by-products of the LAB fermentation, and LAB species' populations decrease. This overall process of microbial succession produces the free sugars, vitamins, amino acids, and organic acids that give kimchi its

(opposite, top)
Bacteria sampled from dental floss and grown on blood agar. The yellowish color indicates the bacterial breakdown of red blood cells.

(opposite, bottom)
Bacteria grown from diluted stool on LB agar. Common gut species include *Escherichia coli*.

distinct taste. Fermented cabbage in another form is sauerkraut, a German word for a dish that is eaten around the world and particularly with sausages. Samplings from kimchi and cabbage show communities of lactic acid bacteria and other microbes, which when isolated also can produce flourishing colonies in petri dishes.

The past century has witnessed the advancement of probiotic supplements, which typically contain microbes that might be found in the gut, such as the bacterial species *Lactobacillus rhamnosus*. Probiotics in development can also modulate niches like the vaginal microbiome, such as those developed by microbial sciences company Seed (and shown in this book). As with fermented foods, but more concentrated and defined, probiotic supplements can have beneficial health effects including improved digestive health, immune function, pathogen prevention or treatment, skin health, and allergies.

Every time my colleagues and I at the lab isolate a strain, we can't help but feel awe toward these tiny organisms. The human body holds about an equal number of microbes and human cells, yet a more minute look reveals an astonishing fact. All of our human cells have only one set of genes, while each of the about 500 bacterial species that compose our microbiomes have a unique set. Total the number of microbial genes within and on us, and they vastly outnumber our human genes. From birth, each of us is an ecosystem composed of more bacterial cells than human cells. What does this do to our notion of self? And how do we define our own species when what makes us truly human . . . is other organisms?

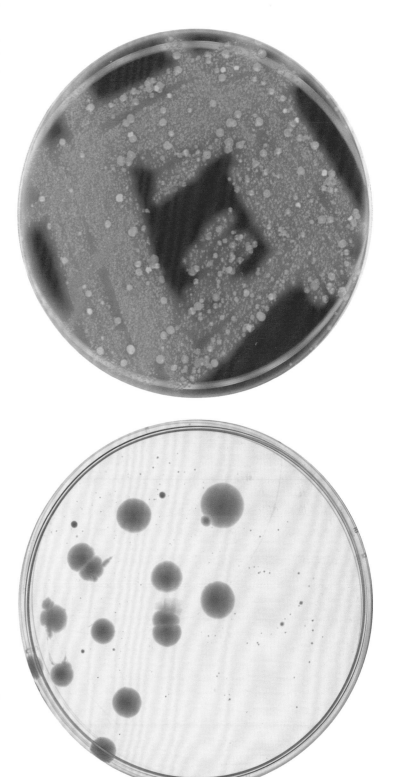

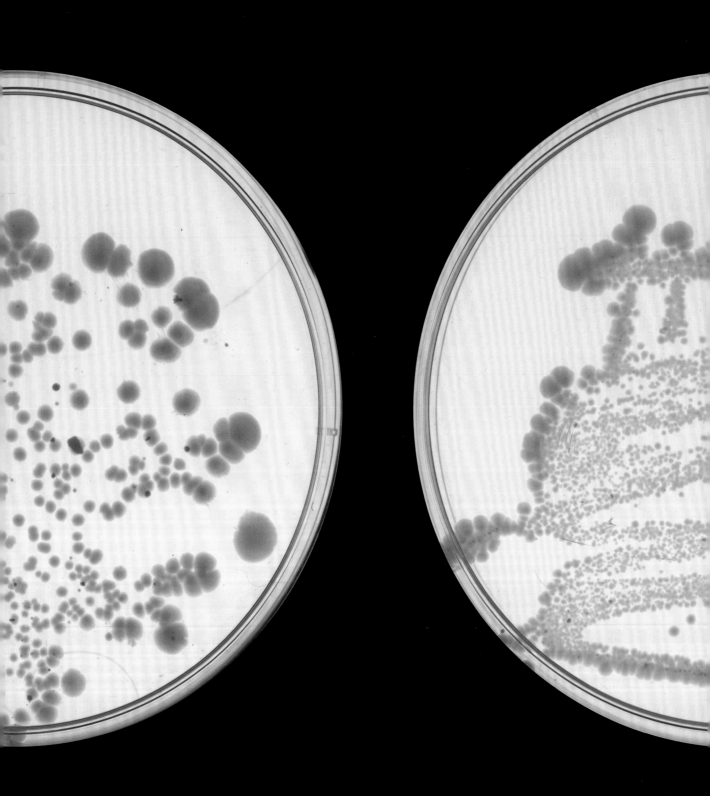

(left to right) STOOL (ADULT, TODDLER, BABY) ON LB AGAR

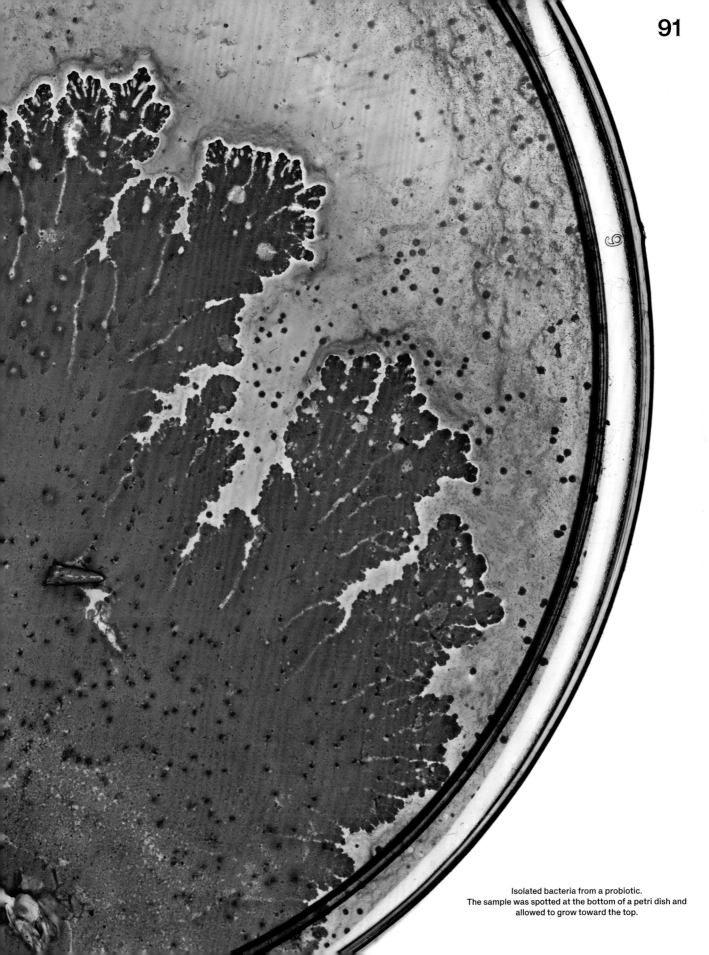

Isolated bacteria from a probiotic.
The sample was spotted at the bottom of a petri dish and
allowed to grow toward the top.

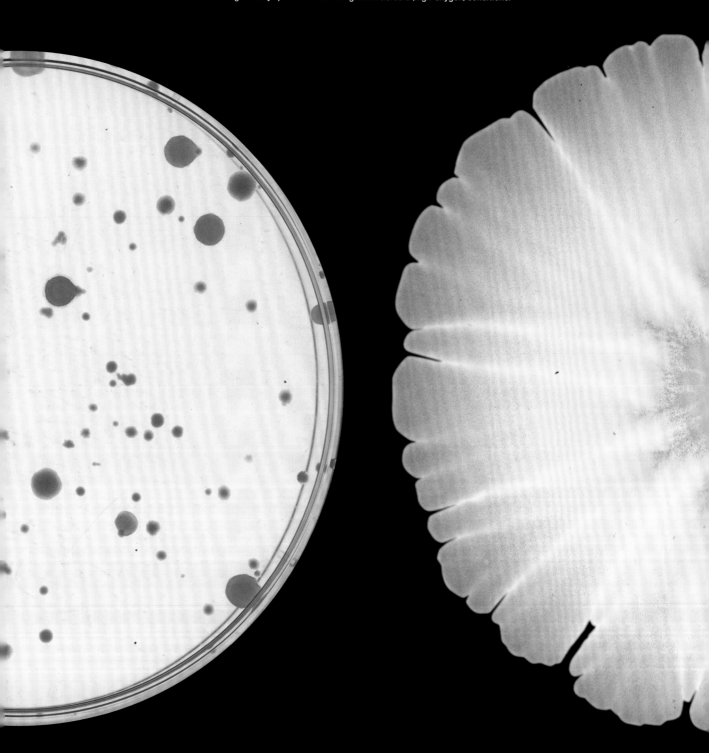

(this page and opposite) A probiotic capsule dissolved in saline (two different dilutions) and spread across LB agar. Many species shown can grow in aerobic (high-oxygen) conditions.

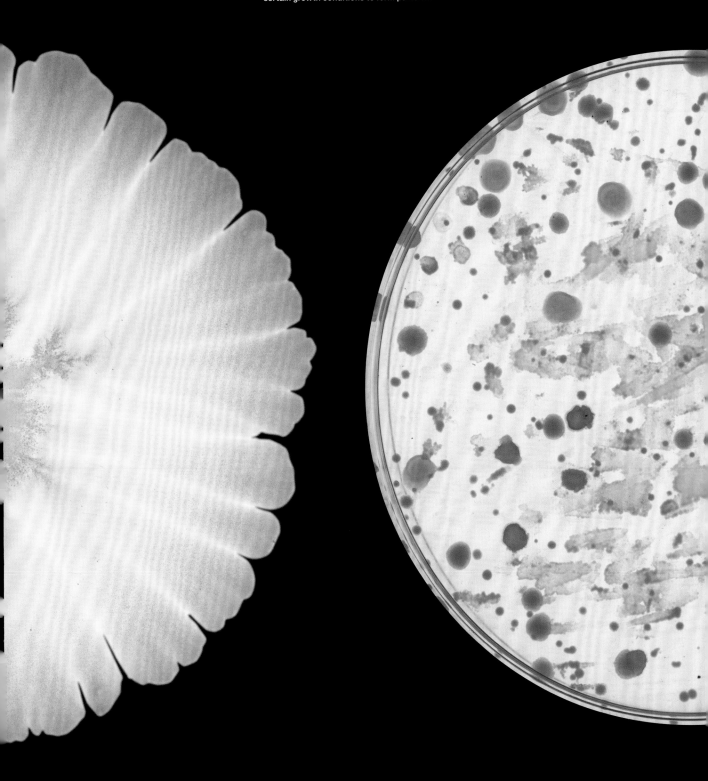

(center) A bacterial colony isolated from a probiotic and "coaxed" via certain growth conditions to form patterns.

ORAL PROBIOTICS

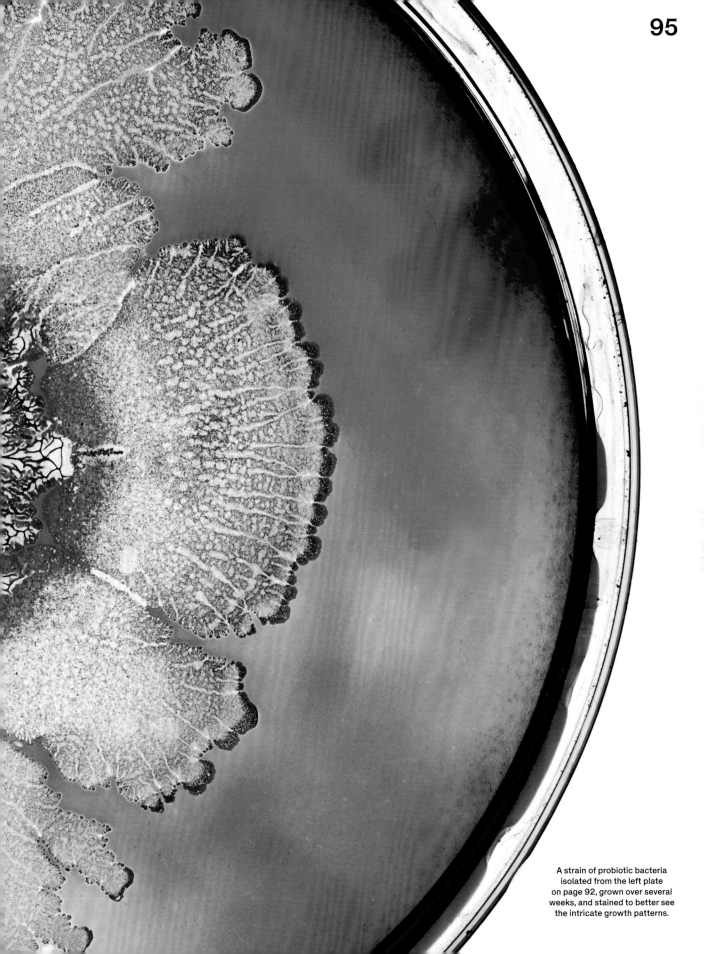

A strain of probiotic bacteria
isolated from the left plate
on page 92, grown over several
weeks, and stained to better see
the intricate growth patterns.

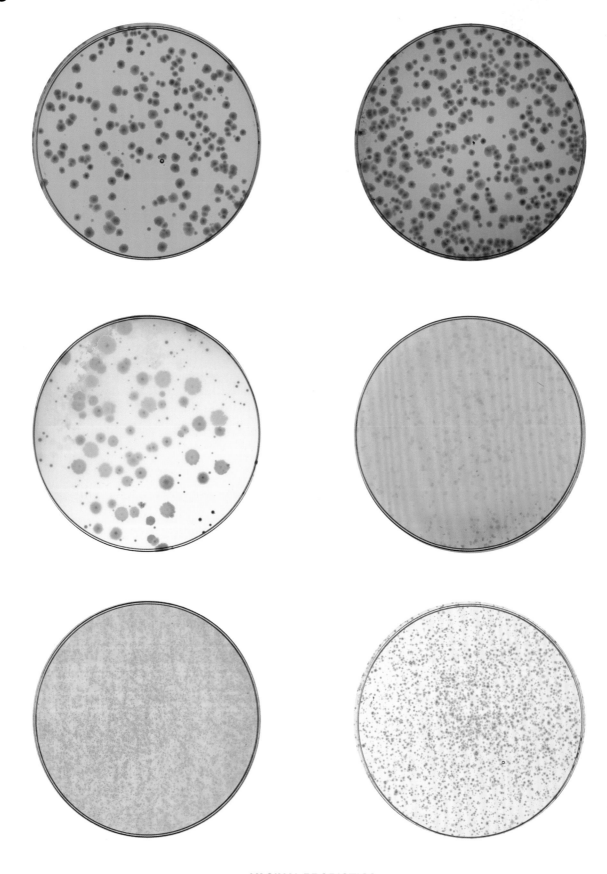

VAGINAL PROBIOTICS

(opposite and this page) **Lactobacillus** strains collected from vaginal probiotics and grown at various concentrations on dyed MRS agar, which is used to favor the growth of these strains.

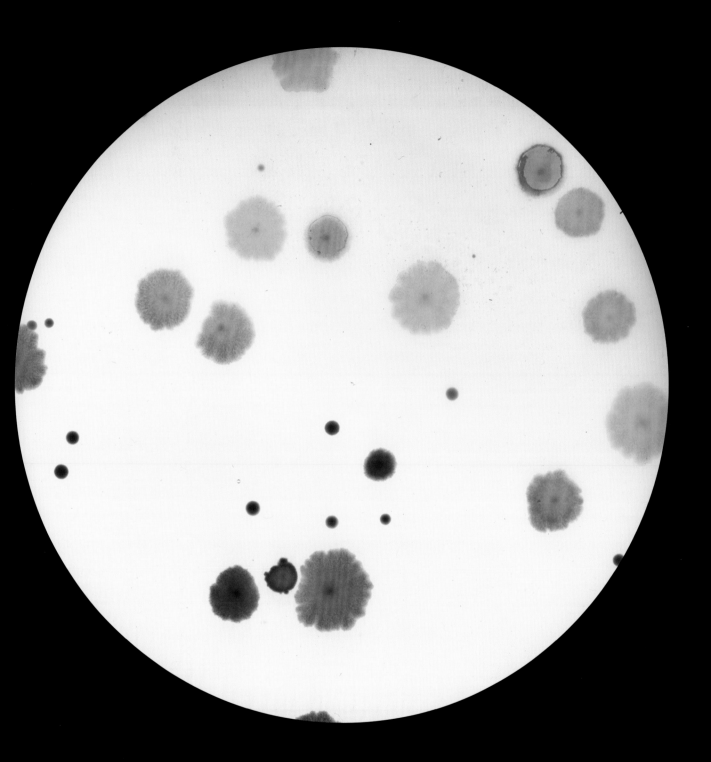

VAGINAL PROBIOTICS

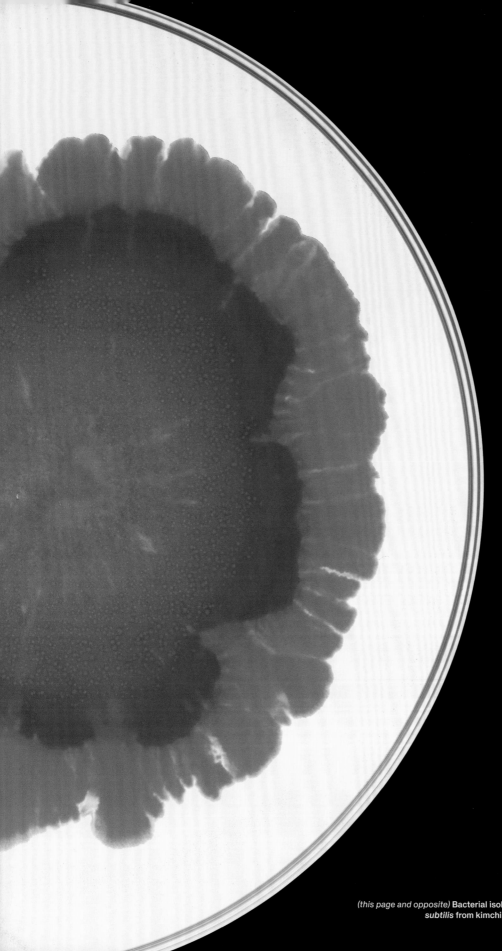

Kimchi is traditionally made and shared in a Korean communal practice known as *kimjang*. Kimchi's ingredients include cabbage, garlic, ginger, red pepper, and salt placed together in a sealed container. These unsterilized ingredients contain microbes that interact with the nutrients, initiating fermentation. The fermentation process is a dynamic interplay between microbial species called "microbial succession"—and is as much an art as it is a science.

(this page and opposite) **Bacterial isolates of *Bacillus velezensis* and *Bacillus subtilis* from kimchi grown in petri dishes.**

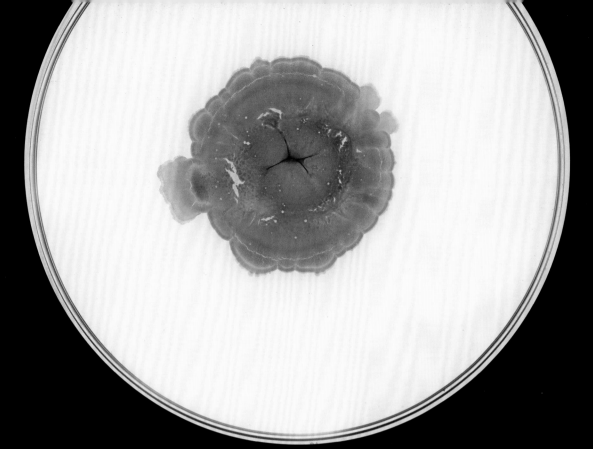

KIMCHI

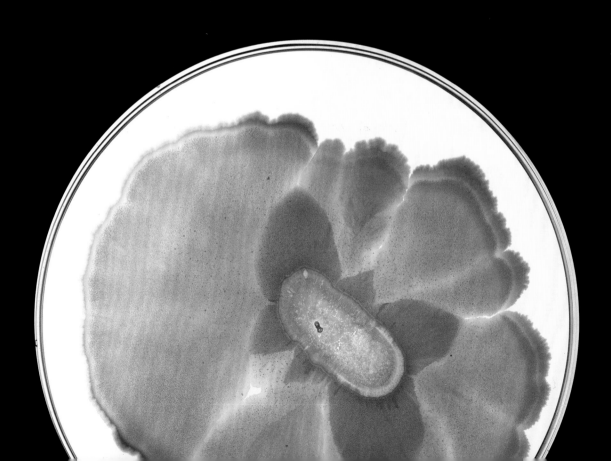

Isolate from sauerkraut grown for two days, showing densely populated, wrinkled colonies with elevated growth.

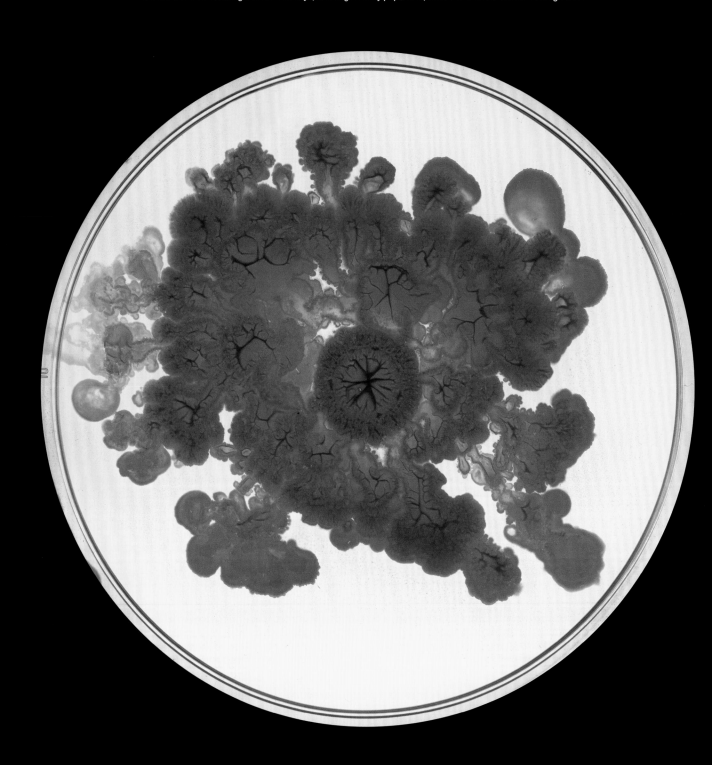

SAUERKRAUT

Isolate from sauerkraut grown for seven days, with the colonies spreading across the petri dish.

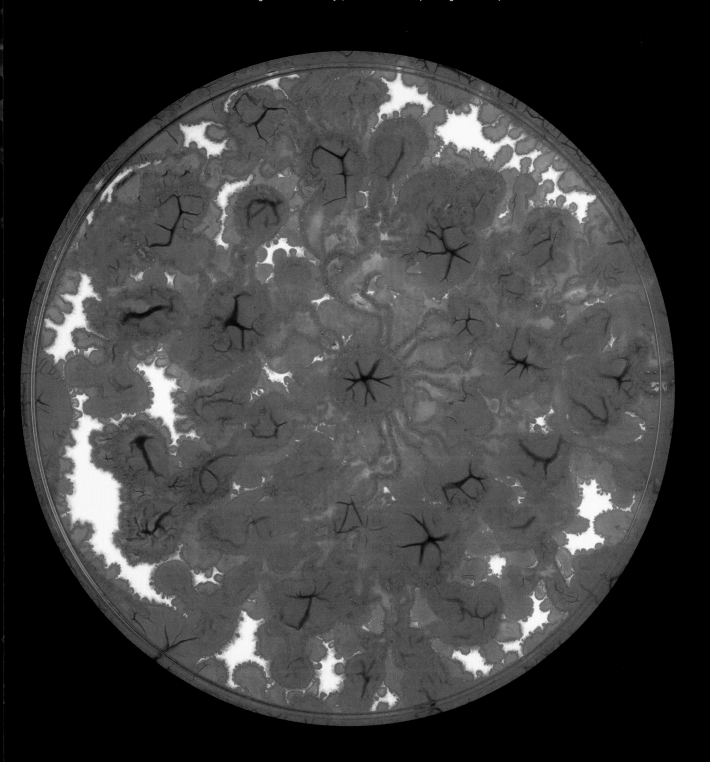

SAUERKRAUT

**LIFE IS A GERM
AND A GERM IS LIFE.**

Louis Pasteur
lecture at the Sorbonne, Paris (1864)

PART

3

BACTERIA
AROUND US

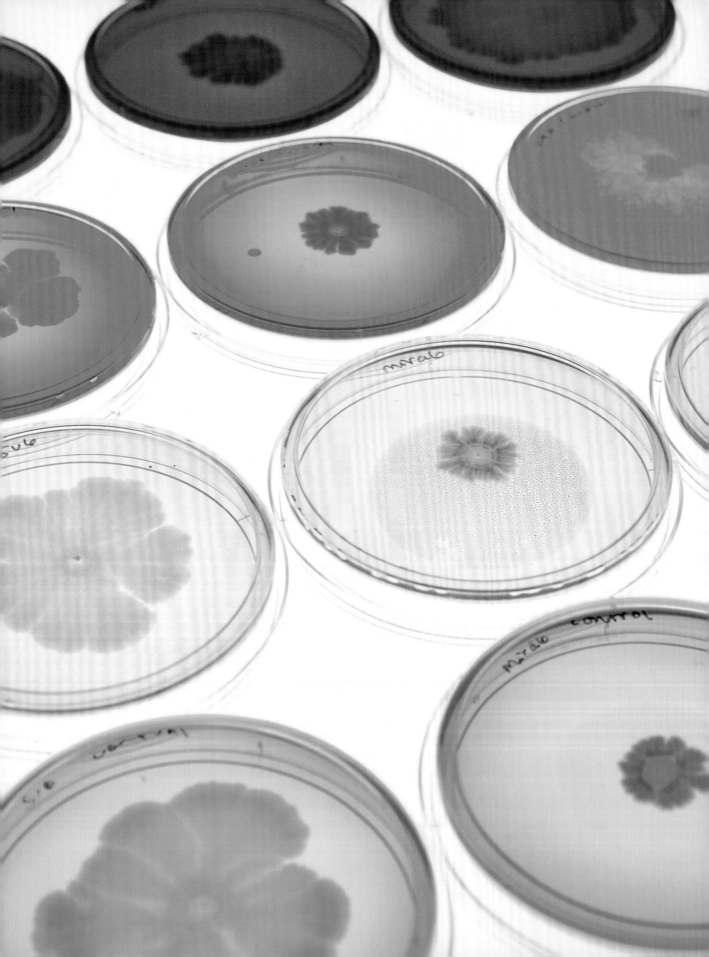

CH. 7 *ABUNDANT GUESTS* IN OUR HOMES

Bacillus subtilis, Proteus mirabilis, and *Bacillus pseudomycoides* grown in petri dishes and dyed with food coloring. Microbes like these are integral to a home's rich ecosystem.

Little do we realize that we have trillions of roommates sharing our homes, eating our food, and lounging around. They colonize surfaces and crevices from busy kitchen countertops to quiet bedrooms, from bathroom fixtures and air vents to doorknobs and coffeepots. The vast majority are harmless, visitors who have made our home theirs—sourced from our bodies, the air, our pets, or trafficked in from outside trips. We don't even notice them, unless we spot a telltale color pink in the toilet or shower. Together these microbes create a kind of macrobiome, the distinct environment that we all call "home."

Just walking through our homes reveals the many places where these microbes survive and—depending on local temperature and humidity, human (and pet) occupants and lifestyles, and cleanliness—where they thrive.

The most abundant bacteria found in the home have an off-white or cream color when grown in a petri dish. However, there are numerous species that naturally produce a rainbow spectrum of colors. For example, a common rosy-hued presence in shower grout and toilet bowls is *Serratia marcescens*. The distinctive color is caused by a bright red pigment called prodigiosin. Prodigiosin comes from the Latin word *prodigiosus*, which means wonderful, amazing, miraculous, supernatural, divine, or "dealing with wonders." Dubbed the "miracle" bacteria, *S. marcescens* has a peculiar and fascinating history.

In the summer of 1819, many peasants living around Padua, Italy, were shocked when their families' cornmeal polenta turned bright blood-red. Fearful of this "bloody polenta," they took it as a bad omen for their families and asked priests to come and free their homes from evil spirits. The city commissioned professors from the University of Padua to investigate this phenomenon, and a pharmacist, Bartolomeo Bizio, independently conducted research. Bizio suspected the blood-red polenta was due to fungus, not evil spirits, and took samples. He cultivated the microorganisms present and discovered that a bacterium was the cause of the bloody polenta. He named the species *marcescens* (Latin for "decaying"), because the pigment was quite short-lived.

Less immediately visible are the multitudes of microbes shed from our bodies, including our skin, mouth, and nose. Some of the most common types of microbes found in homes are *Staphylococcus epidermidis* (a common

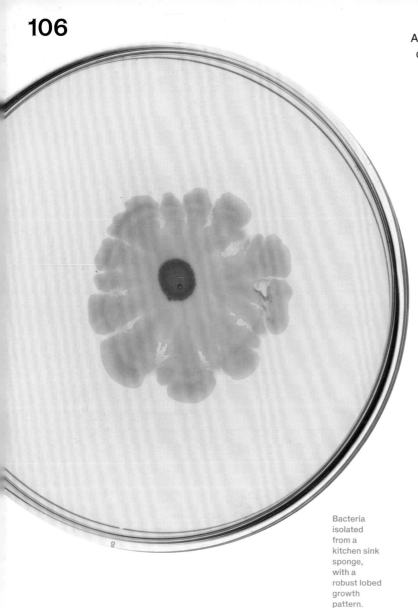

Bacteria isolated from a kitchen sink sponge, with a robust lobed growth pattern.

American Legion convention; an airborne disease that can be transmitted from air vents, it is nevertheless not transmissible from person to person and most people do not become ill if they're exposed to it. Traditionally this gram-negative bacterium is detected by isolating on black agar. Many species of fungi, including from the genus *Aspergillus*, are also commonly found in damp environments such as bathrooms.

As explored in Chapter 4, the environment plays a critical role in shaping the early microbiome—and this has led many researchers to study the effect of having pets in the home. About two decades ago, U.S. researchers reviewed health records of children who had pets such as dogs and cats, and they discovered a correlation between children whose homes had pets and those who had fewer allergies and asthma. Further studies (especially one involving young mice and dust from houses with or without dogs) discovered increased levels of a particular bacterial species, *Lactobacillus johnsonii*, in the gut, potentially explaining the effect from exposure to animals by modulating the immune system. In another study, of about 3,000 children, exposure to indoor dogs (but not to outdoor dogs, cats, or farm animals) during the first year of life was reported to be inversely associated with preclinical type 1 diabetes. These correlations do not show definitive cause-and-effect relationships for humans, but they point to intriguing new research avenues for the design of probiotics or other formulations that might help reduce risks of allergies.

For the images in this chapter, my colleagues and I explored the types of bacteria that live among us, swabbing common household areas such as the bathroom sink, refrigerator, microwave, kitchen sponges, toothbrushes, toilet, and even headphones.

resident from the human skin) and species of *Streptococcus* (common in nasal passages), which take up residence anywhere we sit, eat, work, and relax. The microbial fingerprints of these residences are a blend of a family's or other inhabitants' bacteria. In fact, these microbial species might actually help make a home away from home. In one study of families, microbiome signatures of a new home or hotel room quickly converged with those of previous homes within as little as one day.

Other bacteria are brought in on shoes, like species of *Bacillus* (for example, *B. subtilis*, commonly found in the soil), or in the air, such as *Legionella* species. The latter genus was famously discovered and named after an outbreak of a "mystery" pneumonia-like disease among attendees at a 1976

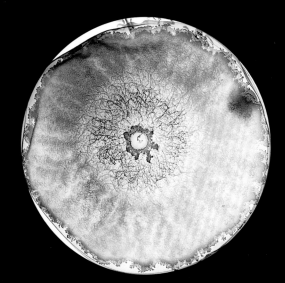

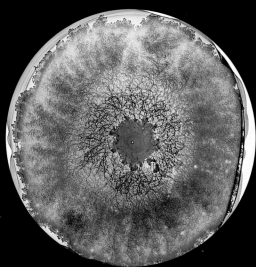

an opportunity to shine over other microbial invaders.

As grown in the lab, samples from my cooperative dog, Cooper, illustrated the complex influence of a pet's microbiome. A sampling of his fur showed a variety of species, particularly many filamentous colonies that are likely soil-dwelling microbes. Similarly his paw, stamped directly onto the gel in a petri dish, also showed high abundance of bacteria and diversity. Many of these species likely originated in the soil and other ecosystems where known microbes like to swarm and pattern on surfaces. Not all microbes grow in standard LB (Lysogeny broth) agar petri dishes, so we spread samples from Cooper's mouth and feces in both standard LB agar petri dishes and blood agar dishes to enable growth of fastidious bacteria. Overall, some dominant cultivatable microbes arose in these petri dishes, but using DNA sequencing approaches can provide a more complete catalog.

From a microbial standpoint, "home is where the heart is" is not far off. Whether we live in mansions or one-room apartments, on farms or in cities, our households become a blend of us and the microbes we invite in. In addition, in the microuniverse's version of a two-way street, microbes impact our own body's microbiomes. The complex relationship between humans and microbes in the home has yet to be fully explored, with implications in health as well as the holistic design of home environments. Nevertheless, it is already clear that microbe communities help create rich, diverse ecosystems—far from always being unwelcome guests to fear and eradicate.

Each sample was collected and spread across a gel surface in a petri dish, and the results were illuminating. The very object that goes into a mouth every day—the toothbrush—did not produce bacteria in a petri dish at all. This is probably due to the fluoride we use to prevent bacterial growth. A kitchen sponge, on the other hand, contains a lot of bacteria, as it may constantly be picking up bits of food and microbes from our hands (and is rarely thoroughly cleaned). Meanwhile, damp environments like a fridge, toilet, and sink had several molds that grew on the same dishes with bacteria. These conditions, often more humid, sugary, salty, and irregular, provide fungi with

Bacillus pseudomycoides, commonly found in soil, stained with multiple dyes that highlight its swarming morphology.

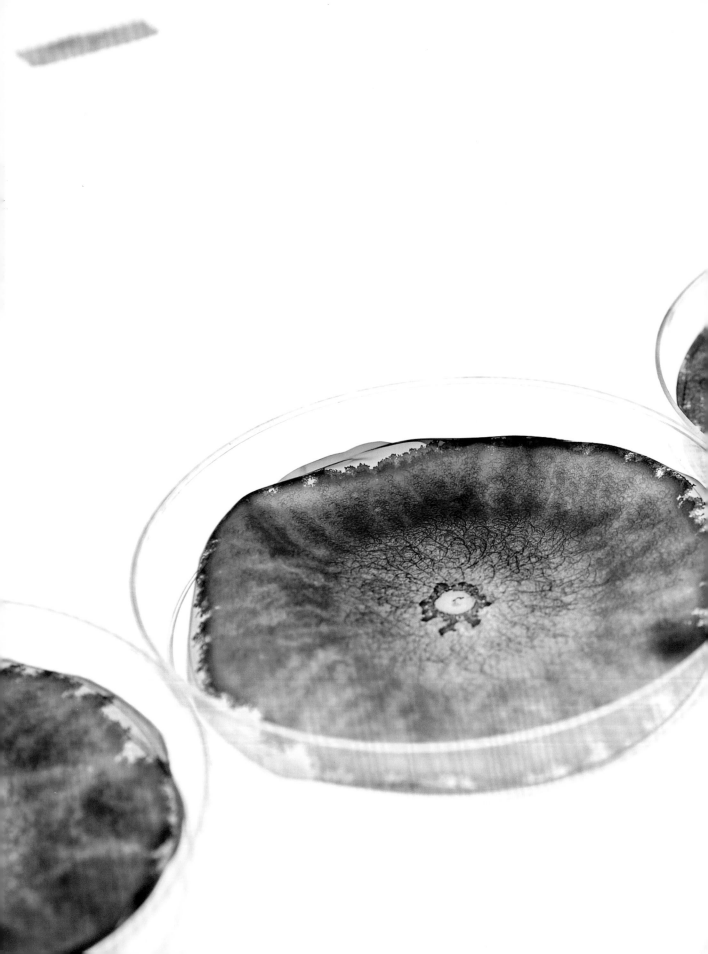

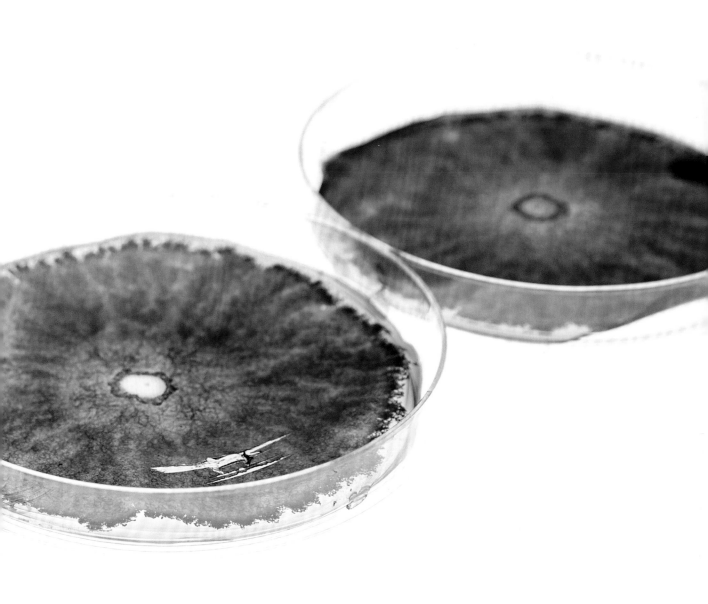

BACILLUS PSEUDOMYCOIDES

Serratia marcescens streaked on a portion of an LB agar plate and grown for two days. It displays its naturally produced distinctive red pigment.

SERRATIA MARCESCENS

Serratia marcescens spread across an LB agar plate and grown for one day. Spreading across the whole plate results in the growth of scattered colonies.

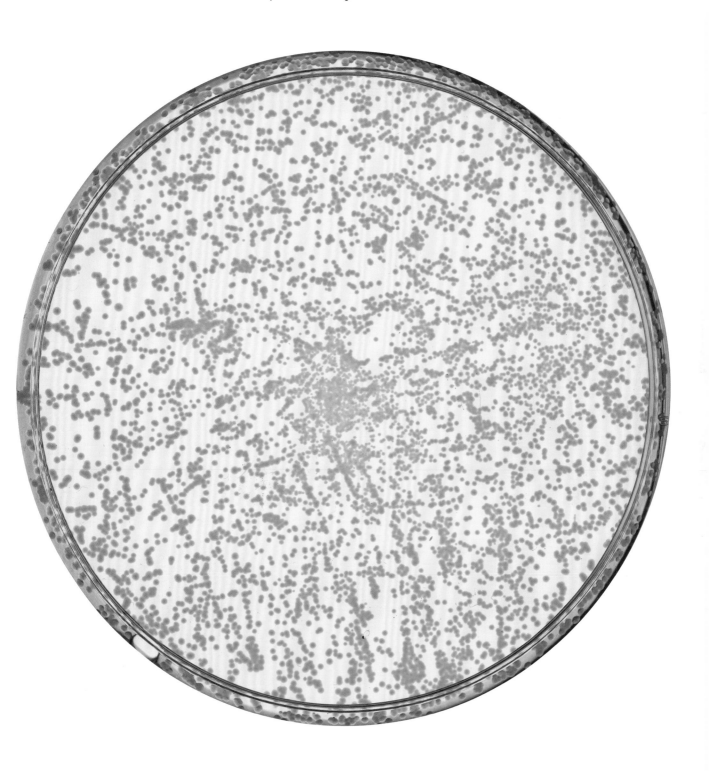

SERRATIA MARCESCENS

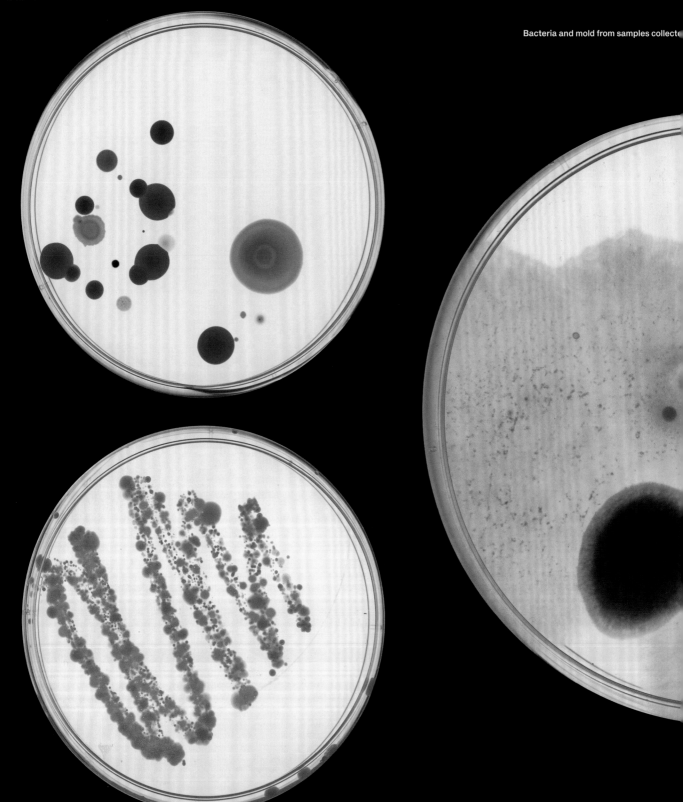

(top, bottom, center) **SINK, SPONGE, REFRIGERATOR**

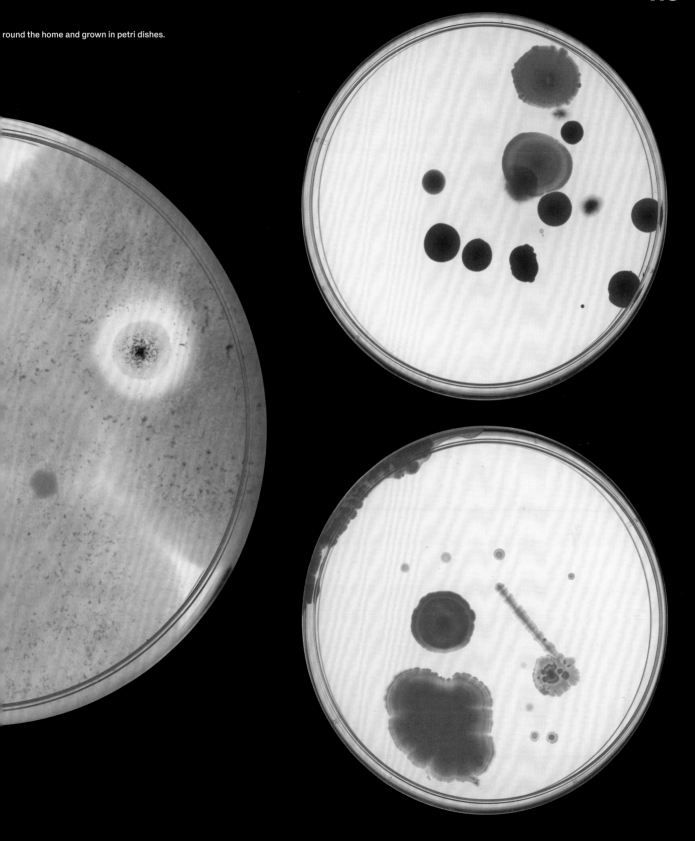

round the home and grown in petri dishes.

(top, bottom) TOILET, MICROWAVE

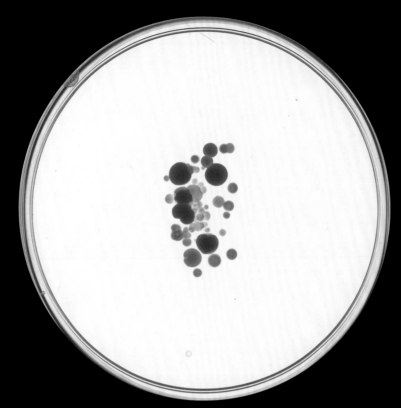

Bacteria from samples collected from a dog, either b

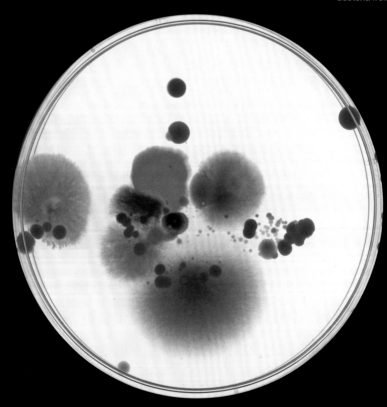

(top, bottom) DOG TONGUE, DOG NOSE

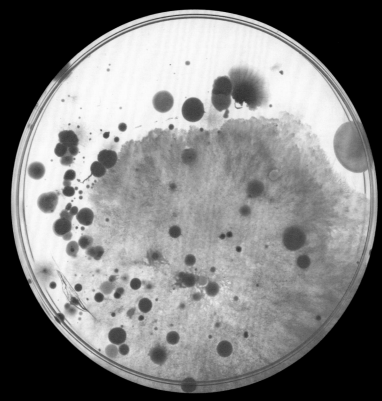

stamping directly on agar plates or by being swabbed.

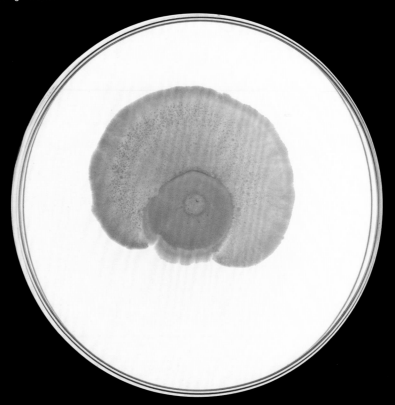

(top and bottom) DOG PAW, DOG FUR

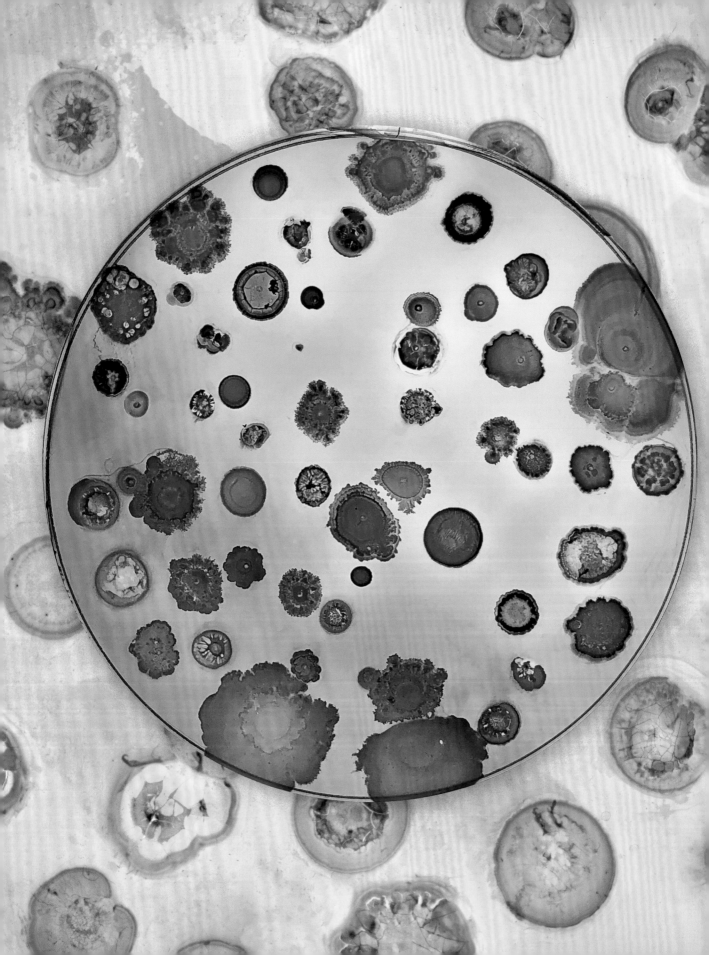

CH. 8

COMPETITION AND COEXISTENCE WITHIN OUR COMMUNITIES

Both images at left are from a sampling of four hundred co-workers, a multitude of distinct bacterial species grown in petri dishes, then stained with artistic dyes to add color and scientific dyes to highlight colonies and patterns.

Within each bacterial colony is a society of millions of individuals. Similar to how cities serve as hubs for trade and exchange, bacterial colonies are biological hubs that interact with neighboring bacterial colonies. These interactions range from cooperation and mutualistic exchange to competition and conflict, from the sharing of resources to engaging in warfare. Just as human communities work collectively to thrive, bacterial colonies engage in complex interactions and form social networks, which shape the structure and dynamics of bacterial communities.

Defense mechanisms are typically controlled by the secretion of toxins or antimicrobial substances, wherein one type of bacterial colony produces molecules that diffuse and reach the boundary of neighboring colonies. For example, *Bacillus subtilis*, found commonly in the soil and in homes, produces antibiotics such as subtilin and bacitracin to create a hostile environment for competing bacterial colonies, essentially using these mechanisms to prevent the encroachment of other bacteria in their territory. (Interestingly, this is the same bacitracin used as a topical antibiotic.)

Perhaps one of the most famous and serendipitous observations of microbial colony interaction was by microbiologist and physician Alexander Fleming in 1928. Before going on vacation, he accidentally left a petri dish containing *Staphylococcus* bacteria uncovered near an open window. When he returned, he noticed that a mold had grown on the dish, but surprisingly the area surrounding the mold was devoid of bacterial growth. He later identified the mold as a strain of the genus *Penicillium*, and he named the antibacterial substance produced by the mold, penicillin. This active compound was further developed by scientists Howard Florey and Ernst Chain, who successfully purified and developed penicillin at a large scale for therapeutic use. Many other antibiotics were found in a similar way, such as the production of streptomycin from *Streptomyces griseus*, isolated from soil bacteria and known for its ability to treat tuberculosis (*Mycobacterium tuberculosis*) and the plague (*Yersinia pestis*).

Especially within the confined space of a petri dish, it is possible to observe how bacterial colonies cooperate or compete. Within the Danino lab, we generated petri dishes to illustrate bacterial coexistence, using soil bacteria isolates such as *Bacillus mycoides*, *Paenibacillus*, *Bacillus cereus*, and others. The results were then each stained; artistic and scientific dyes were poured on top of agar plates and then rinsed out to reveal the stained bacteria. The artistic dyes add color to the dish, while the scientific stains only target the bacteria, which allows viewers to easily distinguish microbial colonies and patterns. The results portrayed the life of microbes as they communicated with one another, competed for resources, and evolved together in larger communities. Two species of bacteria, *B. mycoides* and *Paenibacillus dendritiformis*, were spotted at multiple locations along a large square petri dish (see page 121, top image). Each colony exhibited its own unique growth pattern, some filamentous, some with other swarming morphologies. In this case, microbes grew without much inhibitory interaction and their colonies filled the available space of the petri dish; however, some inhibited growth of nearby colonies, as seen by the "halo" around a colony.

In another experiment, we placed a single colony of a swarming *B. mycoides* species at the center to initially dominate the space in the dish. We opened the lid of the dish (not commonly done in our lab) to see what happens when external bacteria from the environment invade (see page 121, bottom image).

Several smaller colonies grew, albeit with limited radius since they did not have the ability to rapidly move across a solid surface like other swarming bacterial species do. They were able to block pathways of the original *B. mycoides* growth pattern. In another version of the same experiment, we allowed the bacteria to grow for a longer time, showing how the invaders, particularly the *Paenibacillus*, are able to take over much of the empty space and coexist with other species (see page 120, bottom image). Lastly, to explore antagonistic relationships more simply, we spotted only colonies of *B. pseudomycoides*, which grew in local clusters and did not encroach on each other's territories (see pages 122 and 123). Ultimately, whether their interactions were antagonistic, beneficial, or indifferent, the various bacterial colonies populated their surroundings and eventually evolved into a permanent state of coexistence.

Humans' coexistence with microbes profoundly shapes microbiomes. For example, people who live together come in close proximity, touch the same surfaces in the household, eat similar food—and share microbes. Studies have shown exchanges of millions of microbes, from 80 million by kissing to 120 million by shaking hands. Families tend to share their own distinct bacterial strains; one recent study showed that family members share more similar oral, gut, and skin microbiota than that of unrelated people. Even parents who are not genetically related have more microbial overlap with their children than with unrelated children. These micro-bonds might even last a lifetime, with one study finding shared strains between mothers and their adult daughters. "Work families" also share microbiota, because offices' communal restrooms, kitchens, and meeting rooms are all places to easily exchange not just ideas but microbes as well.

To visualize microbes living among a population, the Danino lab sampled bacteria from about four hundred people. A communal bowl with saline solution was placed at the entrance of a company event, and employees dipped their fingers or hands into the bowl to "donate" a sample. As they did this, some bacteria would slough off from each person's hands and get added to the collection. After the event, we streaked some of this communal sample solution

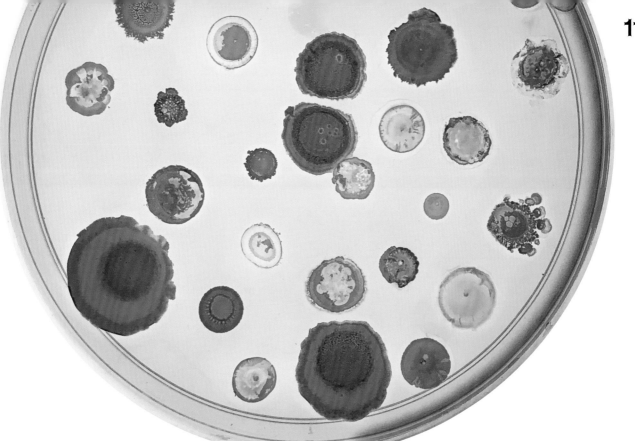

Dozens of bacterial colonies grown from a communal sample of four hundred co-workers. These species, predominantly from the skin microbiome, show limited growth and motility compared to soil bacteria.

onto the gel in petri dishes to allow for bacterial growth. We then selected a diverse set of bacteria, stained them with dyes for visibility, and for display sealed the bacteria into petri dishes using a resin.

Another project involved a number of microbial samples within a social network that illustrated the varieties of ways shared microbes flourish (see pages 124–27). In 2015, I collaborated with artist Anicka Yi to grow samples, collected from women within a social network, in petri dishes as part of one of her art series *You can call me F*. After weeks of growth, these turned into what looked like abstract paintings within circular canvases, with mostly bacterial but also fungal colonies in a variety of colors that grew on the dishes. Each is a record not just of an individual person's microbiome coexisting within a network at a specific geography and time of life, but also the patterns of competition and coexistence that exist within the microbial world.

Competition and coexistence have defined the time we humans have spent on our planet. But perhaps, as Louis Pasteur said in the nineteenth century, "The microbes will have the last word." Imagine a future beyond the current Anthropocene, the geological epoch when human activities are the dominant influences on earth's ecosystems. Due to the threat humans pose to global climate and geological change, perhaps microbes will remain as the only species left on the planet, as they were billions of years ago. In this imaginary new epoch, *Microbocene*, microbes might construct and inhabit sprawling cities at vast scales, gradually evolving into a harmonious and enduring state of coexistence.

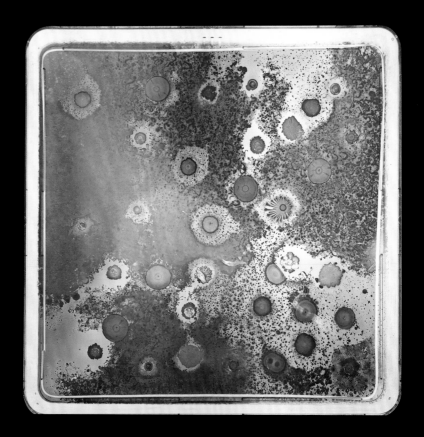

(this page and opposite) Soil bacteria spotted in large square petri dishes grow to fill the space. Some colonies interact innocuously, but some repel others as seen by a "halo" around a colony.

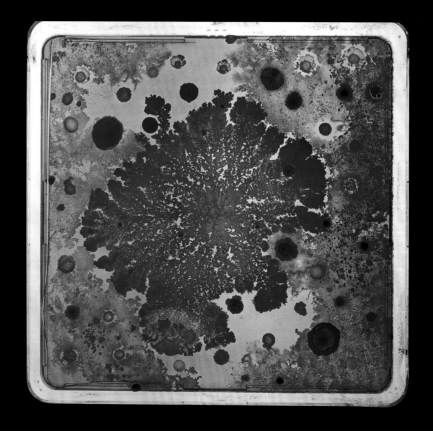

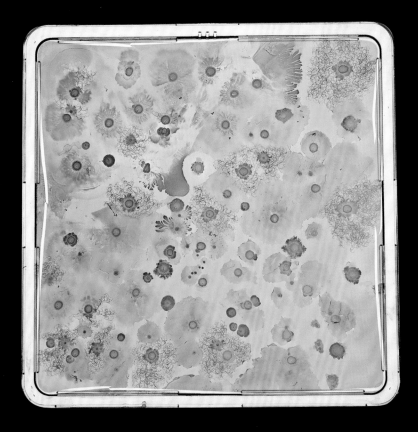

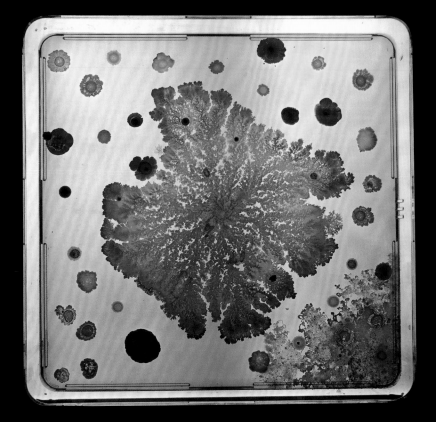

(this page, bottom) ***Bacillus mycoides*** is at the center, slowed by some smaller colonies. An invading colony of *Paenibacillus* species started growing and swarming across the plate.

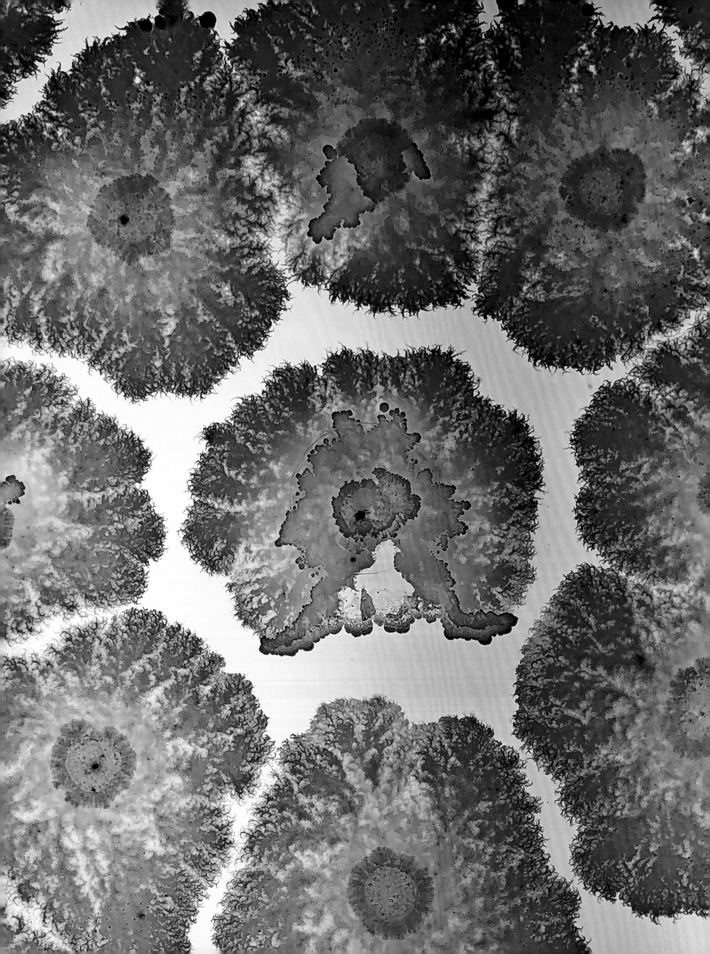

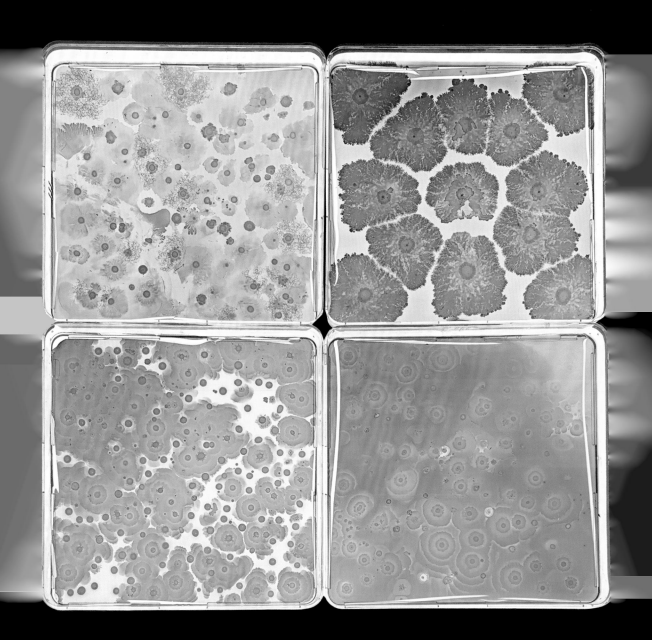

Petri dishes generated from swabbing and collecting one hundred different samples of bacteria from women for our lab's 2015 collaboration with artist Anicka Yi.

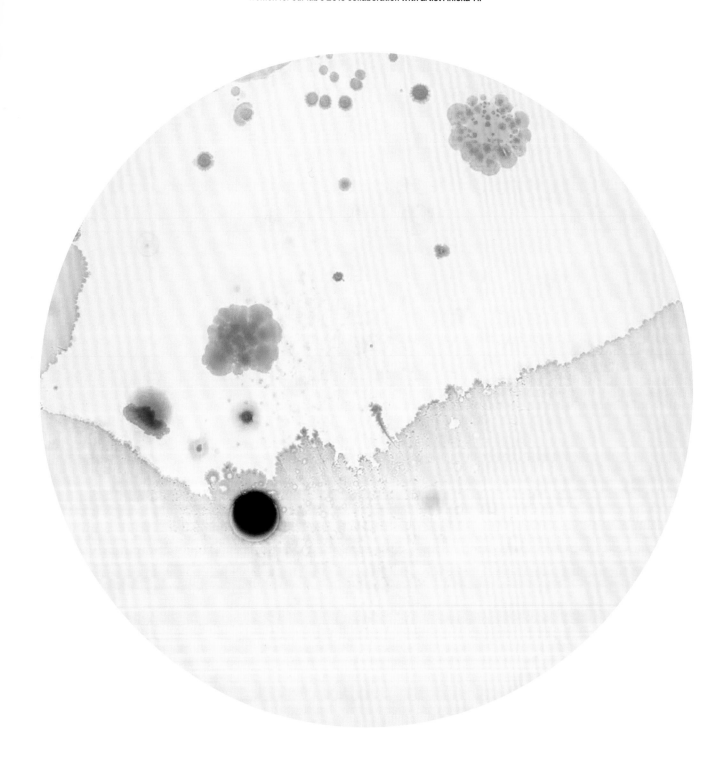

PERSON NO. 1

In each dish, diverse bacteria and fungi collectively form intricate microworlds, resembling otherworldly landscapes.

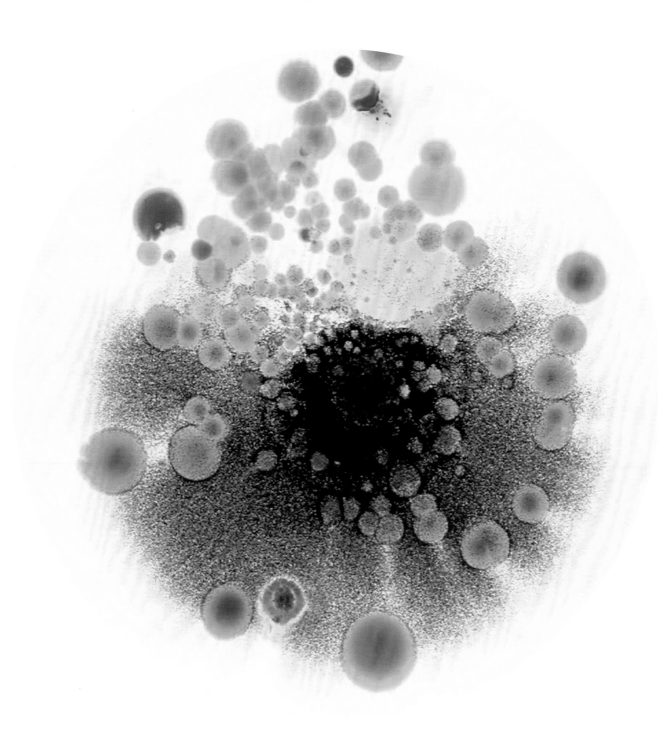

PERSON NO. 2

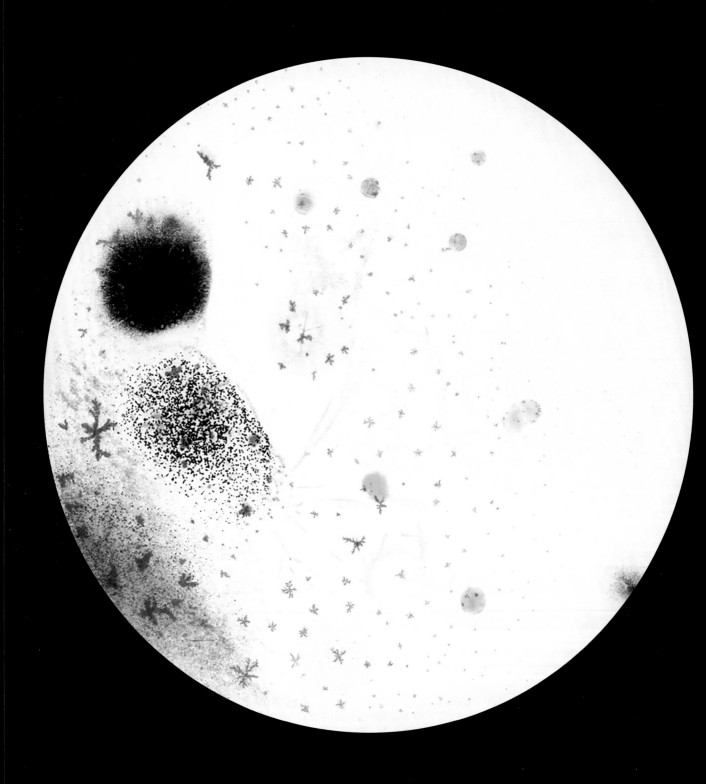

PERSON NO. 3

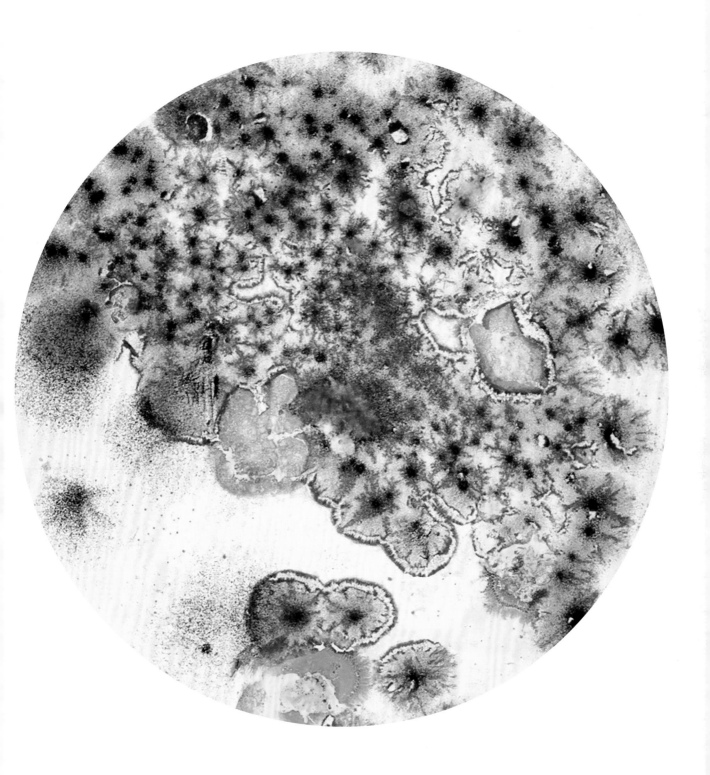

PERSON NO. 4

(this spread and following spread)
**Multiple bacterial colonies
spotted from a communal sample,
which were stained, dried, and
embedded in resin.**

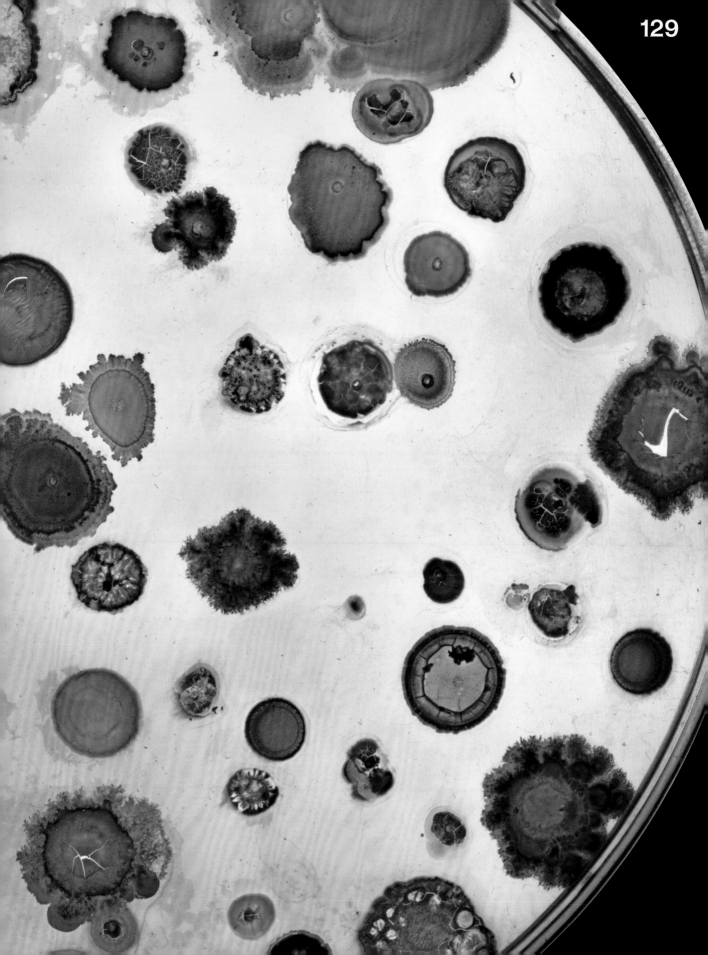

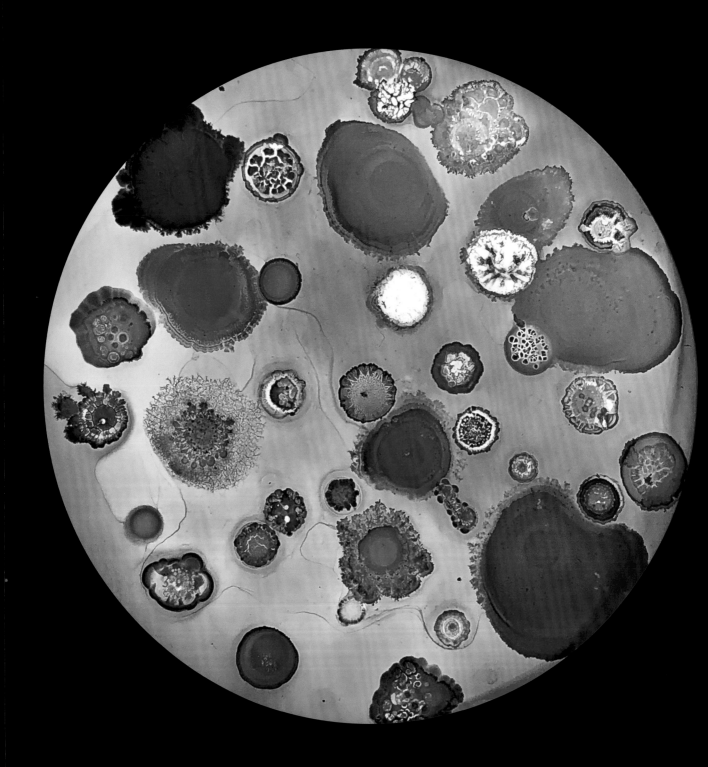

COMMUNAL SAMPLE

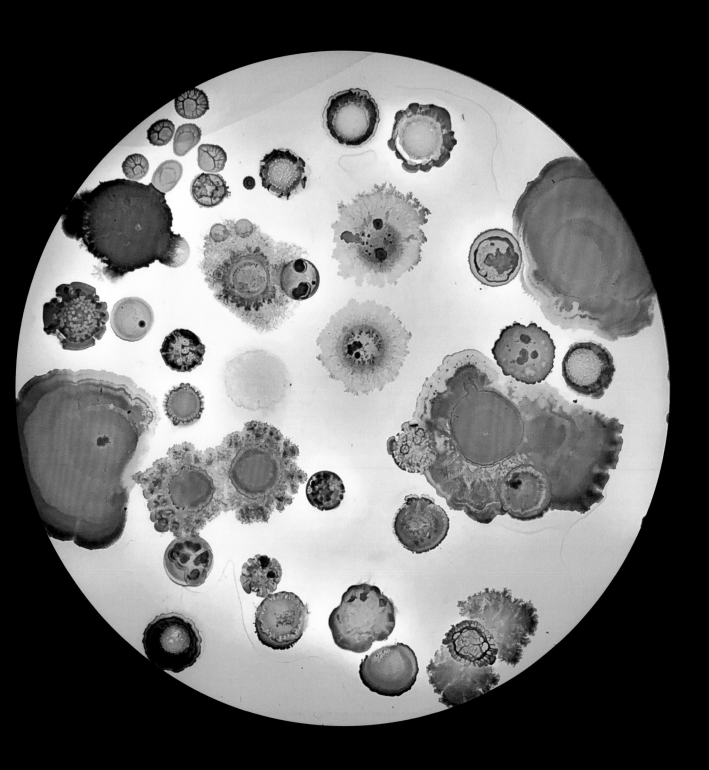

COMMUNAL SAMPLE

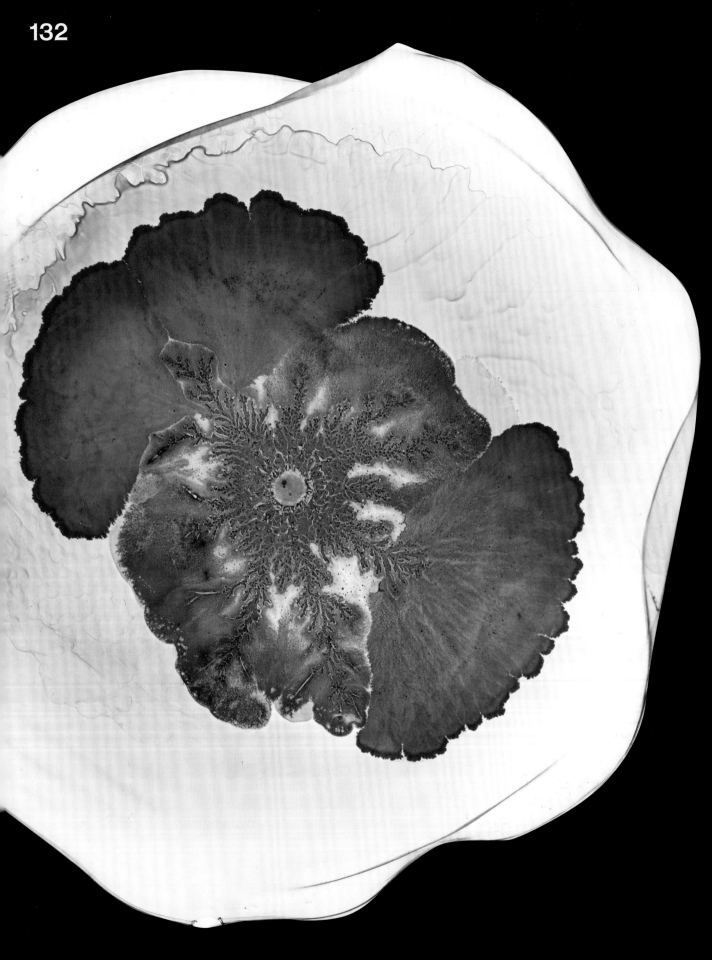

CH. 9 *MICROBIAL MAPS* ON OUR EARTH

A species of
bacteria
isolated from
soil and
grown in a
petri dish.
After being
stained and
dried, the
agar in the
petri dish lifts
and curls
away from
the dish.

Right beneath our feet is one of the most diverse and mysterious communities of microbes on the planet. Often overlooked as mere "dirt," soil is a remarkable composition of minerals, organic components, and a vast array of microorganisms. Microbes serve as the living skin of our planet's land surface, harboring a vibrant community of bacteria, fungi, and other organisms. These microbes contribute to essential functions of the planet such as decomposition, carbon and nutrient cycling, disease suppression, and regulation of plant growth. In just a single teaspoon of soil reside a billion bacteria, representing more than a thousand different species. If the human gut can be likened to a bustling metropolis, the soil is like an expansive intergalactic city with microbes among other soil-dwelling residents such as earthworms, nematodes, mites, and a variety of insects such as beetles, ants, and termites, all of which weave together a complex web of interactions that shape life on our planet.

"We know more about the movement of celestial bodies than about the soil underfoot," Leonardo da Vinci once observed. The first step in uncovering the function of microbes in the soil and other ecosystems has been to create a microbial map or catalog. Most recently, efforts toward creating comprehensive genomic records of the earth's microbiomes have begun, including more than 50,000 genomes of bacteria that were sequenced and cataloged. It is still the early days of cataloging what bacteria are out there, but it's already clear that the diversity of microbes is beyond previous estimates, with fascinating forms and patterns yet to be explored.

Given the sheer diversity of bacteria on earth, perhaps one of the biggest surprises is how similar the planet's bacterial inhabitants can be. One study discovered more than 120,000 species of bacteria thriving in the soil of New York City's Central Park, with most of them previously not identified. However, the diversity of bacteria found in other regions of the world and collected from natural ecosystems was comparable to Central Park's. The study described

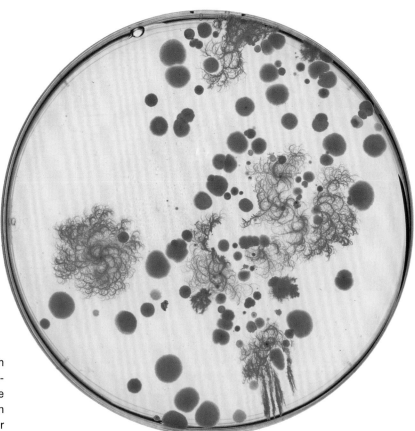

Soil from Isham Park, New York City, collected and spread on LB agar in a petri dish. Many filamentous swarming species are present.

how environmental conditions in soil, such as pH and temperature, rather than climate or geographic distances, have more influence on which bacteria live where. In other words, in order to study and discover new microbes, you don't need to travel far beyond your home.

In this chapter are shown samples of the soil isolated from my home, from a potted indoor ficus plant, outdoor plants, leaves, and rocks. One of my lab colleagues, Soonhee, collected samples from various corners of the globe, encompassing diverse ecosystems that span continents, from hiking paths to sandy beaches and water regions. In one example from our lab, students collected soil from about twenty-five parks in Manhattan. The diversity of patterns and colonies looks fairly similar across parks. Many are a *Bacillus* species including *B. cereus*, *B. wiedmannii*, and *B. subtilis*. We also used black agar, which is utilized mostly for isolating *Legionella* pathogenic species but in this context for aesthetic purposes and enhanced contrast. Under the right growth conditions, some of the bacterial colonies are able to form patterns that are light in color, providing a high-contrast, dramatic backdrop.

Beyond its extraordinary diversity, soil is one of the most important ecosystems that we depend on for food production, energy, and economic prosperity. Soil can be considered in some ways more valuable than oil, but while critical to our society, it has become unappreciated in the increasingly city-dwelling world that is disconnected from the land beneath it. Today, many farming practices such as deforestation and overgrazing have caused significant areas of degraded soil. In addition, the use of agrochemicals such as pesticides that help increase yields in the short term inevitably disrupts the balance and quantities of microorganisms in the soil and stimulates the growth of harmful versus beneficial bacteria. As a result, degraded soil now covers

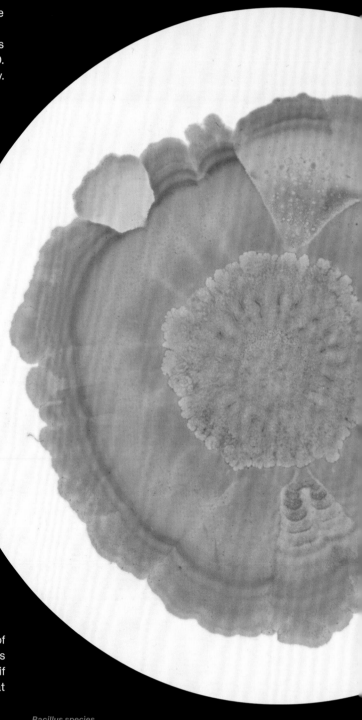

15 to 30 percent of the earth's land surface, which makes land less useful for food and fiber production and carbon dioxide sequestration, leaving a major impact on climate change.

"A nation that destroys its soils destroys itself." What President Franklin D. Roosevelt stated in 1935 remains true today. The soil is composed of a useful ecosystem of minerals and microbes for society and has dramatic implications for global climate and health. Microbes play a fundamental role in sustaining this ecosystem and are vital for the sustainability of the planet. However, the influences of the microbial world on environmental issues such as climate change and sustainability are rarely seen. That is why, for one of the Danino lab's projects, we chose to subtly communicate the role of microbes found in soil, via a process akin to manufacturing food, in which we cultivated, dried, and preserved bacteria for display in a grid that both evoked the distinct rectangular and circular shapes of farm use as seen from aerial views.

Combined, science and art bring attention to the connections between the collective health of human beings and that of the planet, and between the invisible world of microbes and climate change. Here the medium is the message: the tiniest organisms may be the key to one of the biggest problems that the world faces today. Sustainable solutions are possible if we understand—and can engineer—what lies in the minds of living bacteria.

Bacillus species isolated from Santa Monica, California, beach sand and grown in a petri dish.

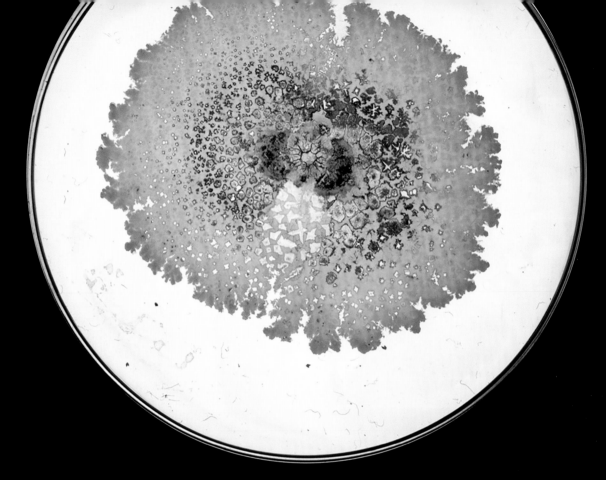

(top and bottom) *BACILLUS SUBTILIS* (FLORIDA), *BACILLUS PUMILUS* (TANZANIA), both on HiCrome agar

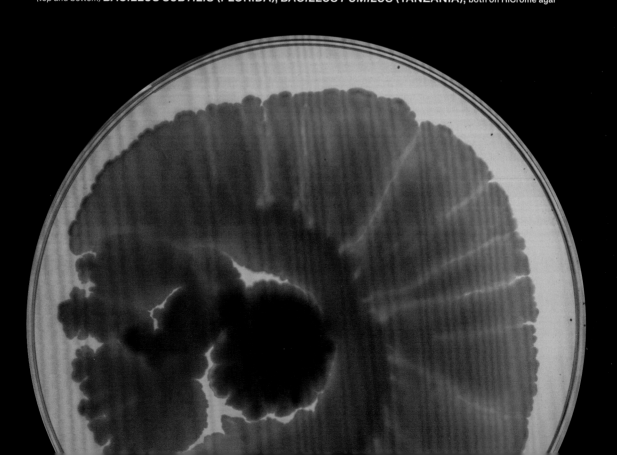

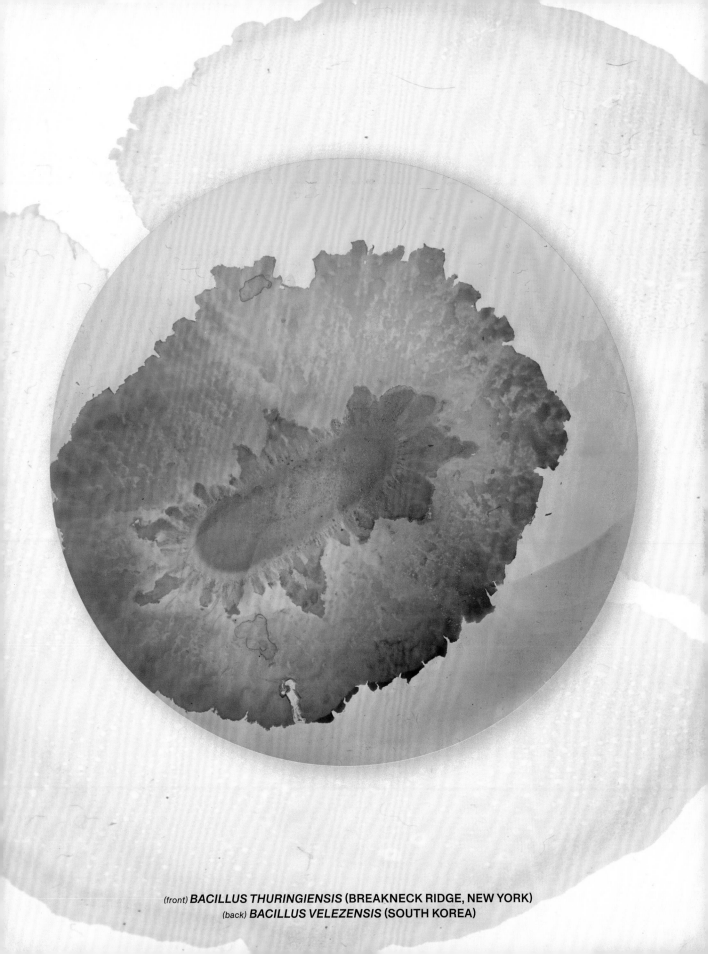

(front) *BACILLUS THURINGIENSIS* (BREAKNECK RIDGE, NEW YORK)
(back) *BACILLUS VELEZENSIS* (SOUTH KOREA)

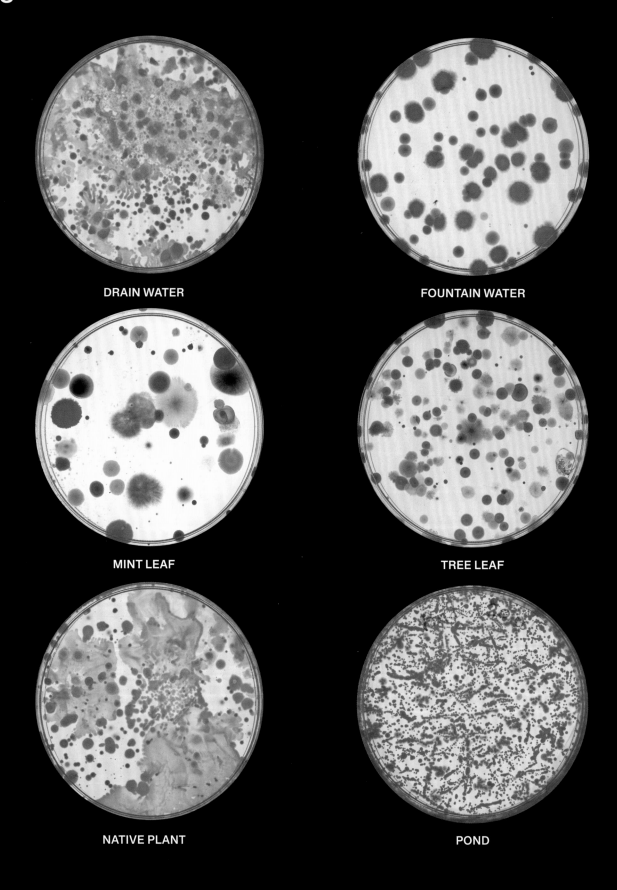

DRAIN WATER

FOUNTAIN WATER

MINT LEAF

TREE LEAF

NATIVE PLANT

POND

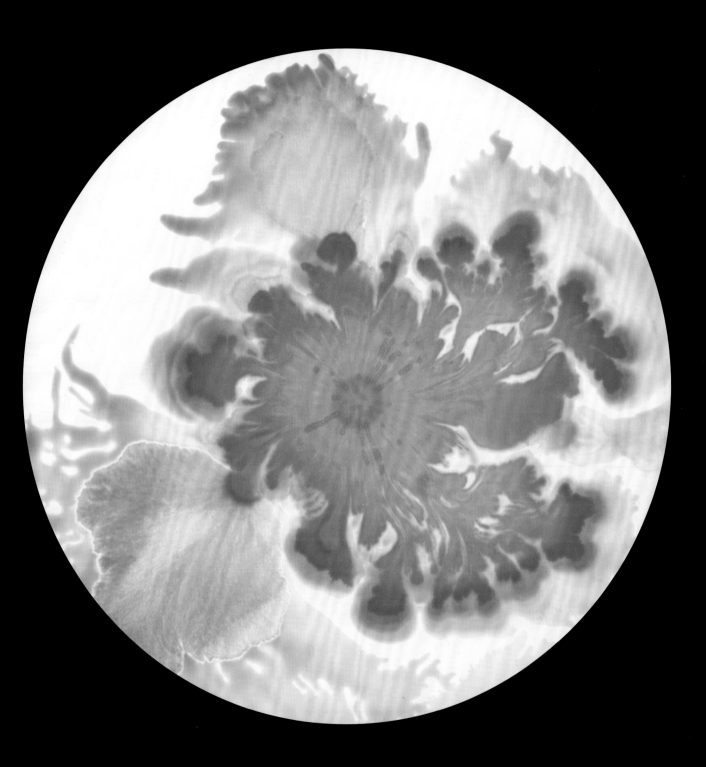

GARDEN SOIL

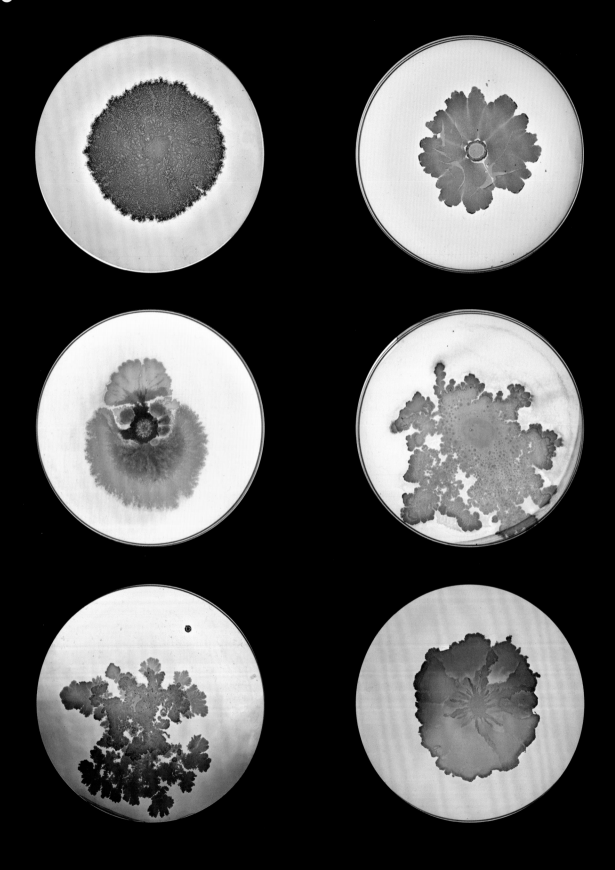

(opposite and this page) **SAND BACTERIA ISOLATES (VENICE BEACH** and **SANTA MONICA BEACH)**

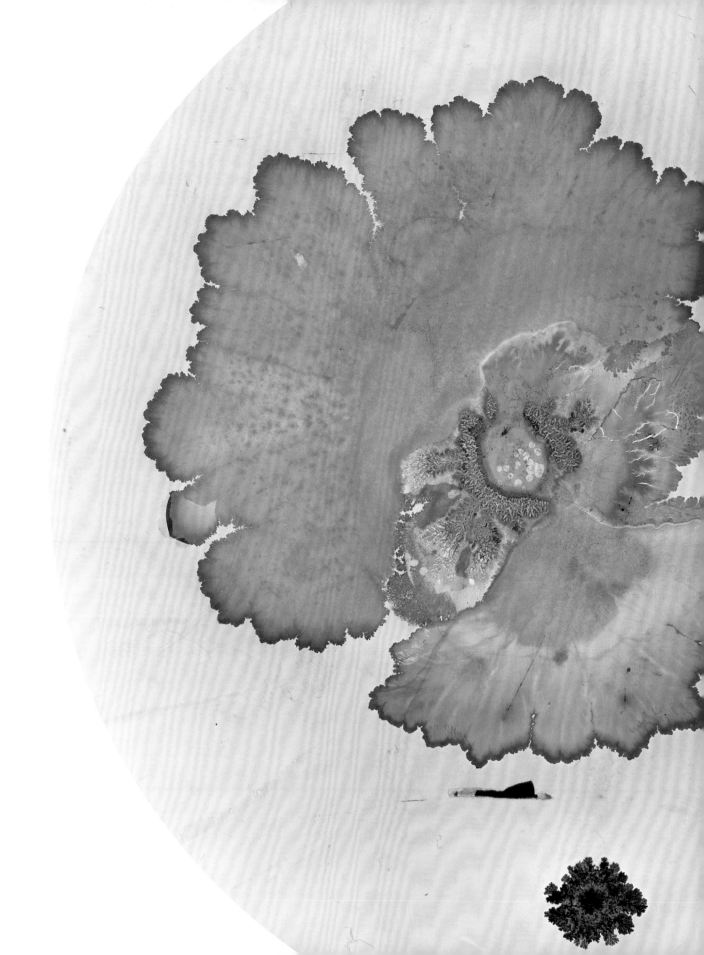

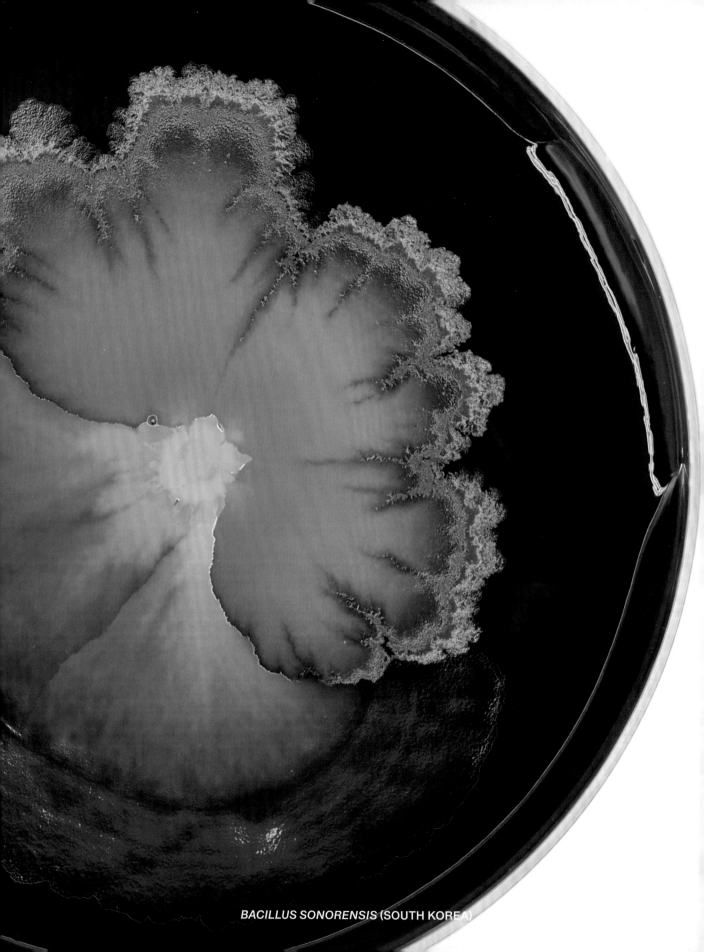

BACILLUS SONORENSIS (SOUTH KOREA)

Isolates from soil samples, grown on black agar for enhanced contrast.

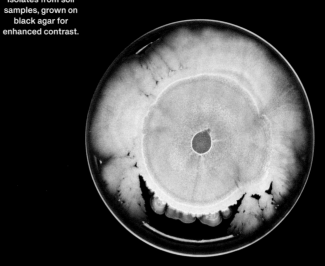

BACILLUS CEREUS (**NEW YORK CITY**)

BACILLUS VELEZENSIS (**SOUTH KOREA**)

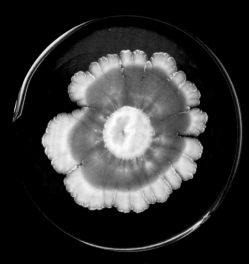

BACILLUS VELEZENSIS (**SOUTH KOREA**)

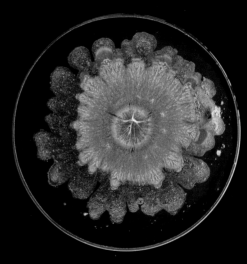

BACILLUS NAKAMURAI (**SOUTH KOREA**)

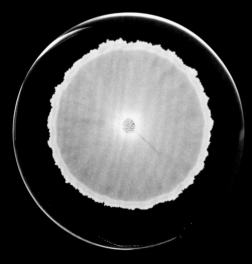

BACILLUS SUBTILIS (**BACILLUS GENETIC STOCK CENTER**)

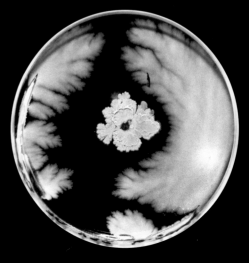

BACILLUS SUBTILIS (**VENICE BEACH, CALIFORNIA**)

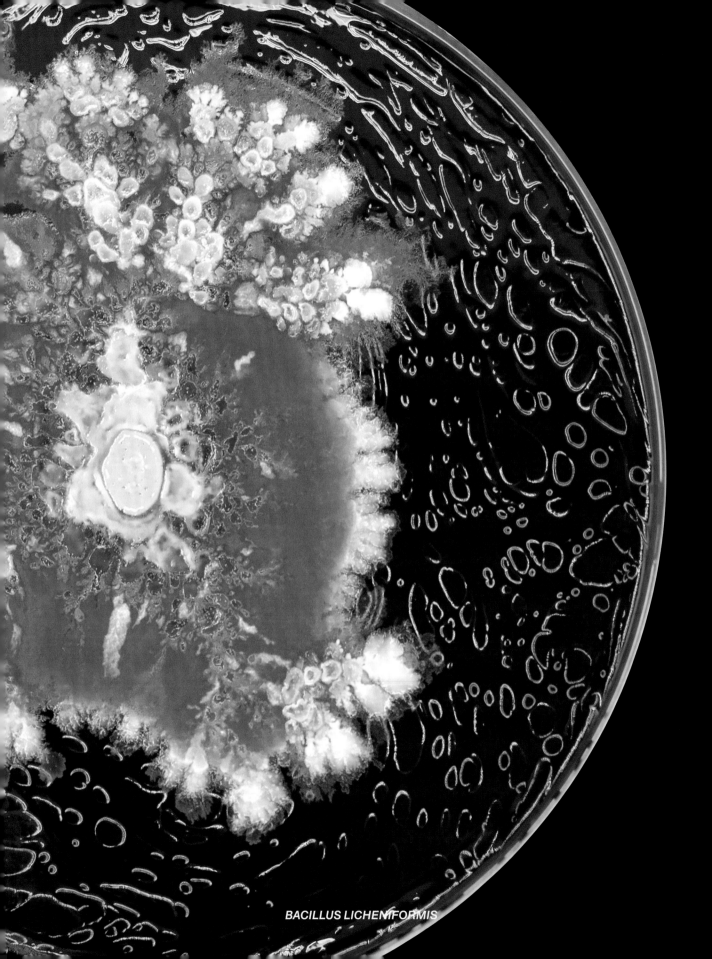

BACILLUS LICHENIFORMIS

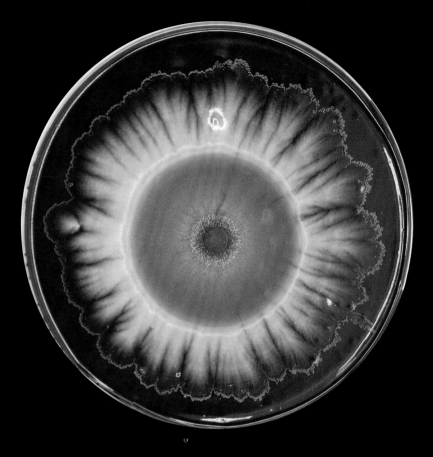

(top and bottom) BACTERIA Both isolated from garden soil, New York City, and grown on black agar

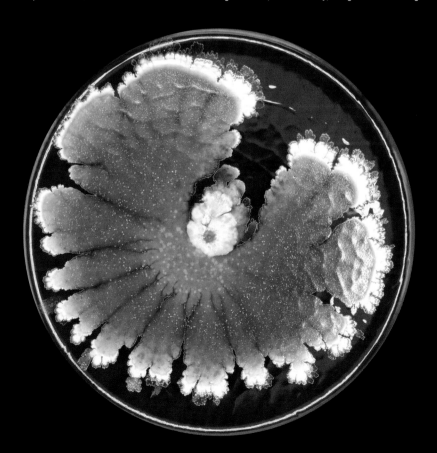

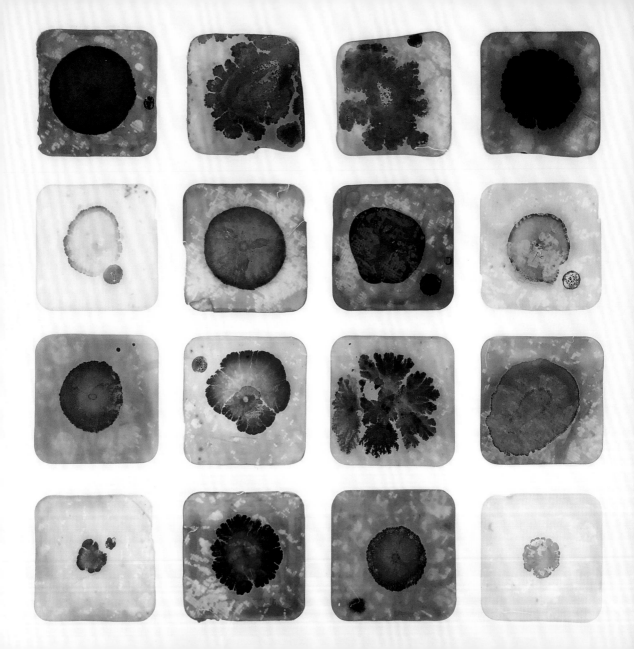

Each of these isolates represents a minuscule fraction of the more than a thousand bacterial strains that live in a teaspoon of soil.

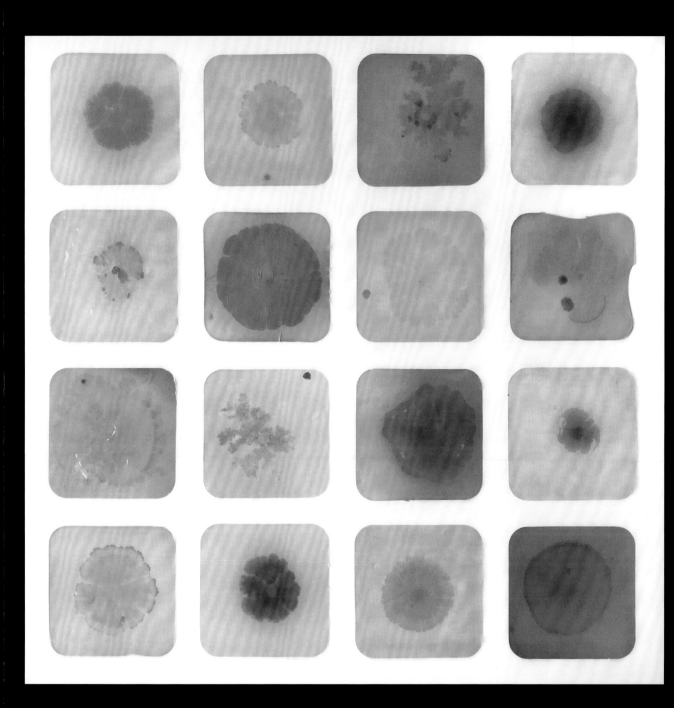

ISOLATES OF SOIL BACTERIA

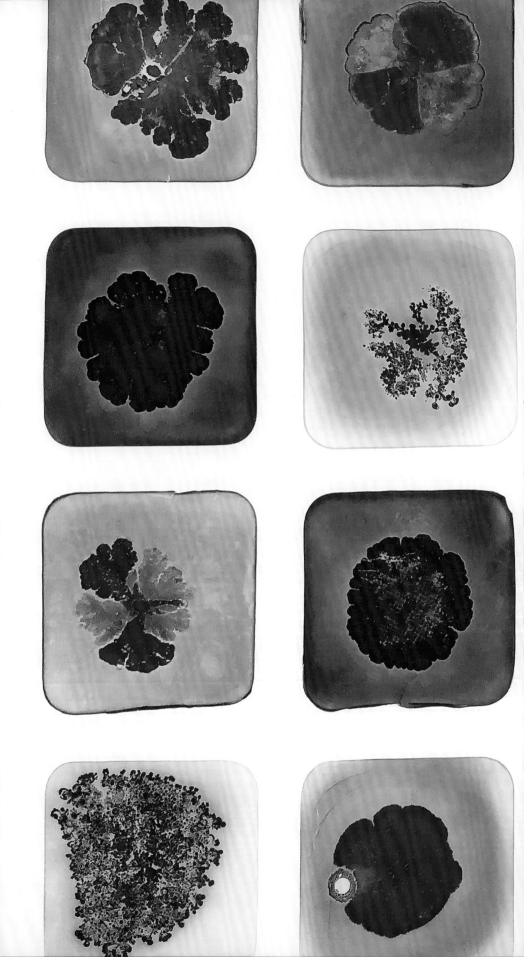

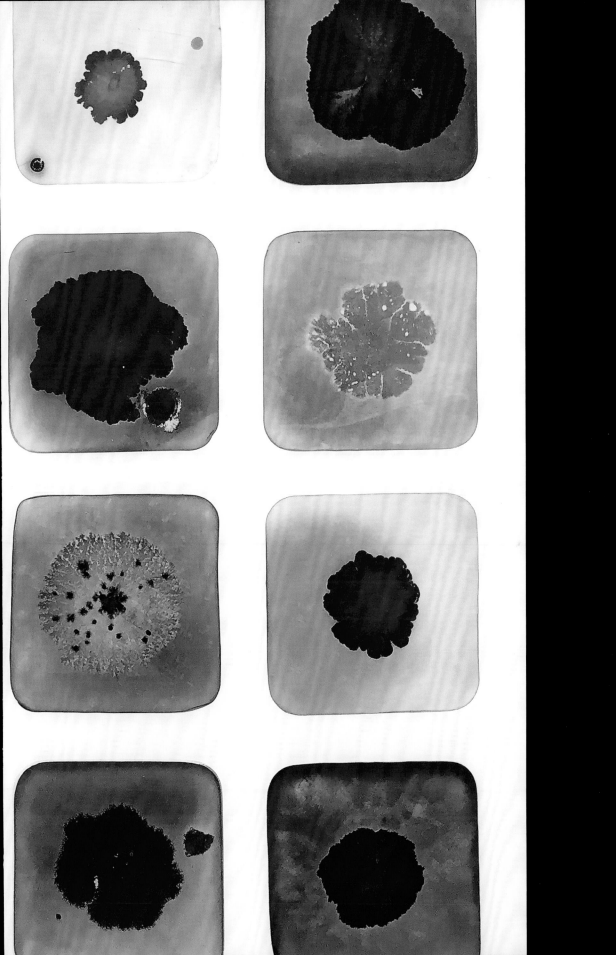

FOR I DIPT INTO THE FUTURE, FAR AS HUMAN EYE COULD SEE,
SAW THE VISION OF THE WORLD, AND ALL THE WONDER THAT WOULD BE. —

Alfred, Lord Tennyson, "Locksley Hall" (1842)

PART

4

BACTERIA
AND OUR FUTURE

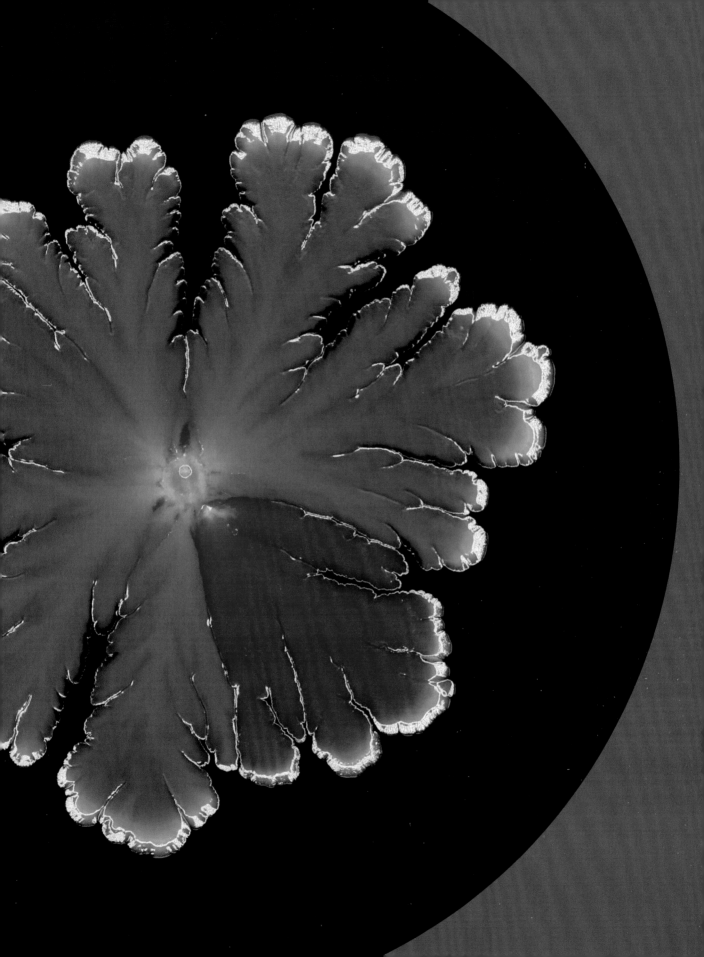

CH. 10 *HARNESSING CHAOS*
BACTERIAL DESIGN

Escherichia coli genetically engineered to produce a pink-colored protein. When grown on black agar from the center of a petri dish, part of the colony eventually evolves to reduce or eliminate this protein's production.

It is a mistake to view microbes as simple and predictable. Their world isn't rigid and orderly but instead is a blend of chaos and randomness. Yet within their world, microbes display an innate capacity to reliably adapt and evolve, no matter the challenge, easily growing and producing an astounding variety of molecules. After all, tiny as they are, they're like other organisms with their own minds, carrying out functions that serve their own survival. These characteristics and abilities are what make microbes a unique kind of partner in a modern collaboration between organisms: genetic engineering.

The manipulation and control of genetic material have opened up unprecedented possibilities, from the modification of crops for increased yields to the development of lifesaving medical treatments. In the history of biotechnology, microbes were the first organisms to be genetically manipulated, in 1973, by Herbert Boyer and Stanley Cohen. Boyer and Cohen performed an experiment in which a gene conferring antibiotic resistance was cut and pasted into plasmid DNA—a circular, mobile DNA molecule that bacteria harbor.

In nature, bacteria take in plasmids all the time, and this is their way of exchanging DNA material. In the lab, plasmids are the workhorses for basic genetic engineering, and they are much easier to manipulate than the entire genomes. Bacteria also exchange DNA via bacteria-specific viruses (called bacteriophages), or by direct cell-to-cell contact through pili (called conjugation), which are also used in the lab to manipulate bacterial genes.

The utility of genetic engineering is exemplified in the production of insulin. Insulin is utilized for patients with diabetes to regulate glucose levels, since their pancreatic cells do not respond properly to levels of glucose that can be toxic. Insulin was primarily purified from the pancreas of animals; however, it caused allergic reactions in many patients. With the rise in understanding of biotechnology, scientists worked to put a piece of plasmid DNA encoding for the human insulin gene into *Escherichia coli* bacteria. The *E. coli* took up the plasmid containing the gene and were able to produce the protein, by virtue of the instructions encoded in the DNA sequence (and the amazing fact that life's

genetic code is shared across all organisms). The bacteria were then grown in large vats, the protein purified, and bacteria-produced insulin was sold for human use in 1982. Since then, the vast majority of insulin used worldwide has been produced by genetically engineered bacteria. Now, by swapping out the insulin gene with other genes, scientists can harness bacteria to synthesize therapeutic compounds, vaccines, industrial enzymes, and essential chemicals.

Another active area of research is using bacteria to produce dyes for the textile industry. Synthetic dyes can require significant demand for energy and water and lead to pollution of water supplies. Some bacteria naturally produce pigments, such as *Serratia marcescens* (see Chapter 7) and *Streptomyces coelicolor* (which produces an ultramarine pigment) but culturing them can be challenging. Thus, many commercial approaches are focused on engineering pigment genes into optimized host bacteria, and then growing bacteria in large vats for mass production. In addition to small-molecule pigments such as indigo, melanin, dopaxanthin, and indoline-betacyanin, researchers have found that chromoproteins, larger molecules that contain a pigmented cofactor, produce a palette of proteins. Our lab has put them into pattern-forming bacteria to improve their visualization and teach concepts in microbiology.

However, bacteria are not merely obedient subjects. They can be engineered to produce pigments—but they don't always want to. Producing an additional protein at high levels is taxing, leaving them less able to complete other tasks and slowing their growth. It is in their best interest to figure out how to stop producing the pigment—and once one bacterium in a population figures out how to stop, this mutated bacterium gains a selective advantage because it will be able to replicate much faster than those that do. In fact, as we have found in our lab, the more a researcher tweaks bacteria to improve production of the pigment, the better advantage a mutated bacterium will have. The rise of mutants can be seen in a petri dish, with a part of the colony spreading outward losing its pigmentation. This becomes a significant issue in commercial applications, because when large vats of bacteria are growing, a mutant can evolve and quickly take over the whole batch. At the lab, we utilized *E. coli* that contains DNA encoding for colored protein production. Each colony starts with the ability to make colors at the center of the petri dish (initial inoculum), and then mutates at different points in time. By doing this, we can visualize the complexities of evolution—in just a few hours.

Humans' ability to harness genetic engineering's potential is based on control over living organisms, particularly microbes. Yet, even within the confined space of a petri dish, microbes emerge as active collaborators rather than obedient organisms. In fact, each collaboration is a testament to the creativity and unpredictability of microbial behavior. Embracing genetic engineering approaches further allows humans to build upon the behaviors of these tiny collaborators.

Escherichia coli producing amilCP, a chromoprotein derived from the coral *Acropora millepora*.

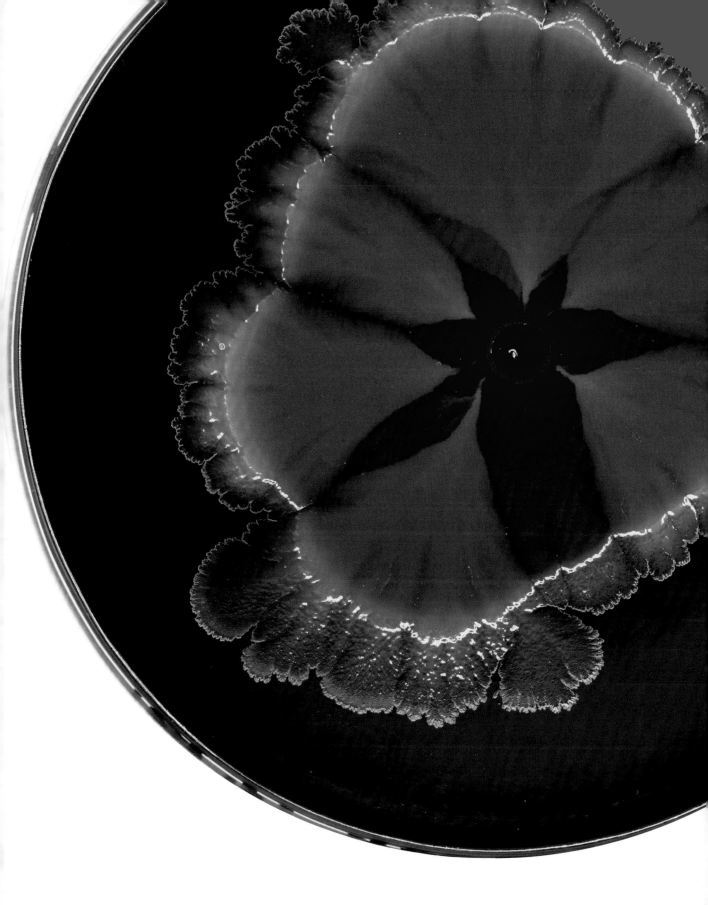

ESCHERICHIA COLI

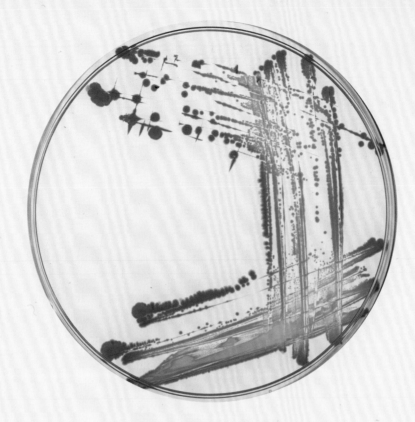

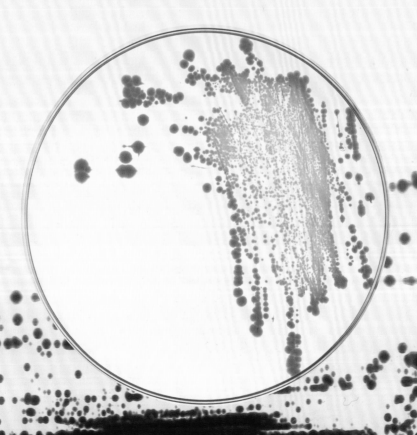

(background) VIOLACEIN PIGMENT FROM *CHROMOBACTERIUM VIOLACEUM*

(top) AEBLUE CHROMOPROTEIN FROM *ACTINIA EQUINA*
(bottom) AMILGFP CHROMOPROTEIN FROM *ACROPORA MILLEPORA*

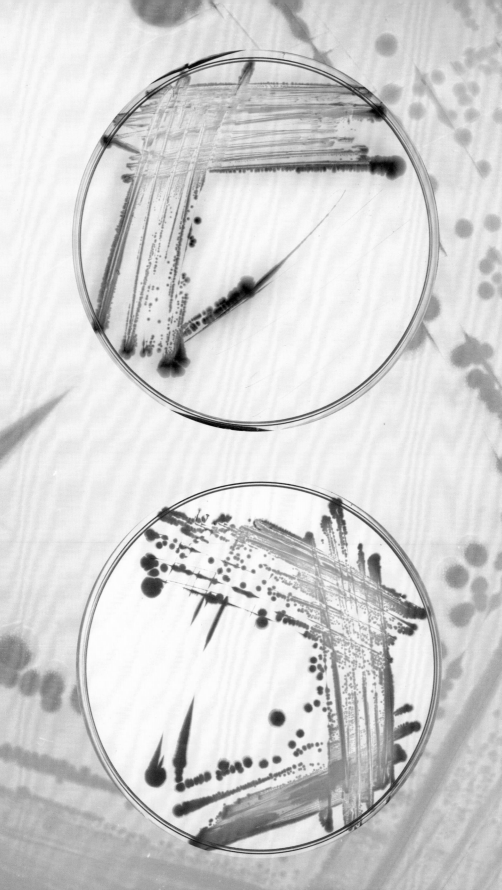

(background) **EFORRED CHROMOPROTEIN FROM *ECHINOPORA FORSKALIANA***

(top) **NISLUX GREEN CHROMOPROTEIN FROM *CHROMOBACTERIUM VIOLACEUM***
(bottom) **EFORRED CHROMOPROTEIN FROM *ECHINOPORA FORSKALIANA***

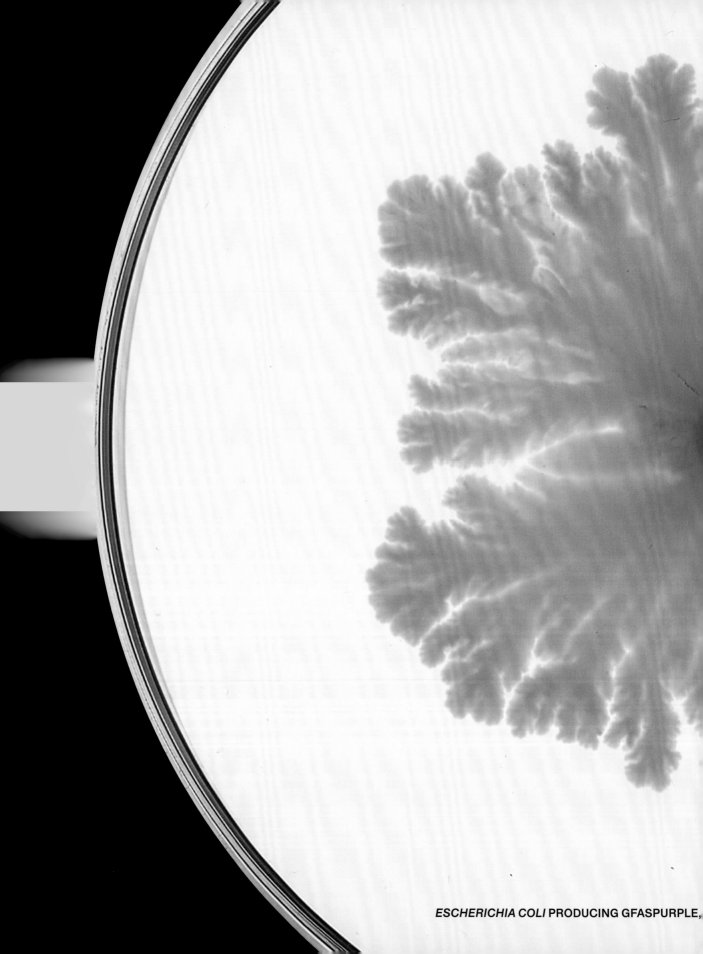

ESCHERICHIA COLI PRODUCING GFASPURPLE,

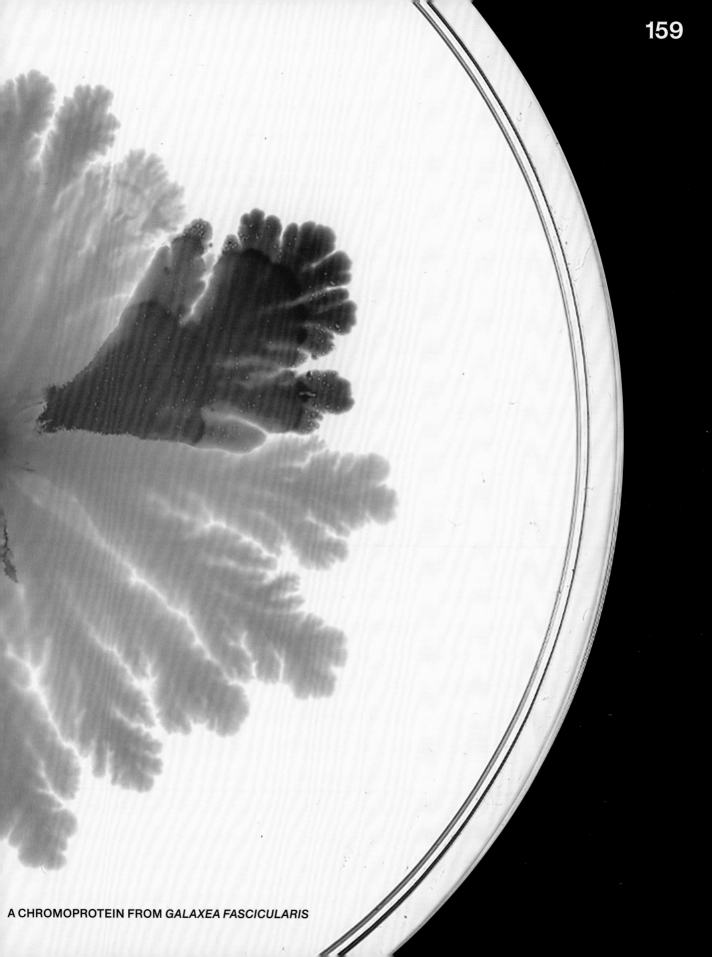

A CHROMOPROTEIN FROM *GALAXEA FASCICULARIS*

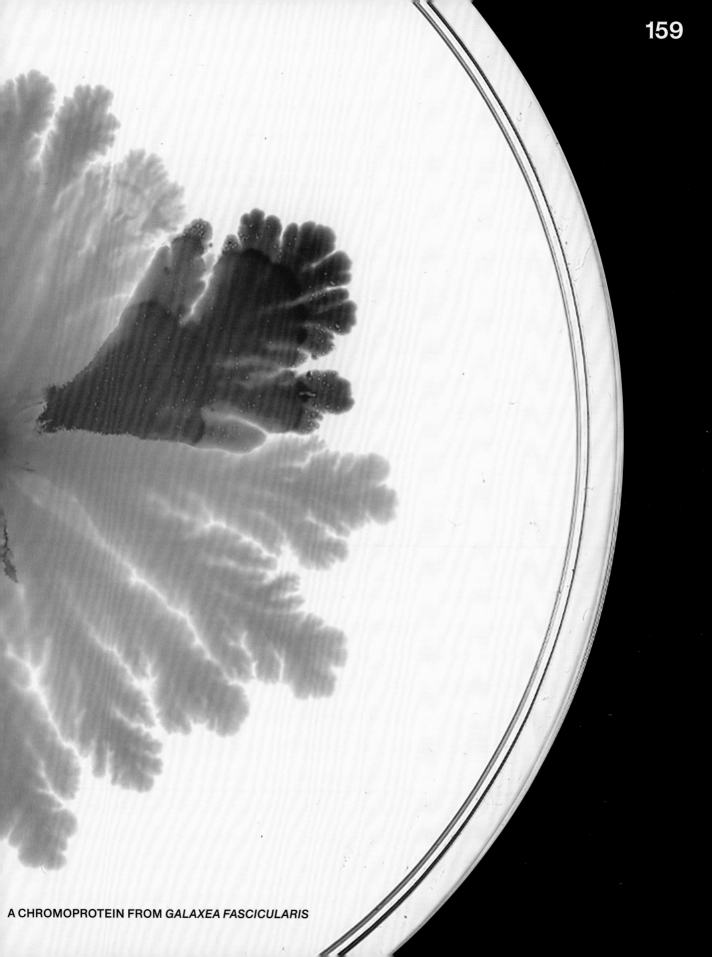

A CHROMOPROTEIN FROM *GALAXEA FASCICULARIS*

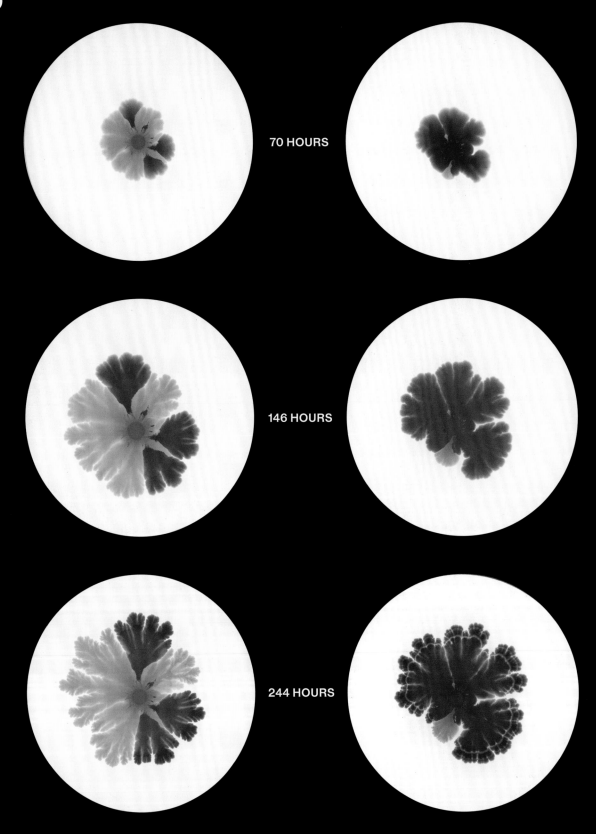

70 HOURS

146 HOURS

244 HOURS

E. COLI PRODUCING VARIOUS CHROMOPROTEINS Time-lapse sequences of growth in petri dishes.

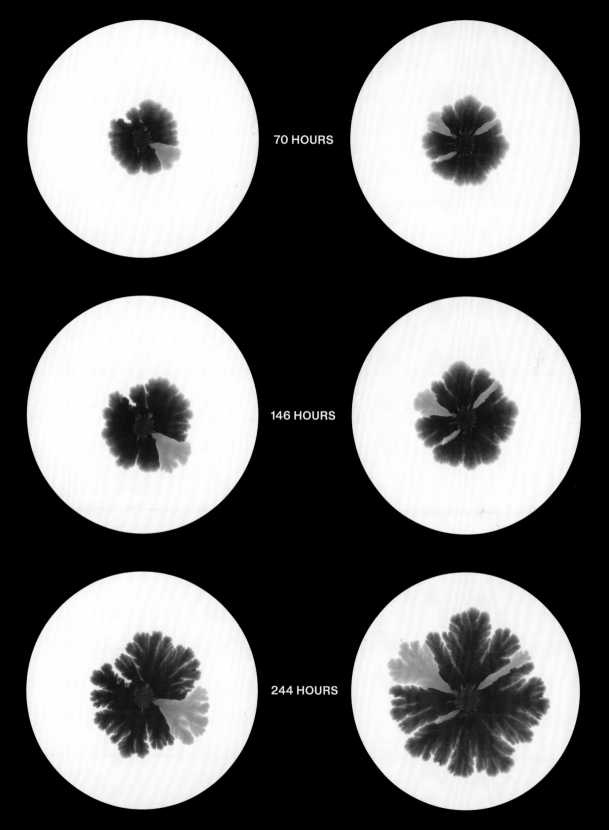

70 HOURS

146 HOURS

244 HOURS

(columns, left to right) **GFASPURPLE, AMILCP, TSPURPLE, TSPURPLE**

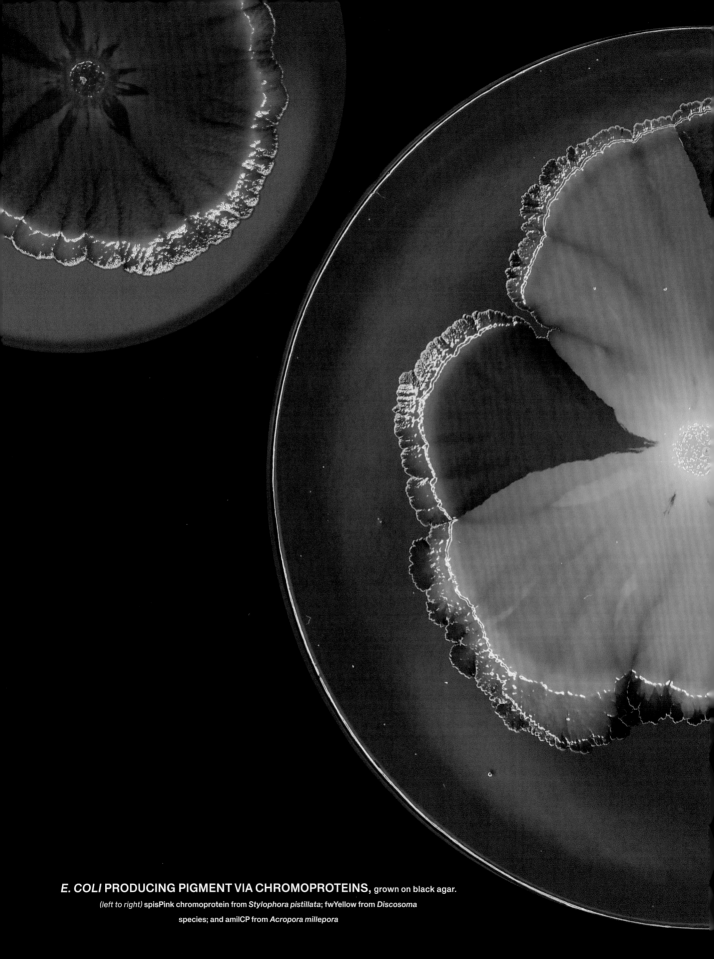

***E. COLI* PRODUCING PIGMENT VIA CHROMOPROTEINS,** grown on black agar.

(left to right) spisPink chromoprotein from *Stylophora pistillata*; fwYellow from *Discosoma*

species; and amilCP from *Acropora millepora*

Since the late 1980s, engineered bacteria have become more colorful with the discovery of blue, pink, purple, and other chromoproteins in sea creatures like jellyfish, reef-building corals, and sea anemones. Though their purpose is not always clear, these proteins are valuable as genetic markers and aids in education due to their visible colors in ambient light. This chapter's images feature chromoproteins from various species, including *Galaxea fascicularis* (gfasPurple), *Acropora millepora* (amilCP), *Stylophora pistillata* (spisPink), and *Echinopora forskaliana* (eforRed).

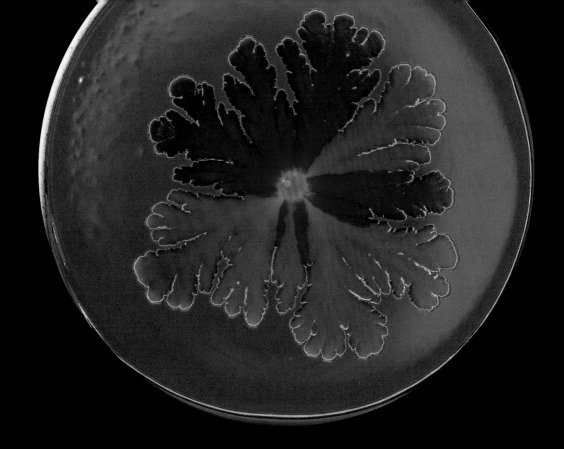

(top) SPISPINK CHROMOPROTEIN FROM *STYLOPHORA PISTILLATA*
(bottom) *PROTEUS MIRABILIS* WITH AEBLUE CHROMOPROTEIN FROM *ACTINIA EQUINA*

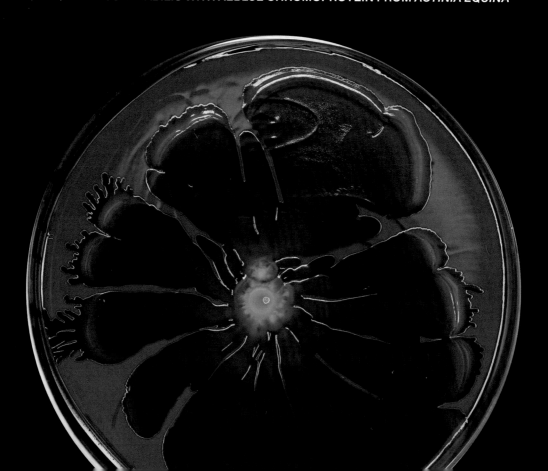

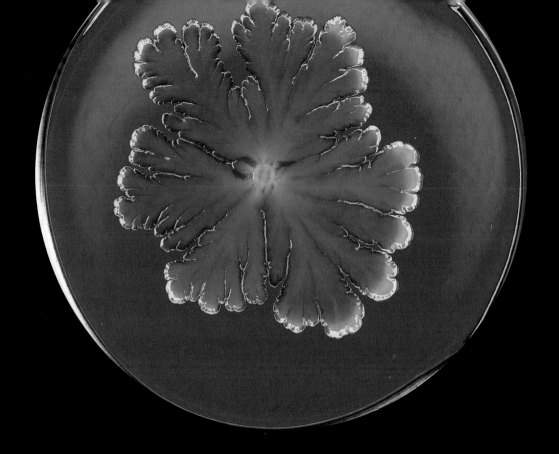

(top) ***E. COLI*** WITH ASPINK CHROMOPROTEIN FROM *ANEMONIA SULCATA*
(bottom) ***E. COLI*** WITH AMILGFP CHROMOPROTEIN FROM *ACROPORA MILLEPORA*

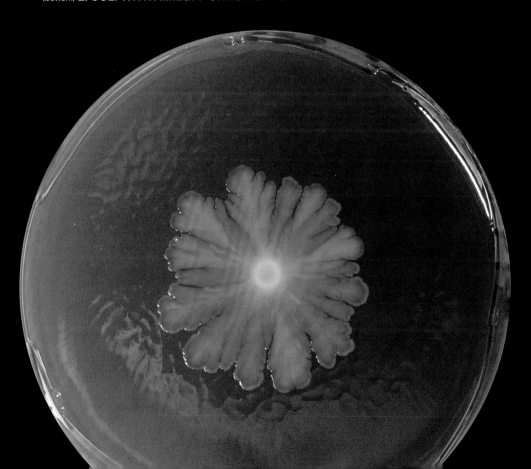

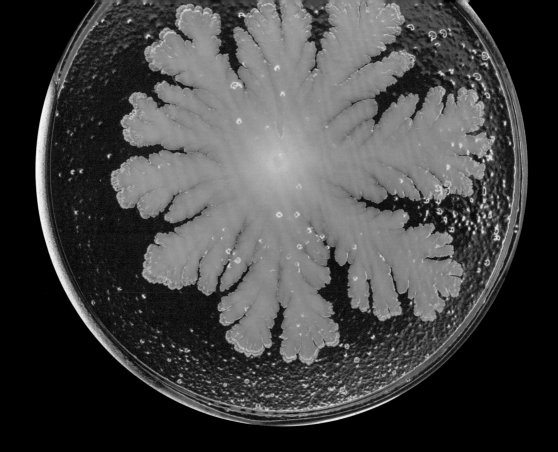

(top) *E. COLI* WITH FWYELLOW CHROMOPROTEIN FROM *DISCOSOMA* SPECIES
(bottom) *E. COLI* WITH SPISPINK CHROMOPROTEIN FROM *STYLOPHORA PISTILLATA*

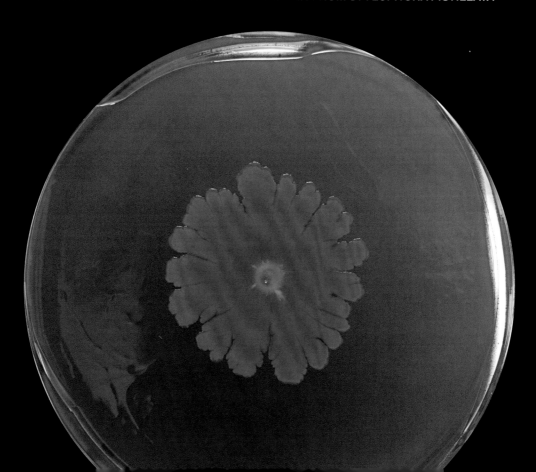

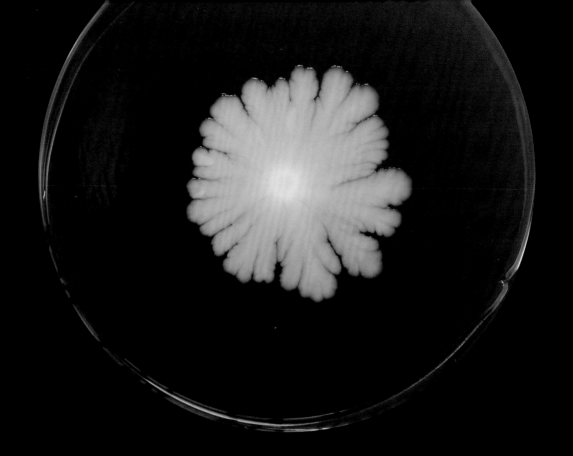

(top) *E. COLI* WITH FWYELLOW CHROMOPROTEIN FROM *DISCOCOMA* SPECIES
(bottom) *E. COLI* WITH SCORANGE CHROMOPROTEIN

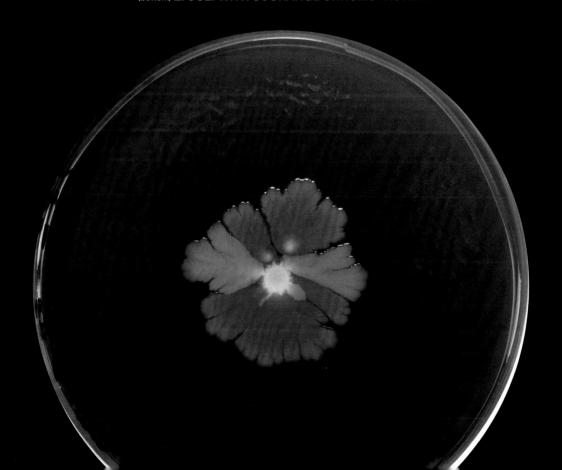

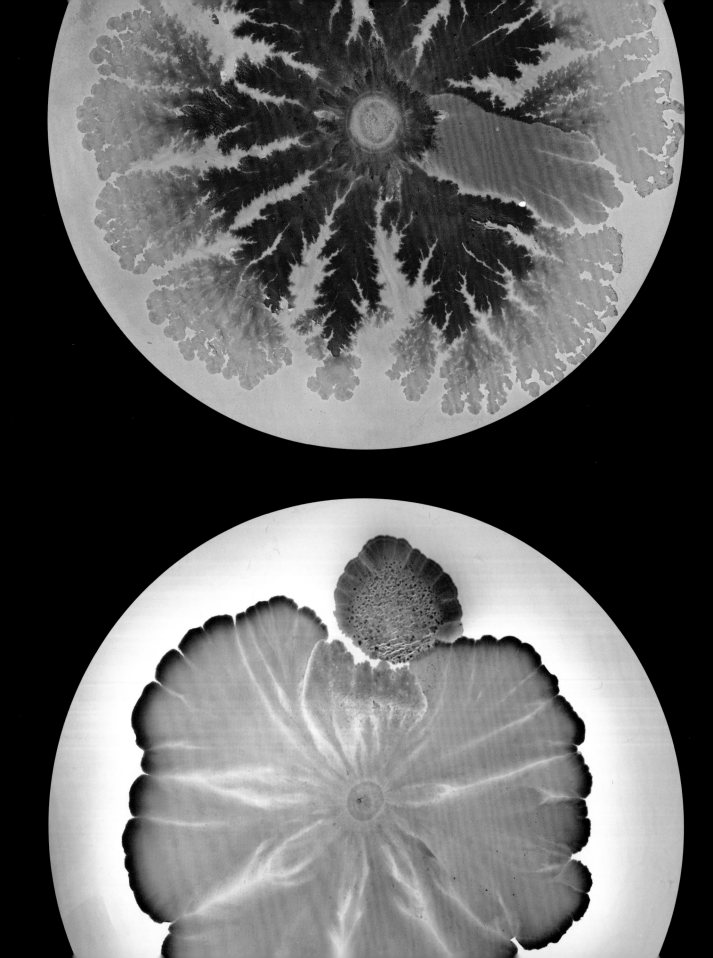

CH. 11 *REWIRING BIOLOGY* PROGRAMMING MICROBES

Various bacterial species grown in petri dishes and embedded in resin. A collection of these images (also see pages 170–71) was used to train an AI model to produce petri dish images—beyond what we could grow biologically.

Over the past two decades, researchers in biotechnology have been learning how to rewrite, rewire, and reprogram the genetic code for bacteria and other living organisms. Beyond providing bacteria with a single gene to produce a valuable product, they now insert several genes that can interact to perform more complex functions. These networks of genes, also known as genetic circuits (analogous to electrical circuits), can enable programmed behaviors.

In 2000, two genetic circuits consisting of two and three genes were published in *Nature*, marking the beginning of the field of synthetic biology—and took organismal engineering to a new level. Over time, genetic circuits have become more complex, incorporating dozens of inputs and outputs together to sense and respond to the environment. At the same time, researchers have evolved or synthesized entire genomes of bacteria using automation, sparking the potential to program microbes completely from scratch. And still other researchers, inspired by the idea of bacteria as computers, are using DNA of bacteria as storage devices, with one gram of bacterial DNA capable of storing all the world's data that has ever been generated.

Most of microbial programming has been manually performed, but artificial intelligence (AI) and machine learning (ML) have become useful tools for designing and analyzing synthetically engineered microbes. Using these tools in the lab, I became interested in thinking about microbes that could exist beyond what we can currently imagine and engineer in the biological realm. We explored using ML and generative adversarial networks (GANs) to mimic how nature programs bacteria, with our library of petri dish images as "training" data for the algorithms. The results were bacterial images that artificially created the biological processes of bacterial evolution and pattern formation, or evolution by design.

Microbes can also be used as living sensors, materials, and therapeutics. To further the idea of bespoke probiotics, administered in the body, that can sense and respond to disease, the Danino lab focuses on engineering bacteria as a cancer therapy.

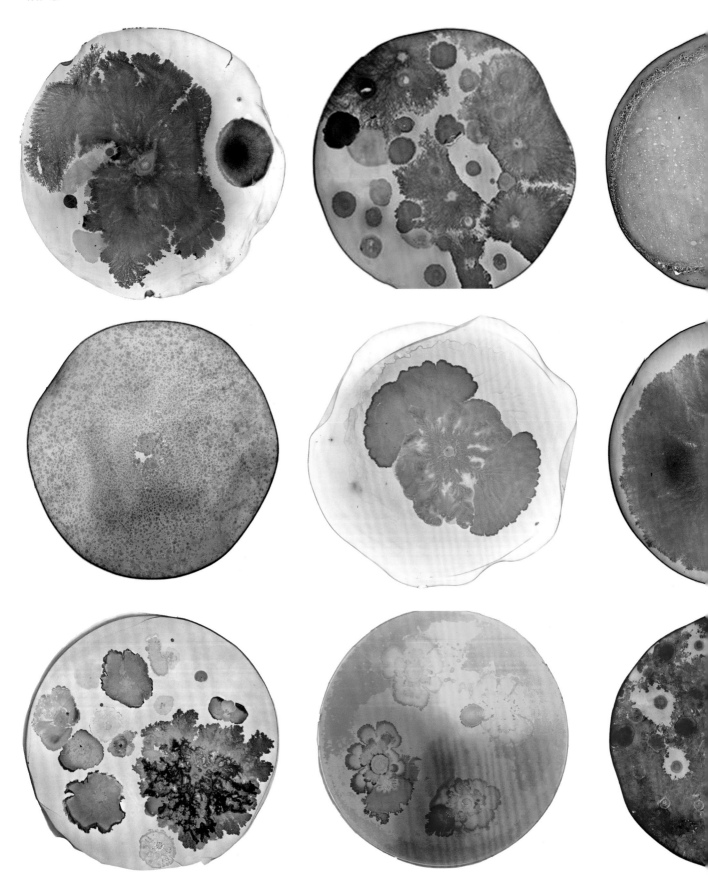

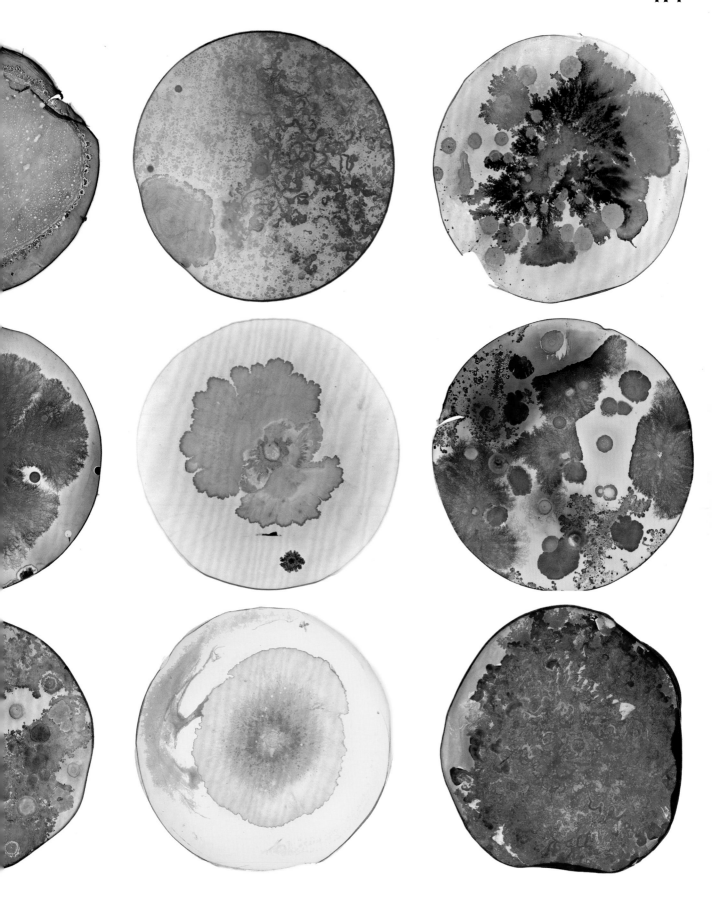

The relationship between bacteria and cancer has a rich history. On one hand, bacteria have been directly linked as a cause of cancer, such as *Helicobacter pylori*, helical-shaped bacteria able to infect the stomach, leading to ulcers, chronic gastritis, and, under certain conditions, to stomach cancer. (Note that the links are fairly complicated; some people do not see *H. pylori*'s detrimental effects, and the bacteria can even be linked to decreases in certain cancers.) On the other hand, some bacteria have connections to preventing or treating cancer. As early as in ancient Egypt, Imhotep, an Egyptian physician, experimented with incising tumors, facilitating infections as a treatment. More than four millennia later, in the nineteenth century, researchers such as Sir James Paget, Wilhelm Busch, Friedrich Fehleisen, and P. V. Bruns reported malignant tumors disappearing when patients contracted an erysipelas infection, a skin disease now known to be caused by *Streptococcus pyogenes*. Bone surgeon William Coley then tested the use of bacteria on a large number of patients and realized that something about the bacterial infection had stimulated the patient's body to fight off the cancer (a discovery that worked for only certain types of cancers). More than a century later, synthetic biologists are programming bacteria to safely deliver cancer therapeutics.

In the Danino lab, we have used several genetic circuits to control the behavior of bacteria to improve their safety as well as efficacy. Some of these rely on the use of bacterial communication systems such as quorum sensing, or the delivery of toxins that soil bacteria and other pattern-forming species produce. Pigments and small, colored molecules can be used as diagnostics, so that the bacteria report on the presence of the tumor, and it is critical to try to reliably control bacteria so that they do not mutate and avoid their given programming. But this is just one of many advances in synthetic biology that are creating momentum for engineering additional features to the billions of years of bacterial evolution.

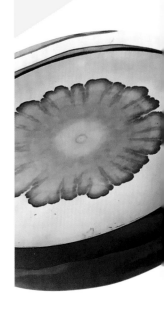

Transcending human-centric lab practices that have been used for centuries by microbiologists, novel approaches are harnessing the power of computers and machines to revolutionize microbial programming. But to be effective, they also have to have interfaces that are humanlike to be accessible and enable creativity. This new relationship between humans, microbes, and machines is unlocking unprecedented possibilities, allowing for the artificial generation beyond what is realizable in the biological and physical world. This synergistic exploration reflects on fundamental perspectives of the human condition and interactions with living and nonliving entities that speak to our collective futures.

(opposite) Bacteria petri dishes artificially generated via generative adversarial networks (GANs). The pixelation reflects the nascent stage of today's bio-technology, much as the look of early video games (like Pong played on TV) reflected the capabilities of technology at the time.

(this page) Various bacterial species grown in petri dishes under pattern-forming conditions and embedded in acrylic.

Various bacterial species grown in petri dishes and embedded in resin.
These microbes, like most in this book, were either manually engineered or "coaxed"
via certain growth conditions to produce patterns.

Could AI learn how nature programs bacteria and do the same, or even more? At the Danino lab, we explored this through the use of ML and generative adversarial networks (GANs) to mimic and expand upon bacterial evolution and pattern formation. The large collection of petri dish images that we have collected over the course of years serves as "training" data for these algorithms, which can then generate new bacterial images that are digitally unique—artificially generating the transient biological existence of life through evolution.

AFTERWORD

JEFF HASTY, PHD

A science brain must be similar to an art brain. This hasn't been demonstrated to my knowledge, but I suspect it's true. Maybe the two brains don't start the same, but accomplished scientists have learned to make jumps in reasoning that defy a pure logic that is often associated with the trade. I was a music major who switched to physics after I was forced by a liberal arts education to take an astronomy course. I can feel my music brain kick in when a particular puzzle in biology doesn't seem to make sense. It wants to jump over logic with intuition.

Tal was the type of PhD student to make intuitive jumps. I recall he realized that our plan for bacterial synchronization was overly complex, like a Rube Goldberg machine. So he created an elegantly simple design and used microscopy to show remarkable bacterial beauty. This reminded me of a favorite quote attributed to the famous bassist Charles Mingus: "Making the simple complicated is commonplace; making the complex simple, awesomely simple, that's creativity."

Biology can appear complex because of the way we look at it. Our solar system seemed complex before Copernicus put the sun at the center. Copernicus had a telescope to track the planets because they reflect the sun. Biologists use reflected light to observe processes such as the development of an embryo, the policing of bacteria by immune cells, and the use of ion channels by biofilms to communicate like a human brain. Somehow physics lies at the foundation of these processes. But it's unclear how we get from the laws of physics to the biological complexity. The marriage of observation and human creativity leads to intuitive jumps.

It's important to remember that bacteria are social. Differing species cooperate or compete; some embrace diversity while others are xenophobic. When we observe these interactions, we don't see an obvious hierarchy. Perhaps interestingly, science is best when it self-organizes into collaborative groups. We can learn from bacteria. And while we don't yet understand the principles that govern species interactions, it is nevertheless clear that no single bacterium is directing the show.

In terms of the need for creativity and collaboration in science, how do we enable the hive of humanity to contribute to science? How do we encourage artists to get involved? *Beautiful Bacteria* represents one avenue. Impressively, Tal Danino has coupled accessible technology (cameras, scanners) with sugar-coated plates and dyes to create art that is as stimulating as it is beautiful. The book lays bare an artificial categorization. This book is enabling. It enables the artist to become a scientist; it enables the scientist to think artistically. Brains are complicated, but I suspect this leads to understanding.

There is no guarantee that biology is understandable by the human brain. We *hope* that the process of evolution selects for principles that we can comprehend. But such an understanding won't arise from pure logic. To me, Danino's book represents a need. A need for the creative brain to exercise. A need for artists in science.

CH. 1: THE ORIGINS OF LIFE

Bozdag, G. Ozan, Seyed Alireza Zamani-Dahaj, Thomas C. Day, et al. "De novo evolution of macroscopic multicellularity." *Nature*, vol. 617 (2023): 747–54. https://doi.org/10.1038/s41586-023-06052-1.

Sagan, Lynn. "On the origin of mitosing cells." *Journal of Theoretical Biology* 14, no. 3 (March 1967): 225–74. https://doi.org/10.1016/0022-5193(67)90079-3.

CH. 2: WONDERFUL TO BEHOLD

De Kruif, Paul. *Microbe Hunters*. New York: Blue Ribbon Books, 1926.

Gest, Howard. "The discovery of microorganisms by Robert Hooke and Antoni Van Leeuwenhoek, Fellows of The Royal Society." *Notes and Records: The Royal Society Journal of the History of Science* 58, no. 2 (May 2004): 187–201. https://doi.org/10.1098/rsnr.2004.0055.

CH. 3: GROWTH AND EMERGENCE

Ben-Jacob, Eshel, Inon Cohen, and David L. Gutnick. "Cooperative Organization of Bacterial Colonies: From Genotype to Morphotype." *Annual Review of Microbiology* 52 (October 1998): 779–806. https://doi.org/10.1146/annurev.micro.52.1.779.

Doshi, Anjali, Marian Shaw, Ruxandra Tonea, et al [including Tal Danino]. "Engineered bacterial swarm patterns as spatial records of environmental inputs." *Nature Chemical Biology*, vol. 19 (2023): 878–86. https://doi.org/10.1038/s41589-023-01325-2.

Kearns, Daniel B. "A field guide to bacterial swarming motility." *Nature Reviews Microbiology*, vol. 8 (2010): 634–44. https://doi.org/10.1038/nrmicro2405.

CH. 4: FIRST ENCOUNTER

Hall, Andrew Brantley, Andrew C. Tolonen, and Ramnik J. Xavier. "Human genetic variation and the gut microbiome in disease." *Nature Reviews Genetics*, vol. 18 (2017): 690–99. https://doi.org/10.1038/nrg.2017.63.

Martino, Cameron, Amanda Hazel Dilmore, Zachary M. Burcham, et al [including Rob Knight]. "Microbiota succession throughout life from the cradle to the grave." *Nature Reviews Microbiology*, vol. 20 (2022): 707–20. https://doi.org/10.1038/s41579-022-00768-z.

Perez-Muñoz, Maria Elisa, Marie-Claire Arrieta, Amanda E. Ramer-Tait, et al. "A critical assessment of the 'sterile womb' and 'in utero colonization' hypotheses: Implications for research on the pioneer infant microbiome." *Microbiome* 5, no. 48 (2017). https://doi.org/10.1186/s40168-017-0268-4.

Tamburini, Sabrina, Nan Shen, Han Chih Wu, et al. "The microbiome in early life: Implications for health outcomes." *Nature Medicine* 22, no. 7 (2016): 713–22. https://doi.org/10.1038/nm.4142.

Yassour, Moran, Tommi Vatanen, Heli Siljander, et al. "Natural history of the infant gut microbiome and impact of antibiotic treatment on bacterial strain diversity and stability." *Science Translational Medicine* 8, no. 343 (June 2016): 343ra81. https://doi.org/10.1126/scitranslmed.aad0917.

CH. 5: INTREPID EXPLORERS

Byrd, Allyson L., Yasmine Belkaid, and Julia A. Segre. "The human skin microbiome." *Nature Reviews Microbiology*, vol. 16, (2018): 143–55. https://doi.org/10.1038/nrmicro.2017.157.

Costello, Elizabeth K., Christian L. Lauber, Micah Hamady, et al [including Rob Knight]. "Bacterial community variation in human body habitats across space and time." *Science* 326, no. 5960 (2009): 1694–97. https://doi.org/10.1126/science.1177486.

CH. 6: MAKING THEMSELVES AT HOME

Carmody, Rachel N., Georg K. Gerber, Jesus M. Luevano Jr., et al. "Diet dominates host genotype in shaping the murine gut microbiota." *Cell Host & Microbe* 17, no. 1 (2015): 72–84. https://doi.org/10.1016/j.chom.2014.11.010.

Farré-Maduell, Eulàlia, and Climent Casals-Pascual. "The origins of gut microbiome research in Europe: From Escherich to Nissle." *Human Microbiome Journal,* vol. 14 (2019): 100065. https://doi.org/10.1016/j.humic.2019.100065.

Rothschild, Daphna, Omer Weissbrod, Elad Barkan, et al. "Environment dominates over host genetics in shaping human gut microbiota." *Nature*, vol. 555 (2018): 210–15. https://doi.org/10.1038/nature25973.

Sender, Ron, Shai Fuchs, and Ron Milo. "Revised estimates for the number of human and bacteria cells in the body." *PLOS Biology* 14, no. 8 (2016): e1002533. https://doi.org/10.1371/journal.pbio.1002533.

Song, Hye Seon, Tae Woong Whon, Juseok Kim, et al. "Microbial niches in raw ingredients determine microbial community assembly during kimchi fermentation." *Food Chemistry*, vol. 318 (2020): 126481. https://doi.org/10.1016/j.foodchem.2020.126481.

CH. 7: ABUNDANT GUESTS

Gilbert, Jack A., Martin J. Blaser, J. Gregory Caporaso, et al [including Rob Knight]. "Current understanding of the human microbiome." *Nature Medicine* 24 (2018): 392–400. https://doi.org/10.1038/nm.4517.

Lax, Simon, Daniel P. Smith, Jarrad Hampton-Marcell, et al. "Longitudinal analysis of microbial interaction between humans and the indoor environment." *Science* 345, no. 6200 (August 2014): 1048–52. https://doi.org/10.1126/science.1254529.

CH. 8: COMPETITION AND COEXISTENCE

Hewitt, Krissi M., Charles P. Gerba, Sheri L. Maxwell, et al. "Office space bacterial abundance and diversity in three metropolitan areas." *PLOS ONE* 7, no. 5 (2012): e37849. https://doi.org/10.1371/journal.pone.0037849.

Mela, Sara, and David E. Whitworth. "The fist bump: A more hygienic alternative to the handshake." *American Journal of Infection Control* 42, no. 8 (2014): 916–17. https://doi.org/10.1016/j.ajic.2014.04.011.

CH. 9: MICROBIAL MAPS

Nayfach, Stephen, Simon Roux, Rekha Seshadri, et al. "A genomic catalog of Earth's microbiomes." *Nature Biotechnology*, vol. 39 (2021): 499–509. https://doi.org/10.1038/s41587-020-0718-6.

Ramirez, Kelly S., Jonathan W. Leff, Albert Barberán, et al. "Biogeographic patterns in below-ground diversity in New York City's Central Park are similar to those observed globally." *Proceedings of the Royal Society B: Biological Sciences*, vol. 281 (2014). https://doi.org/10.1098/rspb.2014.1988.

Wall, Diana H., ed. *Soil Ecology and Ecosystem Services* (Oxford: Oxford University Press, 2012).

CH. 10: HARNESSING CHAOS

Baym, Michael, Tami D. Lieberman, Eric D. Kelsic, et al. "Spatiotemporal microbial evolution on antibiotic landscapes." *Science* 353, no. 6304 (September 2016): 1147–51. https://doi.org/10.1126/science.aag0822.

CH. 11: REWIRING BIOLOGY

Cameron, D. Ewen, Caleb J. Bashor, and James J. Collins. "A brief history of synthetic biology." *Nature Reviews Microbiology*, vol. 12 (2014): 381–90. https://doi.org/10.1038/nrmicro3239.

Gurbatri, Candice R., Nicholas Arpaia, and Tal Danino. "Engineering bacteria as interactive cancer therapies." *Science* 378, no. 6622 (November 2022): 858–64. https://doi.org/10.1126/science.add9667.

Sepich-Poore, Gregory D., Laurence Zitvogel, Ravid Straussman, et al [including Jeff Hasty and Rob Knight]. "The microbiome and human cancer." *Science* 371, no. 6536 (March 2021). https://doi.org/10.1126/science.abc4552.

All images © Tal Danino except the following, which appear by kind permission of the photographers and artists.

Pages 2, 31 (bottom), 63, 65, 68, 71 (all), 72–73, 74, 75, 76 (all), 77, 78, 79, 142, 143 (all), 144, 145 (all), 152, 155, 162–63 (all), 164–67 (all): Photographer Tina Berardi.

Pages 104, 107 (top, bottom), 108–9: Photographer Josh Dickinson.

Pages 124–27: Anicka Yi, You Can Call Me F Portraits, cultured bacteria, 2015 ©2023 Anicka Yi / Artists Rights Society (ARS), New York. Photo courtesy of the artist and 47 Canal, New York.

Pages 182, 183: Bacteria Chirality and Chiral Colony (respectively). 2 of set of 6 dinner plates, 10.6", limited edition of 2,500. Courtesy of Vik Muniz and Tal Danino.

Additional experiments from Danino lab members include: Anjali Doshi (page 44-45), Marian Shaw (pages 44-45, 50–51 unstained images, 158-59, 160–61), Dhruba Deb and Stefani Shoreibah (page 134), Skylar Li (page 172).

page 2: A colony of *Bacillus cereus* collected from a beach and grown on black agar *(detail)*.

ABOUT
THE AUTHORS

First and foremost, my thanks to Soonhee Moon for her incredible dedication to this project. Soonhee started as a photography intern in our lab and has evolved into a remarkable bacterial researcher who has contributed to everything in this book, from making many of the dishes and editing the photography to lending her deep expertise to the captions. A special thanks to all other members of the Danino lab for their contributions, particularly Marian Shaw, as well as Dhruba Deb, Anjali Doshi, Stefan Shoreibah, and Skylar Li. Dooeun Choi's collaboration in the production and curation of bacterial artworks was invaluable.

My sincere appreciation to the Rizzoli Electa team including Charles Miers, Margaret Rennolds Chace, Loren Olson, Richard Slovak, and Kaija Markoe for their support

and enthusiasm in this project. A special thanks to Lucinda Hitchcock and Cara Buzzell for their dynamic design showcasing these beautiful organisms, and Elizabeth Smith for her amazing work in editing and bringing everything together.

To Jeff Hasty and Sangeeta Bhatia, for their support in exploring these types of projects while working in their labs. And to collaborators and colleagues Vik Muniz, Anicka Yi, and Seed (Ara Katz & Raja Dhir).

Lastly, to my partner JoJo for unwavering support as well as to Ada, Violet, and Cooper for their microbiome contributions. My deepest gratitude for all those mentioned and those inadvertently omitted. This book would not have been possible without your collective efforts and belief in the power of art and science.

Tal Danino is a professor in the department of biomedical engineering at Columbia University in the City of New York. He directs an interdisciplinary synthetic biology lab that "programs" bacteria and transforms these microbes into artworks using various forms of media. Originally from Los Angeles, Tal received a PhD in bioengineering from the University of California–San Diego, did his postdoctoral research at the Massachusetts Institute of Technology, and is a TED Fellow.

Vik Muniz is a Brazilian-born artist and photographer based in New York and Brazil. His signature style appropriates and reinterprets iconic images of our time with unconventional materials including diamonds, magazines, chocolate, dust, and dirt. His work has been exhibited internationally and is in the collections of major institutions around the world. In the United States and Brazil, Muniz collaborates on many educational and social projects. In 2010, Muniz was featured in the Academy Award–nominated documentary *Waste Land*.

Jeff Hasty is a professor in the departments of bioengineering and molecular biology, and director of the Synthetic Biology Institute at the University of California–San Diego. He originally received his PhD in physics and mutated into a hybrid computational/bioengineering biologist somewhere along the way. He is a pioneer in the fields of synthetic and systems biology and has established paradigms for the design and construction of genetic circuits in living cells.

Ara Katz is co-founder of Seed Health with a vision to pioneer innovations in microbiome science for human and planetary health. Ara also co-founded Seed's environmental research initiative, SeedLabs, to advance novel microbial innovations for biodiversity and ecosystem restoration, and LUCA Biologics, to accelerate vaginal microbiome research for unmet needs in women's health. With an interdisciplinary background in health, tech, media, and design, Ara has garnered acclaim for her contributions to science communication and translation. Her children's book, *A Kids Book about Your Microbiome*, introduces the next generation to the beautiful, powerful world of microbes that live within us.

POSTSCRIPT

ARA KATZ

In our collective quest for well-being and environmental conservation, we've scaled the vast terrains of visible landscapes, from the verdant heart of rainforests to the mysterious depths of oceans. Yet, it's in the invisible realm where we unearth a revolution. Witnessing this microbial world isn't just a scientific revelation; it's a transformative philosophical shift. By magnifying this miniature cosmos, we can not only redefine the very essence of being human but also unlock solutions to some of the formidable challenges humanity and our planet are confronting.

As Earth's oldest life forms, microbes possess an evolutionary wisdom that humankind has only begun to fathom. Over billions of years, they have perfected the art of adaptation, collaboration, and survival. Today, they promise solutions not just to our most pressing health challenges but also to broader societal inequities that mar our world. Their resilience and interconnectedness hint at a sustainable future, one that places peace and mutualism above conflict and division.

But we have only scratched the surface of their vast potential. For human health, microbial solutions offer hope where traditional methods falter. They invite us into the next frontier of medicine, offering potential new pathways to target unmet and growing medical needs with a precision and effectiveness previously unimagined. In the realm of women's health, microbes promise to bridge glaring gaps left by historical gender biases and socioeconomic injustice. For our everyday lives, they empower agency—a new lens to inform our choices and become stewards of our bodies.

As nature's silent custodians, microbes also have profound implications in our fight against climate change. From carbon sequestration to the sustainable generation of biofuels and bioplastics, microbial processes offer compelling avenues to ferment our future.

This book is more than an exploration—it's an invitation. A call to embed this expanded perspective into our collective consciousness. Embracing microbes empowers us to think and act in ecosystems, to consider the broader ecologies of our communities, our families, and our environment. With them, our anthropocentric view crumbles, revealing a more intricate tapestry, an urgent reminder that all life is connected.

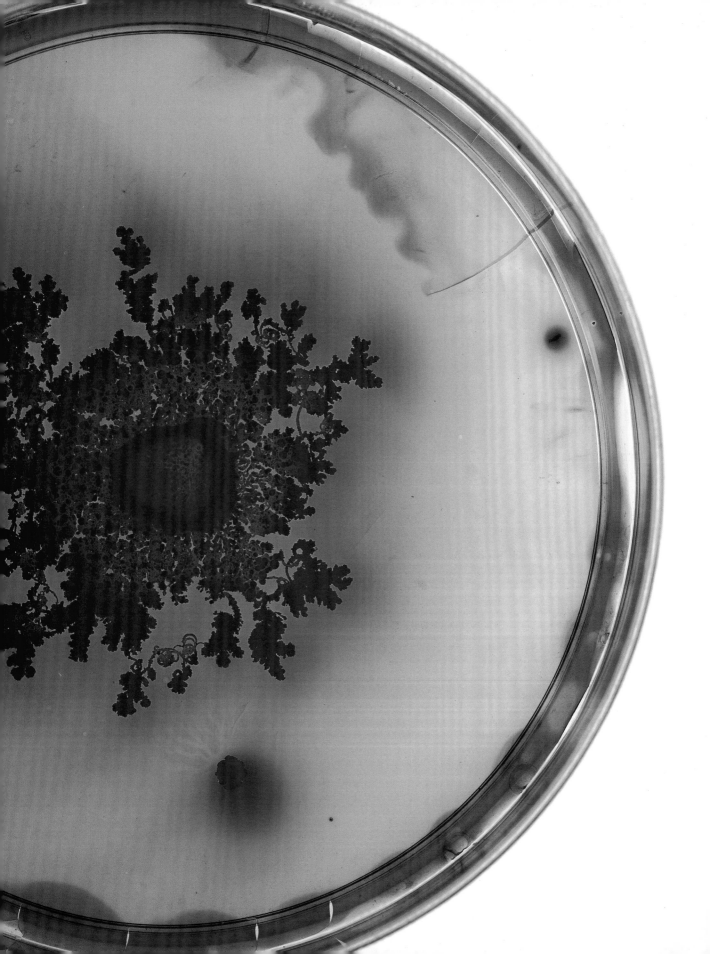

Petri dish images turned into decals and applied to ceramic dinner plates, from our lab's collaboration with artist Vik Muniz on the *Petri* series (2015).

First published in the
United States of America
in 2024 by Rizzoli Electa
A Division of Rizzoli International Publications, Inc.
300 Park Avenue South, New York, NY 10010
www.rizzoliusa.com

Copyright © 2024 Tal Danino

For Rizzoli Electa
Publisher: Charles Miers
Associate publisher: Margaret Rennolds Chace
Managing editor: Lynn Scrabis
Acquisitions editor: Loren Olson
Editor: Elizabeth Smith
Designed by Cara Buzzell and Lucinda Hitchcock
Typefaces: *Helveesti* by Dinamo and *Editorial* by Pangram
Production manager: Kaija Markoe

For the Danino Lab
Principle investigator: Tal Danino
Staff researcher: Soonhee Moon

All rights reserved. No part of this publication may
be reproduced, stored in a retrieval system, or
transmitted in any form or by any means, electronic,
mechanical, photocopying, recording, or otherwise,
without prior consent of the publishers.

Printed in China

2024 2025 2026 2027 / 10 9 8 7 6 5 4 3 2 1

ISBN: 978-0-8478-9986-9
Library of Congress Control Number: 2023942109

Special Thanks to
Seed°